...k Win... ...
a... d... ...ed at W... ...
Court... institute, Lon... ...the ... Uni... ...
West ...erlin. After a career as a journalist and
cartoonist, he taught at University College London,
and then in Cambridge, where he is still attached to
Wolfson College. Well known as a broadcaster and
lecturer, he is now Tutor in Cultural History at the
Royal College of Art, London. His other books
include *Bauhaus* and *Egon Schiele* (also in *World of Art*);
Oskar Kokoschka, A Life; Expressionist Portraits and the
prize-winning *Japanese Prints and Western Painters.*

WORLD OF ART

This famous series
provides the widest available
range of illustrated books on art in all its aspects.
If you would like to receive a complete list
of titles in print please write to:
THAMES AND HUDSON
30 Bloomsbury Street, London WC1B 3QP
In the United States please write to:
THAMES AND HUDSON INC.
500 Fifth Avenue
New York, New York 10110

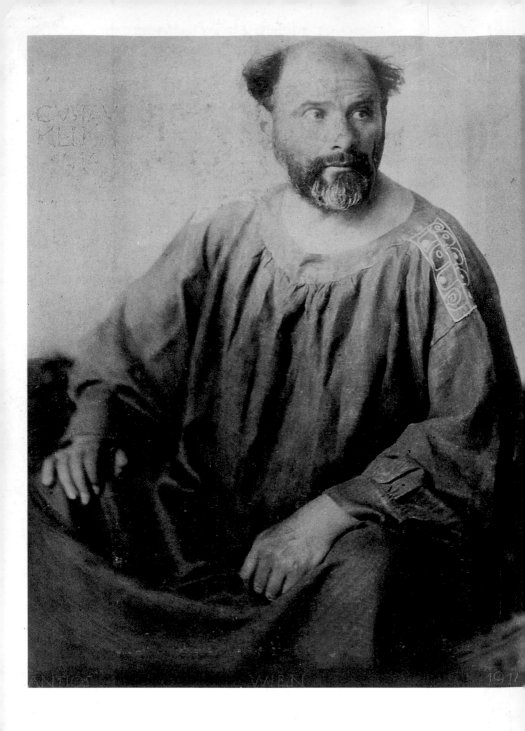

KLIMT

Frank Whitford

With 159 illustrations, 29 in colour

Thames and Hudson

For my parents

Typeset in 10¾/11½pt Monophoto Bembo Roman

Printed and bound in Singapore

Contents

In recent years the history, art and culture of Vienna during the two decades before the First World War have been the focus of an extraordinary amount of critical attention. The interested public has been deluged with books, articles and exhibitions that have covered every aspect of the subject in great depth. The work of Gustav Klimt, the most remarkable artist of the period, is now more popular than ever – this book, indeed, is a product of that popularity.

Klimt was one of the central figures in the cultural life of the Austrian capital around the turn of the century, yet we know far less about him than any of his great contemporaries. He did not keep a diary and wrote very few letters. He said little about himself that was recorded, and so we know almost nothing of his attitude to his own art or that of others. There is, it is true, a wealth of secondary source material, but most of this is anecdotal and of dubious reliability. The picture of Klimt that emerges from it may seem clear at first, but it quickly becomes confused and blurred by subsequently emerging complexities and contradictions.

Klimt was a central figure, yet there is another sense in which he was also peripheral. Unlike most of the writers, journalists, artists, musicians, philosophers and scientists who made fin-de-siècle Vienna such an exciting place, Klimt belonged to no clearly defined circle. He counted other artists and composers among his friends but he met them privately, preferring not to frequent any of the cafés in the heart of the city famous for their conversation and gossip. He lived and worked away from the centre and although he was known, admired and liked by many, his friendships were rarely intimate. Superficially outgoing, even jovial, Klimt was in truth a very private person who kept his deepest feelings and most intimate thoughts to himself.

All this makes it understandably difficult to write about Klimt. Some would argue that the lack of information about the man is of no account: the art is the only important thing and that should speak for itself. Yet so much of what Klimt drew and painted is so obviously personal and its most characteristic qualities so obviously at variance with the image he sought to project, that the attempt to link the art with the life, although fraught with dangers, is entirely justified.

No-one can write about Klimt without incurring a debt to earlier publications. The books, articles and exhibition catalogues on which I have relied are listed in the bibliography, while the sources of the quotations are cited separately. The names of three authors appear there with striking frequency and I must acknowledge a special debt to their work here. They are Christian M. Nebehay, whose anthology of documents provides the richest source of primary material in published form; Werner Hofmann, whose essays about Klimt and his contemporaries sparkle with insight and information; and Carl E. Schorschke, whose book about the culture of fin-de-siècle Vienna is the standard study of the subject. My own chapter about Klimt's paintings for the ceiling of Vienna University relies heavily on his account and his interpretation.

Not for the first time I must also thank two friends, each of them immersed in Viennese art and culture, who were generous enough to read the typescript, make corrections and suggest changes in approach and emphasis. Dr Wolfgang Fischer, who has written widely about Klimt (and organized the first British exhibition of his work more than twenty years ago), is one of those friends. The other is Dr Edward Timms, of Caius College, Cambridge, who interrupted his own work on the second volume of his important biography of Karl Kraus in order to help me. Both made invaluable suggestions and their corrections have saved me much embarrassment. If errors remain, they are entirely mine.

F.P.W.
Great Wilbraham, Cambridge 1989

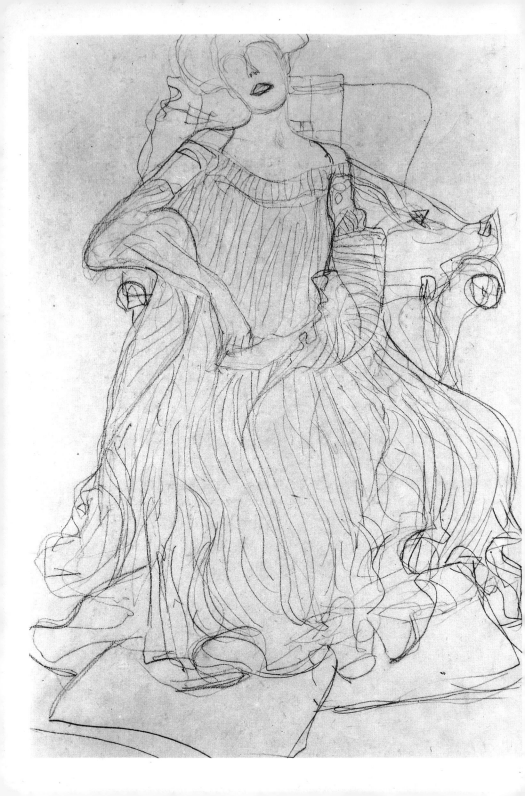

A Portrait and the Artist

In 1907, at the age of forty-five and at the height of his artistic powers, Gustav Klimt completed a most remarkable portrait. It is of Adele Bloch-Bauer, the wife of a Viennese banker and industrialist. Work on the portrait had been slow. The first preparatory sketches and studies were made no less than four years before, and the painting itself took many months to complete. During this period Klimt was much occupied with a more major commission, it is true; but the time it took to complete the painting was in large part due to the elaborate and extraordinary technique he employed, which involved laying down gold and silver leaf and fashioning intricate decorative devices in low relief with gesso.

This is the most lavish of Klimt's portraits. In no other did he use so much gold and silver, and in few others is there so much ornament. The ostentatious materials and prolific decoration remove Adele Bloch-Bauer from the earthly plane, transform the flesh and blood into an apparition from a dream of sensuality and self-indulgence. She inhabits a glamorized, static and airless world whose finely wrought forms recall the art of ancient civilizations. The gold is like that in Byzantine mosaics; the eyes on the dress are Egyptian, the repeated coils and whorls Mycenaean, while other decorative devices, based on the initial letters of the sitter's name, are vaguely Greek.

The portrait is less a likeness than an icon: the image is made numinous by the precious materials that it embodies or evokes through its ornamentation. Most of the painting is glittering artifice. The sitter's body and the gown that adorns it have been virtually eclipsed beneath an impenetrable, enamelled surface which repeatedly draws attention to itself and away from the sitter. In the witty words of Éduard Pötzl, a contemporary critic, the portrait is *mehr Blech als Bloch* – more brass than Bloch.

The painting creates an impression of wealth, influence and sensuality by means of its rich and polished surface. Klimt shows Adele Bloch-Bauer not as she really was, nor even as she might have wished herself to be, but rather as her husband (who commissioned the painting) desired her to be seen by others. The portrait is adorned with ornament for much the same reason that she wore the gowns, furs and

1 Study for *Adele Bloch-Bauer, c.* 1903

2 *Adele Bloch-Bauer, c.* 1907

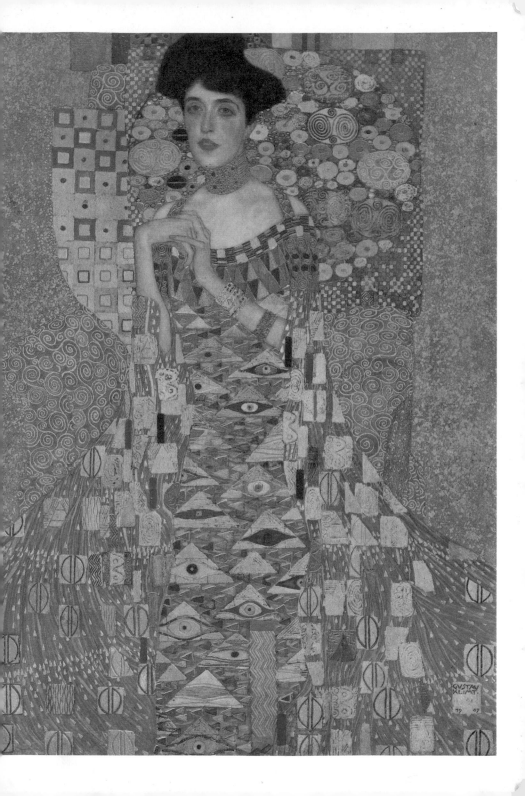

jewelry her husband gave her – not only to enhance her beauty but also to exhibit his taste and affluence: the painting, after all, was hung in a prominent position in the sitter's home, where it proclaimed her husband's artistic discernment and status. Itself one of Ferdinand Bloch's possessions, the portrait depicts another: his wife.

Bloch was a director of a large merchant bank in Vienna and also had interests in the sugar, printing and paper industries. In 1901 he entered an arranged marriage with Adele Bauer, a member of a wealthy Jewish family. They had no children. Denied the education then widely thought unsuitable for well-bred young ladies, Adele educated herself, partly by establishing a salon at which the celebrated writers Stefan Zweig and Jakob Wasserman were regular guests. The Social Democratic politician Karl Renner was also a frequent visitor.

Almost all of Klimt's portrait commissions came from the same class as the Blochs, or at least from those of its members who had sophisticated and adventurous tastes. The Viennese middle class would spend their evenings at the theatre, the opera or at dinner parties where they engaged in cultivated conversation with composers, performers, actors, writers and painters. Some of them consulted Sigmund Freud. Many of them were Jews who, whether converted to Christianity or not, had been completely assimilated into society. Many had affairs with artists and writers, partly no doubt as an escape from the stifling conventions of their lives.

Adele Bloch-Bauer became acquainted with Klimt not long before she married and, according to an article by the American psychiatrist Salomon Grimberg, they soon began an affair which lasted for twelve years. Grimberg, who produces no evidence for his claim, admits that the affair went unnoticed in Vienna, a seeming impossibility in that gossip-hungry city, but claims that it did take place, known only to Adele Bloch-Bauer's maid and personal physician.

Paintings support Grimberg's assertions, however. The features of Judith in what is perhaps Klimt's most erotic painting, *Judith and Holofernes*, are plainly those of Bloch-Bauer as, less obviously, are those of the woman in his second version of the same subject. In the earlier *Judith* she wears around her neck the same deep, jewel-encrusted choker that reappears in the portrait of 1907. It was a present from her husband.

Extraordinary though it now seems, no one before Dr Grimberg had noticed the striking resemblance of Adele Bloch-Bauer to Judith and it may be that her husband was equally blind to this apparent evidence of his cuckoldry. He did see *Judith and Holofernes* when it was first exhibited, however, and he must have been struck by the obvious resemblance of the fatal, sexually aroused woman to his wife, especially

3, 4 Studies for *Adele Bloch-Bauer, c.* 1903

since she is wearing a distinctive choker which is unmistakably the one
he had given her.

In the portrait of Adele Bloch-Bauer the jewelry and coiffeur
provide some indication of the epoch to which she belongs, but neither
her pose nor her location suggests her character, interests or status as
they might in a more conventional painting. This suspicion, that in
spite of their intimate relationship Klimt was not much concerned with
the character or even the physical appearance of Adele Bloch-Bauer, is
strengthened by the studies for the portrait. In each of these chalk *1,3,4,7*
drawings the face is represented by little more than a shorthand formula
and the top of the head is almost always cut off at the edge of the paper.

Adele Bloch-Bauer's face, hands and shoulders occupy less than a
twelfth of her portrait and they provide very little information about
her personality. Their relatively naturalistic treatment does convey
something of the quality of flesh and of the bone structure beneath it,
and the awkward attitude of the hands is characteristic of the sitter. (As a
child, Adele Bloch-Bauer had an accident which disfigured the middle

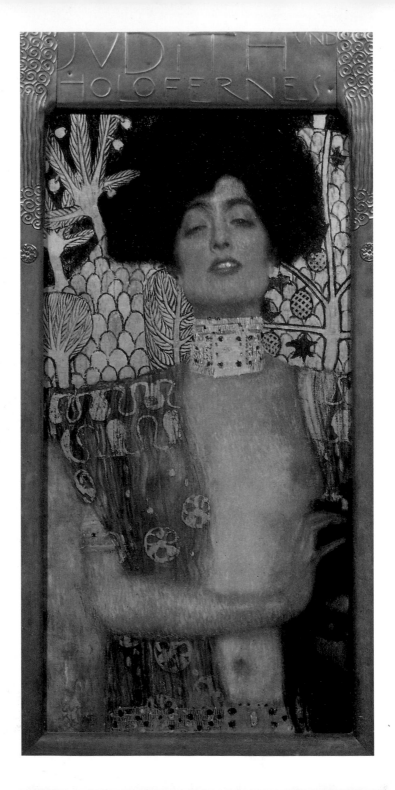

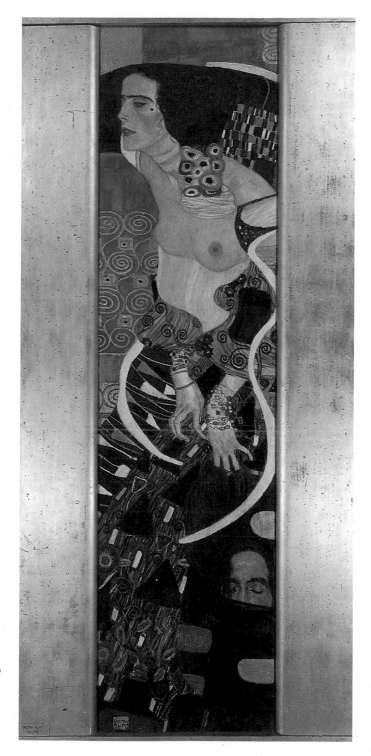

5 *Judith and Holofernes*, 1901

6 *Judith II (Salome)*, 1909

finger of her right hand. Conscious of the mutilation, she always tried to keep it hidden – as she does in the portrait.) Indeed, Klimt's painting of the skin certainly displays some concern for light and the variety of local colours it reveals. But this relatively small island of naturalism is surrounded by an ocean of texture and ornament. In this portrait Klimt attempted the impossible: the reconciliation of the natural and artificial.

In its artifice, as well, *Adele Bloch-Bauer* is precariously poised between two quite dissimilar artistic worlds. In its display of opulence and its determination to cram every available space with decoration it betrays a nineteenth-century weakness for claustrophobic clutter and bizarre embellishment bordering on kitsch. Yet in its flight from familiar reality and in the expressive nature of its decoration, it betrays a more modern belief in the suggestive potential of abstract form.

The two vying approaches contribute both to the painting's allure and to our own unease at finding ourselves intrigued by it. The same contradiction lies at the heart of most of Klimt's mature work and it is not fanciful to see it as a reflection of contradictions both within Klimt's artistic personality and the society in which it was formed.

Some paintings provide a deeper insight into the nature of an epoch than do several shelves of books. Klimt's portrait of Adele Bloch-Bauer speaks volumes about Viennese society during the declining years of the Austro-Hungarian Empire: about the elaborate compromises which enabled it to function and the gulf between pretence and reality on which its foundations were precariously and fatally built.

Austria was a country of contradictions. They began with the nature of the State itself. At a time when elsewhere in Europe state was newly synonymous with nation, Austria was a multi-national empire whose only unifying force was the Habsburg dynasty that ruled it. Since the Emperor of Austria was also King of Hungary, everything was simultaneously *kaiserlich* (imperial) and *königlich* (royal) – 'k and k'. Punningly playing with the sound of that abbreviation in German, the writer Robert Musil, in his novel *The Man Without Qualities*, was to dub Austria-Hungary *Kakania* – the land of pooh – and to itemize some of the contradictions, paradoxes and compromises on which the State was founded. He began with its name:

On paper it called itself the Austro-Hungarian Monarchy; in speaking, however, one referred to it as Austria, that is to say, it was known by a name that it had, as a State, solemnly renounced by oath, while preserving it in all matters of sentiment, as a sign that feelings are just as important as constitutional law and that regulations are not the really serious things in life. By its constitution it was liberal, but its system of government was clerical. The system of government was clerical, but the general attitude to life was

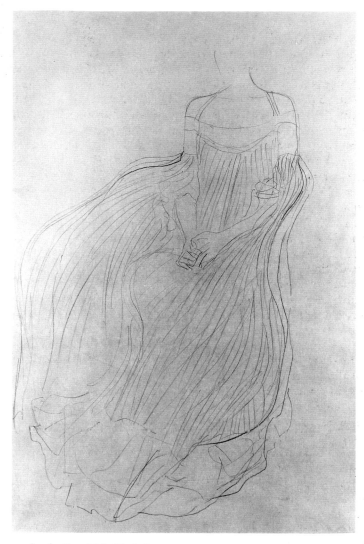

7 Study for *Adele Bloch-Bauer*, c. 1903

liberal. Before the law all citizens were equal, but not everyone, of course, was a citizen. There was a parliament, which made such rigorous use of its liberty that it was usually kept shut; but there was also an emergency powers act by means of which it was possible to manage without Parliament, and every time when everyone was just beginning to rejoice in absolutism, the Crown decreed that there must now again be a return to parliamentary government.

The contradictions did not end there. German was the language of Austria, but on the streets of Vienna Czech, Hungarian, Romanian, Romany, Yiddish, Polish and Italian could be heard almost as often. (Even the oath of allegiance taken by every member of the Imperial forces to the Emperor was issued in eleven languages.) While the fashionably elegant paraded along the Kärnterstrasse or drove out in their carriages in the Prater exhibiting their wealth, the poor were struggling to survive in the squalor of suburban slums. Whilst society preached the virtues of marital fidelity and the evils of promiscuity, adultery and prostitution were rife.

Klimt's art, in its contradiction and compromise, reflects something of the nature of the Austria in and for which it was produced. It is also virtually the only guide to the personality of the artist himself. Klimt was not fond of words. He rarely talked about his work, never described his artistic aims, did not keep a diary and wrote few letters (one of the longest of the small number extant is a complaint to his landlord about the state of a stove). He preferred to communicate with people on the telephone and when that was not possible, to send brief messages on postcards via the *Rohrpost* – the pneumatic mail.

The only record of Klimt's view of himself is contained in an undated typescript of something he wrote, or more likely said in conversation. It is called 'Commentary on a non-existent self-portrait'.

I can paint and draw. I believe as much myself and others also say they believe it. But I am not sure that it is true. Only two things are certain:
1. I have never painted a self-portrait. I am less interested in myself as a subject for a painting than I am in other people, above all women. But other subjects interest me even more. I am convinced that I am not particularly interesting as a person. There is nothing special about me. I am a painter who paints day after day from morning until night. Figures and landscapes, portraits less often.
2. I have the gift of neither the spoken nor the written word, especially if I have to say something about myself or my work. Even when I have a simple letter to write I am filled with fear and trembling as though on the verge of being sea-sick. For this reason people must do without an artistic or literary self-portrait. And this should not be regretted. Whoever wants to know something about me – as an artist, the only notable thing – ought to look carefully at my pictures and try to see in them what I am and what I want to do.

Klimt was a subject of general curiosity in Austrian society because of his notoriety and because some regarded him as the most brilliant painter of his generation. His work was often controversial and sometimes provoked outrage. But if the public were forced through

want of information to seek clues to the nature of the man in his art, they were likely, at least according to the few people who knew Klimt well, to be seriously misled. One of Klimt's friends, the writer Emil Pirchan, warned, in his book *Gustav Klimt. Ein Künstler aus Wien*, that the 'highly sensitive drawings, the strangely twilit, shimmering colours of [Klimt's] exotic, often even extravagant pictures' created the impression of a man who was

a weak, over-refined, indulged, exhausted and sickly aesthete. But how surprised the general public was when it actually saw the artist himself: an energetic, large and powerful body with a head like that of an apostle on a strong, bull neck − a head reminiscent of Dürer's Peter . . . The eyes, melancholy and unworldly, gazed out from a hard, tanned face framed by a dark, severe beard. That and the unruly coronet of hair sometimes gave him a faun-like appearance.

Others were also struck by the contrast between the refined qualities of the paintings and Klimt's direct and straightforward manner, his pronounced Viennese accent and his unsophisticated, sometimes crude sense of humour. Klimt was no unworldly aesthete, no Aubrey Beardsley working by candlelight in a room with the curtains drawn. The only aspects of his appearance that were in any way in keeping with the conventional image of the artist were the long, full blue robe rather like an Arab burnous which he habitually wore (with nothing underneath) when working, the sandles on his feet, his beard and his hair, which he wore high on his temples. He knew how much his work was worth and asked considerable sums for it. He worked long and regular hours. He lived modestly at home with his mother and two unmarried sisters and slept in a small, sparsely furnished bedroom. Early every morning he took breakfast at the Tivoli Café in Schönbrunn from where he took a fiacre to his studio. He worked there in the company of many cats and several models who were always in attendance whether he needed them or not. He never took a break for lunch. In the evenings he liked to play skittles and at dinner to eat enormous quantities of food. He neither lived nor worked in the centre of Vienna and kept his distance from the places in which opinions were formed and influence originated. He frequented none of those celebrated cafés where artistic, literary or intellectual matters were daily debated. He seldom went abroad and rarely travelled anywhere except in the summer when he always spent several months at the same place in the Salzkammergut, the Austrian lake district. In spite of his love of company, in all important senses he was withdrawn.

Perhaps the only trait in his personality consistent with the hypersensitive qualities of his art was his hypochondria. He was bluff,

the picture of rude health, but always afraid that he might fall victim to some serious illness and paid an annual preventative visit to a spa to take the waters.

Unlike Mahler, Freud, Karl Kraus, Adolf Loos or indeed most of the other figures who dominated the artistic and intellectual life of Vienna around the turn of the century, Klimt led a life disappointingly lacking in the stuff of fascinating biography. But perhaps it is simply the paucity of trustworthy information that makes it seem so; and if we had a greater knowledge of the man himself perhaps the contradictions between his art and his personality might appear less extreme.

Year after year his life seemed to follow an unchanging pattern. He never married but enjoyed a long and intimate relationship with his sister-in-law Emilie Flöge which, however, was probably never physical. He had, it is true, a number of illegitimate children born to different women, but Klimt and his mistresses were invariably discreet. His affairs resulted in neither drama nor scandal. How much more might we understand Klimt's supremely erotic art if we had some insight into his relationships with women?

Lack of reliable documentation does not only apply to this inevitably fascinating aspect of Klimt's life. Early in his career Klimt changed direction. He ceased to do what he knew he was good at, which had pleased a large public and brought him fame and financial security. He preferred to go his own way, to offend his patrons and risk his future. Was this because of some personal crisis? Or because some other event in his life provoked a moment of blazing revelation? We simply do not know, and as a result the paintings for Vienna University (in which Klimt's change of direction is glaringly apparent) remain infuriatingly enigmatic.

Again, the imagery of those paintings and many others also remains obscure because we know so little about what Klimt himself knew and thought. What books did he read? What did he know of the major developments in philosophy, literature and science that were taking place in Vienna during his lifetime? Too often we can only speculate.

Klimt's art and its development remain elements in a fascinating conundrum. It is not entirely representative of the late nineteenth century, nor does it quite belong to the twentieth. A spectacular but uneasy mixture of Historicism and Symbolism, of Naturalism, Expressionism and Abstraction, it defies all attempts to categorize it. It is as complex and contradictory as the times in which it was made and as the man who made it.

28,34,37

8 Klimt, c. 1912, in the garden of his studio in the Josefstädterstrasse

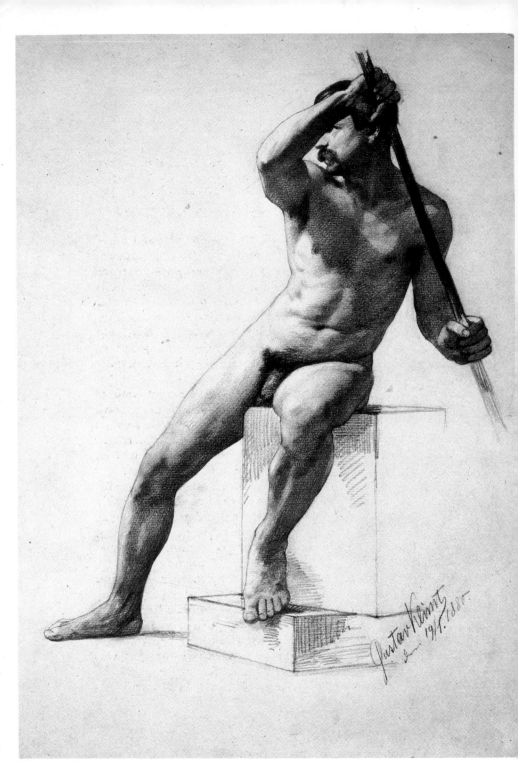

Pageantry and Paradox

The span of Gustav Klimt's life matched almost precisely the final phase of the Habsburg Empire, which began with the opening of the first pan-Austrian parliament in 1861, a year before he was born, and ended, only months after he died, in 1918 with the defeat of Austria-Hungary in the First World War.

At the time when Franz-Josef I, the Emperor of Austria and King of Hungary, drove out from his residence to open parliament, even the appearance of the city itself suggested the birth of an era in Austrian history. The Emperor's coach took him past the remains of the recently demolished ancient city walls to the wooden construction at the Schottentor where the parliament was temporarily located. Soon the rubble would be removed, an imposing boulevard would encircle the city centre and new buildings, the parliament house amongst them, would be erected along its length. The boulevard – the Ringstrasse – would become the symbol of the new Austria.

Klimt was born in Baumgarten, a suburb to the south-west of Vienna, on 14 July 1862. His father, an immigrant from Drabschitz near Leitmeritz in Bohemia, had been brought to the capital by his parents at the age of eight. He was a gold engraver by trade and had married a Viennese girl, Anna Finster. Anna was musical and nurtured an ambition to go on the stage which she was never able to realize.

Gustav, the second of seven children, displayed obvious artistic gifts from an early age. His brother Ernst, two years his junior, was probably just as skilled a painter and until his death at the age of twenty-eight had shown every sign of becoming as famous and successful. The youngest brother, Georg, was also talented and became a consummate craftsman in metalwork.

Apart from the exceptional abilities of the three brothers, the Klimt family was typical of many thousands of others in all respects. Many immigrants had come to the capital from Bohemia in search of a better life, only to fall on hard times after the catastrophic stock market crash of 1873 followed the financial failure of the Vienna World Exposition of that year. Such families would have lived towards the fringes of Vienna, where the relatively low rents and the proximity of the countryside did little to compensate for the miserable living conditions

9 *Male Nude Seated on a Pedestal*, 1880, one of the many life-drawings Klimt made as a student at the Kunstgewerbeschule

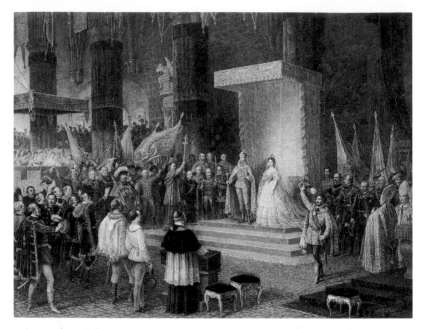

10 Eugen Doby, *Coronation of Franz-Josef I*, 1867. Franz-Josef I was crowned King of Hungary in an attempt to quieten Hungarian demands for self-determination.

there. Their horizons were narrow, their expectations of improvement limited and their health poor.

The Klimt family had little money. The house in which Gustav was born – 247 Linzerstrasse in Vienna's XIVth district – was small, cramped and badly lit and, in spite of its appearance in photographs, scarcely better than a malodorous and insanitary slum. It was difficult for Klimt's father to find work and the family was frequently forced to move in search of ever cheaper accommodation. Between 1862 and 1884 the family had no fewer than five different addresses and as late as 1889, when their circumstances had somewhat improved, the father's annual income amounted to no more than 832 Gulden – less than half that of the average worker. Klimt's sister, Hermine, recalled that 'at Christmas there wasn't even any bread in the house, let alone presents'.

The family's financial problems were compounded by domestic tragedy. In 1874 the second youngest daughter, Anna, died at the age of five after a long illness, while Klara, the eldest of the Klimt children, became mentally disturbed and fell victim to a religious mania. She

never fully regained her sanity and subsequently her mother is believed to have suffered from frequent and profound depressions.

Klimt's parents were ambitious for their five healthy children, however, but their aspirations were confined by their poverty. Gustav was not able to attend a *Gymnasium* – the type of secondary school that provided a thorough grounding in the humanities and languages as a preparation for a university career. He, like most Viennese children of modest background, went to the more ordinary *Bürgerschule* which offered a sound but basic education to children who, after they left school at fourteen, were expected to become factory workers, craftsmen, unskilled labourers or petty clerks.

At school Gustav's talent for drawing was judged remarkable. A relative advised his mother that he should apply for a place at the Kunstgewerbeschule – the School of Arts and Crafts – which trained its students to become teachers, craftsmen or designers and thus assured them of a career, status and a regular income.

Klimt passed the entrance examination to the Kunstgewerbeschule (which consisted of making a copy of a plaster cast of a classical female head) with distinction and in October 1876, at the age of fourteen, he began his studies, intending eventually to become a drawing master at a *Bürgerschule*, a position which offered a secure salary and a guaranteed pension.

11 Leaflet announcing the development of the Ringstrasse, 1860

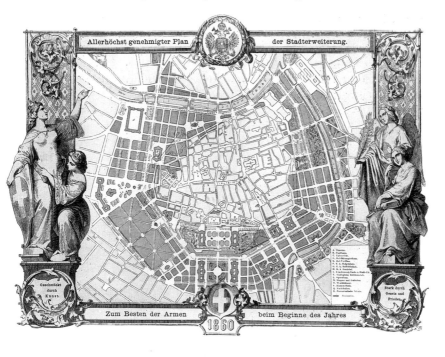

Allerhöchst genehmigter Plan

der Stadterweiterung.

Geschmückt durch Kunst.

Stark durch Gesetz und Frieden.

Zum Besten der Armen

beim Beginne des Jahres

1860

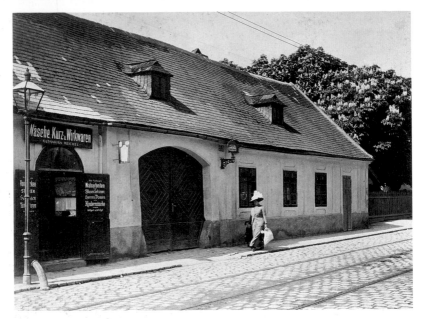

12 247 Linzerstrasse, the house where Klimt was born in Vienna's XIVth district. His parents lived in the room to the right of the entrance.

The Kunstgewerbeschule was one of two public art schools in Vienna. The other, older and grander, was the Akademie der bildenden Künste – the Academy of Fine Arts – which trained painters and sculptors in the traditional manner. The Kunstgewerbeschule, situated on the most eastern section of the Ringstrasse, was a less conventional institution. Founded as recently as 1868, it was the first Continental school to teach art and craft in a manner which, pioneered in Britain, was based on the copying of historical models.

The Vienna Kunstgewerbeschule was initially an adjunct to the Austrian Museum of Art and Industry, which provided students with both exemplars and inspiration. In 1871 the Museum moved into a grand new building designed in Italian Renaissance style, and equally impressive premises for the School adjacent to the Museum were completed six years later, a few months after Klimt began his studies.

13,14 These were but two of the many new buildings that were shooting up around the Ringstrasse at this time – not only the structures that gave a public face to the modern mercantile and liberal state (the parliament, the university, the state opera, a court house, a new town hall, a stock

26

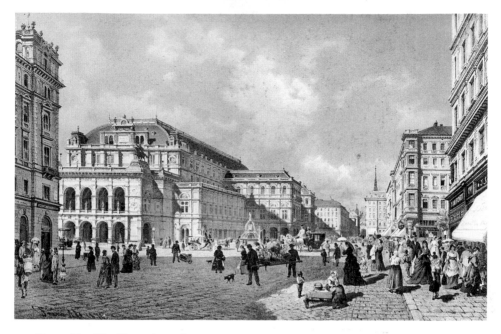

13 Franz Alt, *The Opernring*, 1872

14 G. Veith, *View of the Ringstrasse*, 1873

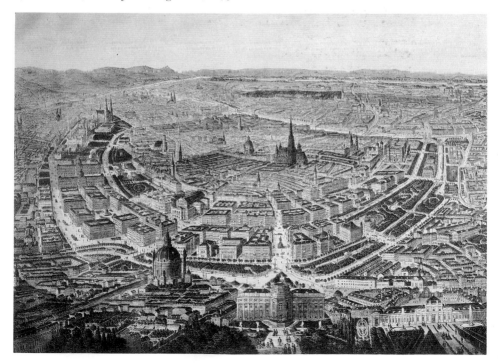

exchange, a theatre, a concert hall and museums of art and natural history), but also palatial blocks of apartments for the new, bourgeois rich. Yet the various styles of these hardly suggested their newness. Each of them was designed in a style borrowed from the past. The Neo-Gothic stood cheek-by-jowl with the Neo-Classical, the Neo-Baroque with the Neo-Renaissance. In part it was the architectural vogue for historicism, widespread throughout Europe, which dictated the use of these past styles; however, they also served to confer on such recent institutions as the parliament an air of legitimacy and authority. The parliament house recalled the buildings of classical and democratic Greece, while the Gothic town hall evoked ideas associated with medieval civic pride. Above all, the architecture of the Ringstrasse suggested that the recently created bourgeoisie were the legitimate heirs to a past that had previously been the exclusive possession of the aristocracy.

The building of the Ringstrasse and, a little later, of a second, outer ring – the Gürtel – was an achievement far greater than Haussmann's reconstruction of Paris under Napoleon III. During the last four decades of the nineteenth century it provided seemingly endless employment for architects, artists and craftsmen. Klimt, as we shall see, also benefited from the boom as soon as he left the Kunstgewerbe-schule, seven years after his training began there.

When it was finally completed, the Ringstrasse – planted with plane trees, ailanthuses and limes – was not only one of the grandest and most imposing boulevards in Europe. It took on an added significance: it was a symbol, a *via triumphalis*, and in many ways a stage set and an imperial exercise in public relations.

The construction of the Ringstrasse coincided with, and was in part the result of, the rise to economic dominance of the middle class. Having failed to overthrow the absolutist regime in the revolution of 1848, it finally achieved a degree of influence commensurate with its economic power after the humiliating defeat of the Habsburg armies by Prussia at the Battle of Sadowa in 1866. It expressed its gratitude for its new status in society with a degree of adulation the monarchy had never previously enjoyed.

Anxious to defend its achievements, the Viennese bourgeoisie was conservative and conformist. Having no history, standards or – apart from the Biedermeier – style that was entirely its own, it could only imitate the past from which it had once been so anxious to escape and followed traditional models for its manners and behaviour. In their houses and apartments middle-class families assembled collections of furniture, objects and art which were as cluttered and anachronistic as

15

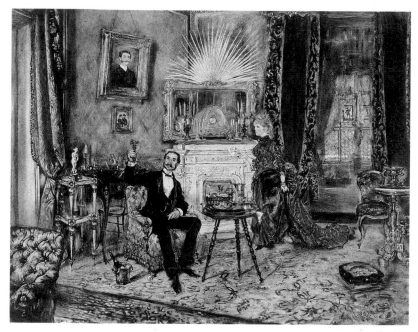

15 Anton Romako, *Lady and Gentleman in a Drawing-room*, 1887

the historicist facades they lived behind. What struck one writer about
the appearance of these apartments was

> a stuffing, an overloading, a filling of space and an over-furnishing ... These
> are not spaces for living in but pawnshops. Simultaneously in evidence is a
> strong preference for anything shiny – silk, satin, polished leather, gold
> frames, gilded stucco, gilt-edged books – and for loud, unrelated decorative
> pieces: rococo mirrors ..., multi-coloured Venetian glass, heavy old German
> decorative china. On the floor is the skin of a wild beast ..., while in the hall is
> a life-sized wooden blackamoor ... everything is there only for show.

Yet the apartments did not so much resemble pawnshops as
museums and, like the people who owned them, they pretended to be
what they were not: they masqueraded as Italian *palazzi* while those
who lived in them passed themselves off as members of the ancient
Catholic aristocracy. They were assisted in their pretension by the
multitude of titles, some of them hereditary, from *Ritter* to *Hofrat*,
liberally handed out by the Court as if it were distributing some kind of
placebo.

In emulation of the aristocracy, the bourgeois Viennese patronized
the arts; but what they commissioned and bought – bogus ancestral

29

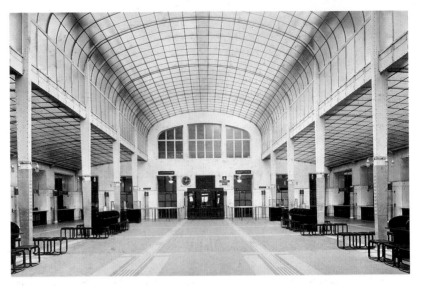

16 The Postal Savings Bank, Vienna, 1904–06, designed by
Otto Wagner

portraits, inflated allegorical representations and history paintings –
reflected the same motivation and delusions which governed every
other part of their lives.

 Despite this patronage, the middle class put its faith in science and
industry. The economic growth and scientific progress during the fifty
years before the First World War were most remarkable; and the effects
of this were more dramatic in Austria than in other European countries,
such as Britain or France, which had industrialized earlier. In Vienna the
Danube was rerouted by means of a remarkable feat of modern
engineering (to stop frequent and disastrous flooding), the first electric
lamps appeared on the streets, as did the first automobiles and trams,
while the telegraph and telephone revolutionized communications.

 Vienna was the city not only of the Ringstrasse but also of Otto
Wagner's municipal railway, one of the world's most efficient. The
bridges and stations together with other buildings that Wagner
16 designed later – the Postal Savings Bank, for example – are, in their
striking use of modern materials, quite unlike the buildings on the
Ringstrasse and anticipate a more modern kind of industrial
architecture.

 At the turn of the century Vienna led the world in medical research.
The widespread enthusiasm for science and the faith in uninterrupted
progress towards an envisaged Golden Age was shared, paradoxically,

by people whose artistic tastes were for the old, whether genuine or artificial. The ageing Emperor, however, was amongst the few who resisted the advance of technology, fearing perhaps that it would eventually make the monarchy itself seem an anachronism. There were no telephone lines to his residence in the Hofburg, where the rooms continued to be lit by oil lamps; imperial letters were not typed but handwritten; sanitary arrangements remained primitive; and the Emperor still drove out in a horsedrawn carriage.

In a famous essay of 1898, 'The Potemkinian City', the architect Adolf Loos unforgettably compared the Ringstrasse to the cloth and cardboard villages hastily erected in the Crimea by Field Marshal Potemkin to impress Catherine the Great with the splendid living conditions of the peasants there. 'When I walk along the Ring', Loos wrote, 'I always get the feeling that a modern Potemkin has wanted to create the impression in the visitor to Vienna that he has arrived in a city inhabited exclusively by the nobility.'

This was certainly not the case: increasingly, away from the centre, Vienna was becoming a city not of the aristocracy, or even feigned aristocracy, but of the proletariat, of badly paid, badly housed workers whose living conditions – as the young Adolf Hitler was to discover in the series of public shelters in which he took refuge – were even worse than those in other industrialized countries.

However, life in Vienna for the proletariat was not entirely joyless and was obviously thought preferable to life in the villages, as the influx of immigrants from every part of the empire would seem to testify. They came, buoyed up by their hopes for improvement, if not for themselves then for their children. They knew that social advancement was possible, that fortunes could be made. Klimt's career demonstrates that the faith in the open society was not misplaced. His beginnings were humble but his talents were to ensure him fame. One of the horde of upwardly mobile, he was anxious to make his name and knew that conformity was a prerequisite of success.

In spite of the reforming spirit in which the Kunstgewerbeschule was founded, parts of its syllabus and some of its teaching methods were traditional. Klimt was first obliged to undergo an intensive training in drawing which involved the faithful copying of ornamental designs and decorations and then of plaster casts of classical sculpture. Only later was he permitted to draw the figure from life. Klimt impressed his teachers from the beginning. They thought him too gifted for a career in teaching and urged him to become a painter. He consequently joined the specialist painting class at the School, which was directed by

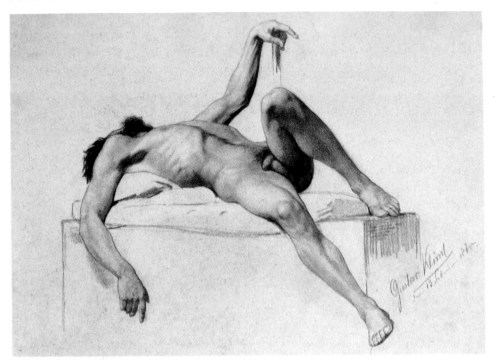

17 *Reclining Male Nude*, 1880

Professor Ferdinand Laufberger and which was taken over after his death in 1881 by Julius Viktor Berger.

Clear evidence of Klimt's prodigious talent as a draughtsman is provided by the life studies that he produced as a young student. Executed in soft pencil, which enabled him to describe the articulation of muscles by means of subtle variations of tone, they are extraordinarily accurate studies of the male body both in action and at rest. Yet, they are highly conventional – the result of observation rather than inspiration, of a desire to rework old solutions rather than seek the new. All of Klimt's later work bears the stamp of the thorough and traditional training he received. His mastery of Naturalism, his inventive use of pattern and ornament and his ability to paint the figure were firmly rooted in what he learned as a student.

Laufberger was evidently an inspiring and unusually generous teacher. He treated his students like apprentices in a medieval studio, involving them in his own commissions and, when he felt the time was ripe, helping them to acquire commissions of their own.

9,17

32

Laufberger's work, some of it for buildings on the Ringstrasse, was of the kind that was then highly regarded throughout Europe. It was an example of what is known as history painting, a term which describes the subject rather than the style of such work. In it, historical, biblical, literary, mythological or allegorical subjects were treated usually on a large scale and in a didactic, intellectually improving or morally uplifting manner. The aim of most history painting was a kind of retrospective realism, the recreation of an event as it must have happened and looked at the time. It thus put its audience in touch with the past and enabled it to regard itself as the heir to a particular historical and cultural tradition. It also demanded of the painter a wide knowledge of history and art history, classical and other world literature, the Bible, mythology and philosophy, and an ability to undertake painstaking research into the history of dress and architecture. It is thought that Klimt set about acquiring the necessary knowledge in museums and libraries.

At the time Klimt was a student at the Kunstgewerbeschule the most celebrated history painter in Vienna, and perhaps all of Central Europe, was Hans Makart, who has been described as the most representative artist of the Ringstrasse era. Makart's style consists of a clever, if over-rich mixture of Naturalism and Symbolism, the power of which is enhanced by borrowings from Titian and Rubens. His bravura technique and dramatic effects of light give the historical events and exotic scenes he portrayed a magic and mystery that were heady and theatrical.

18 Hans Makart, *The Entry of Charles V into Antwerp*, 1878

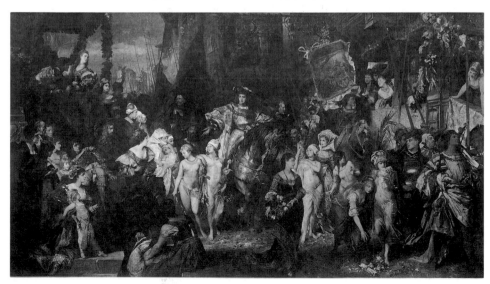

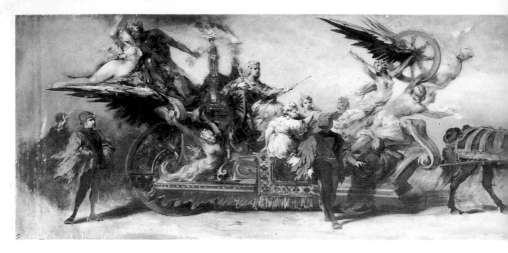

19 Hans Makart, *The Railways*, 1879, design for a float for the procession celebrating the Emperor's silver wedding on 27 April 1879

One of Makart's best-known paintings is *The Entry of Charles V into Antwerp* (1878), which depicts an important episode in the history of the Habsburg dynasty and a vital part of the national myth. More than nine metres wide and five metres high, it shows a scene of peaceful conquest which bustles with life-sized figures, both clothed and naked. Some of them, like the Emperor himself and Albrecht Dürer (who witnessed the event in 1520 and whose account of it served Makart as a source) are historical personages. But no one could have regarded the painting as a realistic representation. It is a rhetorical and grandiloquent exercise in propaganda which turns historical fact into Grand Opera.

In an article published in 1900 the critic Ludwig Hevesi (who was one of Klimt's most ardent admirers) discussed Makart's love of the theatre and its significance for his art:

He himself wore costume all his life. Not merely on the outside, like an actor, but above all inside himself. He wore the costume of a prince and a multi-millionaire . . . He dressed up all of his life as a fairy story, Vienna as Baghdad. As long as he lived the year had to have 365 days and 1001 nights.

Makart, who earned enough to live – as well as dress – like a prince, was as famous for his pageants as for his paintings. The most extravagant pageant he ever designed marked the silver wedding of the Emperor and Empress in 1879 and was based on a series of sixteenth-century woodcuts, *The Triumph of Maximilian I*. To the accompaniment of massed orchestras and brass bands, scores of lavishly decorated

horsedrawn floats bearing tableaux of people costumed as allegorical and historical figures wound their way around the Ringstrasse, taking five hours to pass. No fewer than 14,000 people in folk costume, historical dress and uniform took part in what must have been one of the most elaborate charades in history.

These tableaux not only portrayed the history of the guilds and the traditional occupations – hunting, horticulture, the work of dairymen, butchers, brewers, wigmakers, roofers, opticians, and watchmakers. They also celebrated the more recent bourgeois institutions, such as the association of wholesalers, and the new industries – the railways and steam shipping. Tellingly, however, they did so not in contemporary dress but Renaissance costume.

The floats, created by hundreds of students, Klimt among them, working to Makart's designs, could scarcely have generated any sense of wonder at the marvels of technology and science, either: they were calculated rather to give the modern age a dubious history and a spurious legitimacy by means of theatrical devices and classical allusion.

A contemporary description of the float representing the railways, *19* one of the most potent symbols of modern life, makes this clear. It appeared as

the triumphal chariot of the God of Fire who married [sic] a water nymph in flight. At the front of the float were three figures with trumpets personifying fame and carrying the symbol of the railways, the winged wheel. Beneath this was the head of the Hound of Hell . . . In the centre of the float six ladies in heraldic costumes represented the provinces of the Empire: Austria, Bohemia, Moravia, Polonia, Silesia and Styria.

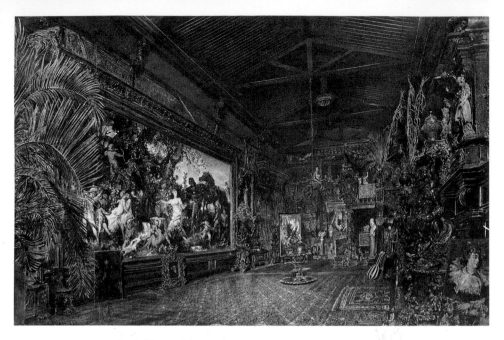

20 Rudolf von Alt, *Makart's Studio*, 1885

In their attempt to give their subjects an instant historical patina, the tableaux in Makart's pageant were the temporary, mobile equivalents of the buildings of the Ringstrasse, in front of which they made their measured and triumphal progress. Both the floats and the buildings were part of the same theatrical performance.

Theatre indeed – especially operetta – was the art form which the Viennese best understood and to which they most passionately responded. Actors and singers were the most celebrated members of society and ordinary people cultivated the gestures and tone of voice of certain thespians in their search for a role model for everyday life. The writer Stefan Zweig, who grew up in Vienna before the turn of the century, remembered that

the Court Theatre, the Burgtheater, was for the Viennese, for the Austrian, more than a mere stage on which actors performed plays. It was the microcosm which mirrored the macrocosm, the colourful reflection in which society looked at itself, the only correct 'cortigiano' of good taste. In the court actor the audience saw a model of how one dressed, how one entered a room, how one conversed, which words one might use as a man of good taste, and which words one should avoid. Instead of being a place of

mere entertainment, the stage was a living guide to good behaviour, to correct pronunciation, and a nimbus of respect like a halo surrounded everything that had even only the slightest connection with the Court Theatre. The prime minister, the richest magnate could walk through Vienna without anyone turning his head; but a Court Actor, an operatic singer, was recognized by every salesgirl and every coachman . . .

Although not an actor, Makart was their representative. He, too, played a role and was imitated by others in such areas as design and home furnishing. The modish interior of his studio could have been described in detail by those who had never visited it, for it was the subject of many photographs and paintings. One of them is a large and meticulously detailed watercolour of 1885 by Rudolf von Alt. [20] Prominent in the left foreground are the huge, dead but decorative leaves for which he was famous:

Makart who refreshed himself with the delicate tones of all faded things was one of the first to employ the discreet old gold of a dried palm frond to give life to a dark corner . . . the bunch of dried grass, palm leaves, thistle flowers, feathers, woollen pom-poms, exotic butterflies . . . was named after him. Whoever possessed a Makart bouquet did not need to trouble further about the decoration of his room in the Old German style . . . The palm forests of Africa were no longer sufficient to supply the German demand. Large factories made possible the purchase of a Makart bouquet in all sizes.

Klimt revered Makart. As a student he once bribed one of the painter's servants to let him into the studio during Makart's afternoon nap so that he might inspect the latest masterpiece there. Klimt also dreamed of emulating Makart's success. And, in a way, he succeeded, at first by carrying out the same kind of commissions and eventually even by completing projects which Makart's early death had prevented him from finishing. What is more, Klimt wished to be seen chiefly as a painter of architectural decorations even after he had put historicism far behind him.

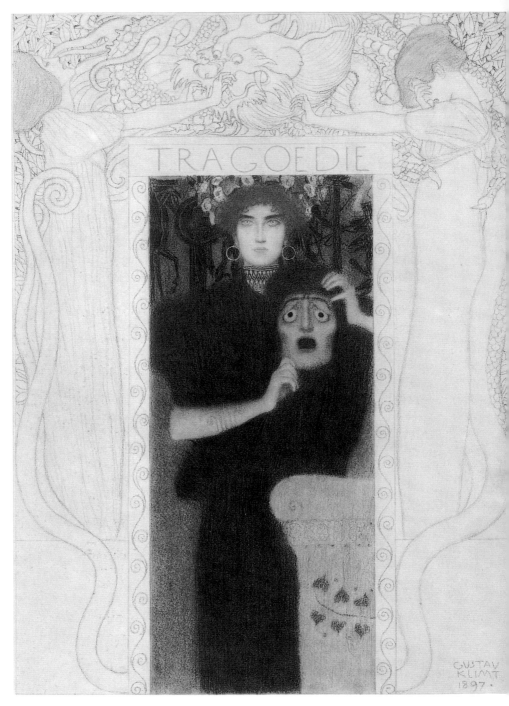

TRAGOEDIE

GUSTAV
KLIMT
1897·

21 *Tragedy*, 1897, from the second series of 'Allegories and Emblems'

The Company of Artists

Gustav Klimt was no rebel. He neither despised nor reacted against the academic training he received and did not question the purpose or relevance of history painting. On the contrary: he was determined to become a painter like Makart.

Before Klimt left the Kunstgewerbeschule he was joined in the painting class by his younger brother Ernst. They became friends with another student, Franz Matsch, who was nine months older than Gustav. Klimt had known Matsch since the day of the entrance examination when they sat together making test drawings from the plaster cast of a classical sculpture.

Both were highly regarded by their teachers who considered them good enough to be recommended for paid work outside the school and they soon carried out a number of minor projects together, the earliest of which was to enlarge the designs for some of the windows for the Votivkirche, the Neo-Gothic church on the Ringstrasse and one of the first buildings to be completed there.

The fees from these projects were of great benefit to the entire Klimt family, which quickly came to rely on Gustav's contributions. Once Ernst had joined the painting class he began to collaborate too, and the three students were prepared to turn their hands to anything, decorating plates and jars, drawing portraits from photographs, even making precise medical illustrations for an ear specialist. Such was their success that they decided to set themselves up in business, calling themselves the Künstlercompagnie, the 'Company of Artists'.

Laufberger recommended them to a Viennese firm of architects which specialized in designing theatres throughout the Habsburg Empire, the Balkans and Germany. In 1880 the firm asked Matsch and the Klimts to produce four paintings representing poetry, music, dance and the theatre to decorate the corners of the boardroom in the headquarters of a paper manufacturer in Vienna.

That year the same architects commissioned another painting, entitled *The Music of the Nations*, for the ceiling of the Kurhaus at Karlsbad. Other work quickly followed – for theatres in Reichenbach, Fiume, Bucharest and Karlsbad. The Künstlercompagnie was even 22

asked to produce a series of ancestral portraits, based on engravings, for a royal palace in Romania.

When Klimt and Franz Matsch left the Kunstgewerbeschule in 1883 the success of their business immediately enabled them to rent a studio spacious enough to produce the large-scale decorative works in which they specialized. They knew that people of influence could help them secure commissions, as a letter of 1884 to the Director of the Museum of Applied Arts, Rudolf von Eitelberger, shows. Probably written by Matsch who, unlike the Klimts, had a facility with words, it was jointly signed and in its elaborate courtesy is presumably typical of many:

until now our work . . . has been largely intended for the provinces and foreign countries. Our most fervent wish is therefore to carry out a larger piece of work in our native city, and perhaps there is a possibility of this just now since the new monumental buildings of Vienna are nearing completion . . . and the most outstanding artists will already be fully occupied.

One sign of the firm's growing reputation in Vienna was a request from a publisher to contribute to an expensive part-work of allegories

22 *The Organ Player*, 1885, oil sketch for the 'Allegory of Music' commissioned for the Bucharest National Theatre

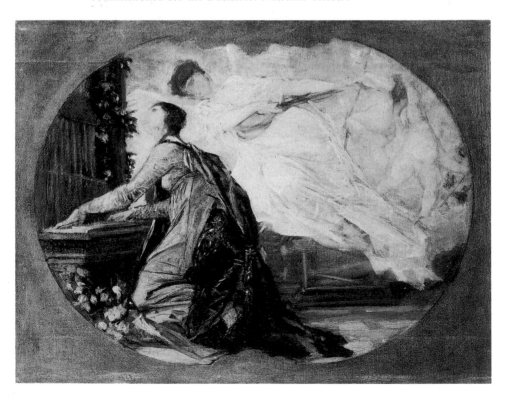

and emblems, most of which were to be illustrated by artists better known than the Künstlercompagnie. Klimt was asked to draw or paint eleven subjects, among them *The Fairytale, The Times of Day, Youth, Opera, Fable* and *Idyll*. It was an entirely typical late nineteenth-century project which drew on but also attempted to re-invent the kind of symbolic language employed and readily understood in the Middle Ages and the Renaissance.

The first series of 'Allegories and Emblems' was a great success and a second, published between 1896 and 1900, followed. For this Klimt produced *Sculpture, Tragedy* and *Love*. In *Tragedy* many of the elements that would characterize Klimt's mature work are already in evidence: gold paint, flat patterns, curving outlines, a mixture of classical, vaguely oriental and personal imagery and the stern-faced female figure all reappear to varying degrees later.

For all their impressive technique these works are not entirely convincing. The tradition which they sought to continue and renew was long since bankrupt. Nothing demonstrates this so much as *Love*. It is a piece of pure kitsch. The girl, eyes closed, head expectantly cocked, is about to be kissed by a handsome man, more gigolo than suitor, with a well-groomed moustache. In the background a series of faces hover, perhaps symbolizing the three ages of woman. The gilded panels decorated with white roses to each side of the central scene push the sentimentality of the painting still further towards bathos and the knowledge that white roses are traditionally the attributes of Venus and of the Blessed Virgin Mary do nothing to rescue it.

The work, trivial and risible though it is, is worth close examination here because, like the other, more successful designs Klimt produced for 'Allegories and Emblems', it shares something with some of his later paintings. This was the first time in Klimt's work that the real and the abstract had appeared together and the purpose of the background figures is to transform a negligible genre scene into a symbolic statement, to encourage the mind to dwell on the larger implications of an otherwise unremarkable episode. Klimt was to become very fond of such background figures in his search for an allegorical language that aspired to contemporary validity.

In 1888, Klimt and Matsch were each commissioned by the Vienna City Council to make a record of the old Burgtheater before it was demolished. (The new Burgtheater had already been erected on the Ringstrasse.) The modest size and medium – not oils but gouache – of Klimt's painting scarcely reflect the importance of its subject to a society obsessed with theatre, but the minutely detailed and almost photographically precise picture had historical significance as soon as it

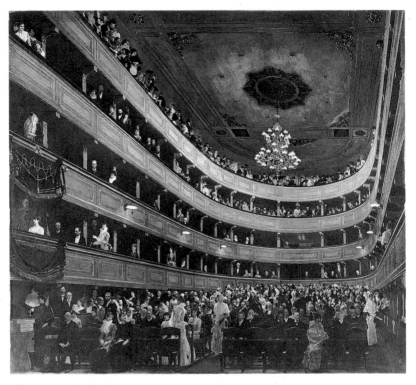

23 *The Auditorium of the Old Burgtheater,* 1888–89

was finished, since it marked the passing of a great era in Viennese cultural life and looked forward to the beginning of an even more glorious epoch ushered in by the opening of the splendid new Burgtheater.

The difference between Matsch's treatment of the subject and Klimt's is revealing. While the former showed the stage from the auditorium, Klimt painted the auditorium from the stage, filling it with some 150 tiny portraits, many of them of regular and prominent members of the Burgtheater audience. The Prime Minister can be identified, as can the Mayor, the composers Brahms and Goldmark, and the Emperor's mistress, Katherina Schratt, who, as an actress, was more often on the stage than in the stalls. Klimt seems to be hinting at the metaphorical role of theatre in Viennese life by adopting a view of his subject which suggests that the audience are just as much on stage as the actors.

Members of the public begged Klimt to include their portraits in his picture and to make copies of the painting which they could hang in their homes. They were motivated by more than the desire to be immortalized: they wanted to have their close connection with the theatre – and thus with Viennese society – publicly demonstrated.

That same year Matsch and the Klimts were asked to decorate part of the new Burgtheater. Financed from the Emperor's private purse, a more important commission could scarcely have been imagined. The Künstlercompagnie was to be responsible for ceiling paintings above the two main staircases, together with panels above the entrances to the auditorium and to the theatre itself. As was customary with such commissions, they were not at liberty to choose their own subjects. The decorations had to illustrate specific aspects of the history of world theatre.

The three artists did not collaborate on the work. Instead, each undertook a number of paintings on his own and they drew lots to determine which subject was to be painted by whom. They had cultivated such similar styles, however, that it is difficult to see which hand was responsible for which picture. Among the subjects which fell to Gustav Klimt were a scene from a classical Greek drama, another from a medieval Mystery play, and the death scene from *Romeo and* *24,25* *Juliet*. Klimt depicted this as it might have been performed at the Globe Theatre in London, watched by an Elizabethan audience. In the only self-portrait he ever painted (and obviously forgot about when dictating his 'Commentary on a non–existent self-portrait'), Klimt himself appears on the right in the audience, wearing a large white ruff and leaning forward. His brother Ernst and Franz Matsch are beside him.

24 *The Globe Theatre in London*, 1886 88

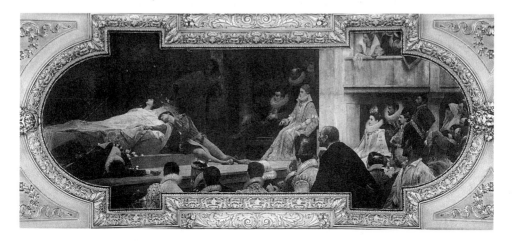

The work for the new Burgtheater took two years. The historical research and other preparation for the panels were painstaking and exhaustive. The accuracy of detail and high degree of realism were achieved with the aid of photographs – the artists employed a camera extensively, with each other and members of their families dressed in period costume acting as models.

Something of Makart is evident in these paintings; more obvious, however, and clearly discernible in the poses and treatment of some of Klimt's figures, is the influence of two of the leading English painters of the day, Lord Leighton and Alma-Tadema. Equally clear in some of Klimt's preparatory drawings for the Burgtheater decorations is his admiration for Ingres. The work for the Burgtheater was very well received and in 1893 the painters were awarded a major state prize.

Three years earlier, the Künstlercompagnie had received another commission as important as the Burgtheater assignment: they were asked to produce paintings for the vast entrance hall of the Kunsthistorisches Hofmuseum, yet another new building on the Ringstrasse, designed to house the matchless Imperial collection of painting and sculpture and thus to draw attention to the generosity and public spirit of the royal family in sharing its treasures with the common man. Makart had originally been commissioned to carry out the work but had managed to complete only twelve of the lunettes before his early death in 1884. This in itself is testimony to the importance with which the project was seen and to the growing reputation of the Künstlercompagnie. Gustav Klimt, not yet thirty, had been invited to follow in the footsteps of the most celebrated Austrian painter of the age.

An older and well-established artist, Michael Munkacsy (whose work repeatedly caused a sensation when shown at the Paris Salons during the 1870s), was entrusted with the painting of the ceiling panel while Matsch and the Klimts were given no less than forty smaller wall spaces to decorate between the columns. These were to show the development of art from ancient Egypt to the Cinquecento, each in a style appropriate to its period. Eleven of them were to be by Gustav Klimt.

Once again the preparations were elaborate and involved the use of photography. But the unified style which makes it hard to distinguish the various hands in the Burgtheater decorations is no longer apparent in these paintings. Although it is extremely difficult to see them clearly in the Museum itself – they are high up and have to compete with a riot of coloured marble and gilded stucco decoration – photographs reveal the high quality of Klimt's work. The young woman in one of his representations of the art of Ancient Greece (with a black-figured Attic

44

vase behind her) marks the debut in Klimt's oeuvre of an obviously contemporary female masquerading as someone from the distant past who, posed and dressed in a way that anticipates Art Nouveau, would reappear in later paintings. Klimt had departed, however slightly, from academic convention and a discerning eye could now distinguish his work from that of his partners.

The Künstlercompagnie was now enjoying the height of its success. It had gained a reputation, extraordinary for such young painters, for work of high quality carried out at speed and always to the full satisfaction of the client, and in 1892 it moved into a new and bigger studio in the Josefstadt district. But at the end of the year tragedy struck: Ernst Klimt died of pericarditis following a heavy cold. Only six months before, his father had also died. Both deaths, but especially that of his brother, deeply affected Gustav, who now assumed financial responsibility not only for his mother and sisters but also for his brother's widow and their infant daughter.

25 Study for the dead Juliet in *The Globe Theatre in London*, 1884

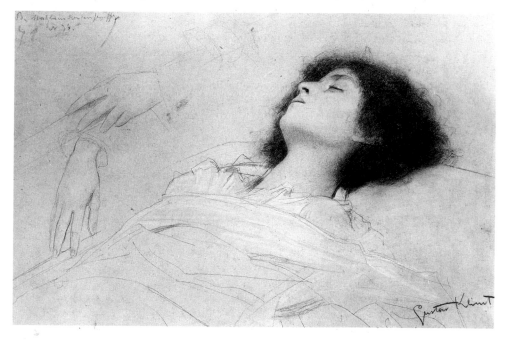

The widow was Helene Flöge, whose father owned a business producing the then popular meerschaum pipe. The family lived comfortably in both the city and the country, where they owned a house, and through them Ernst Klimt had gained entry to the ranks of the solidly respectable middle class. Now Gustav Klimt followed him. He was a frequent and welcome visitor to the Flöges' apartment in Vienna and began an intimate friendship with Helene Flöge's sister Emilie, which he was to maintain until he died.

At this time he seems to have experienced a creative crisis and produced little work during the following few years. Matsch moved out of the studio which Klimt continued to occupy on his own. Whether grief was the only, or even the major reason for the crisis is uncertain. What is clear is that the next major commission he and Matsch accepted caused serious differences between them, and revealed that Klimt's view of art had changed. He ceased to conform and was no longer content to be a mere journeyman who realized the often tired ideas of others. He now questioned the conventions of academic painting and found them wanting. In an attempt to breathe new life into history painting, however, Klimt would soon discover that his efforts were neither generally understood nor appreciated.

26, 27 Frescoes in the Kunsthistorisches Museum, 1890–91; *Ancient Greece* (above)

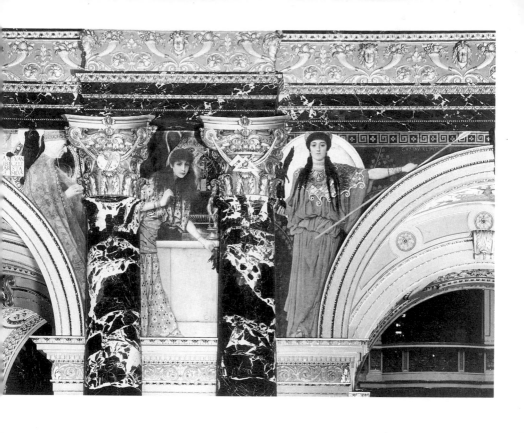

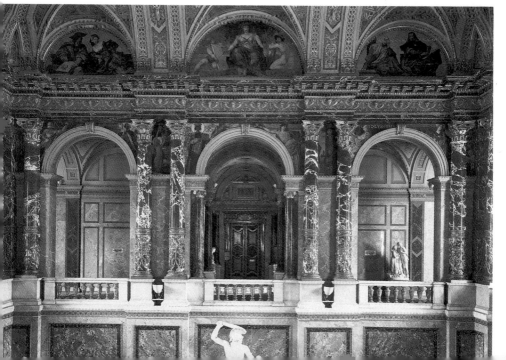

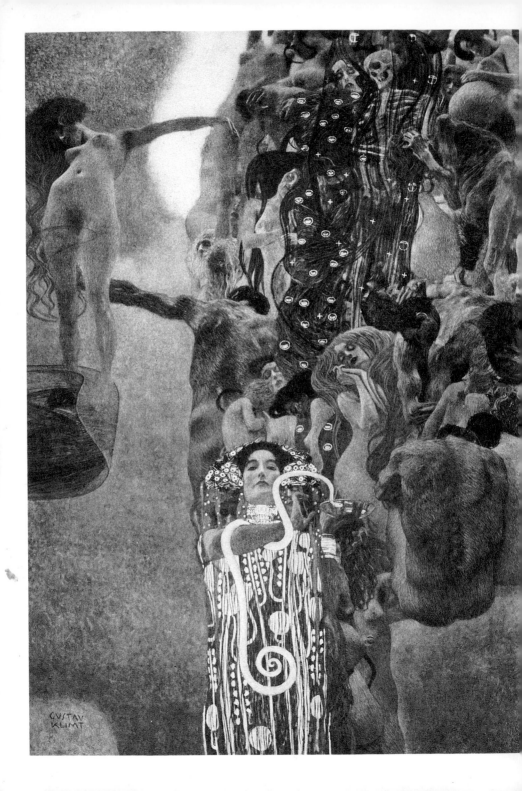

Scandal

The decorations for the Kunsthistorisches Hofmuseum were so well received that the Artistic Advisory Committee of the Ministry of Education immediately asked Matsch to submit designs for another important project: the decoration of the Great Hall of the University of Vienna, yet another new building on the Ringstrasse and in a sense the one most symbolic of the rise of the middle class. In 1848, when most of the academics and their students sided with the revolutionaries, the University, which had been founded by Maria Theresa, was driven out of its original building by the military. It had been forced to make do with temporary, scattered accommodation ever since. Its relocation was a clear sign of the triumph of the liberal ideas it espoused.

Klimt's estrangement from Matsch must have been common knowledge, since the Ministry initially approached only the latter to submit ideas. They were ready early in 1893, but the sketches were rejected and Klimt was asked – whether by Matsch or the Ministry is not known – to participate. The alternative proposal, to which Klimt contributed, was met with some enthusiasm. The commission was the largest that Klimt and Matsch had undertaken. The ceiling paintings were to be entirely their own work: they were not expected to carry out some detailed programme which had been devised by others, nor to integrate their work into a scheme already partly completed by other hands. It was also the last project on which they were to collaborate. Klimt's career was now set fair, but like some augury of future difficulties, one event darkened an otherwise clear horizon. In December 1893 Klimt was elected to the Chair of History Painting at the Akademie, but the Ministry of Education refused to ratify the election and Kasimir Pochwalsky was appointed instead.

For a variety of reasons, some of them obviously personal, Matsch and Klimt no longer found it possible to work together as quickly as they once had. The first sketches and studies were not begun until the summer of 1894 and a comprehensive scheme was not submitted to the Committee until 1896. The Ministry of Education was not able to consider detailed studies for the paintings until May 1898 and it then took Klimt two more years to bring even the first of the paintings to a state close to completion.

28 *Medicine*, 1900–07, executed for the Great Hall ceiling, Vienna University

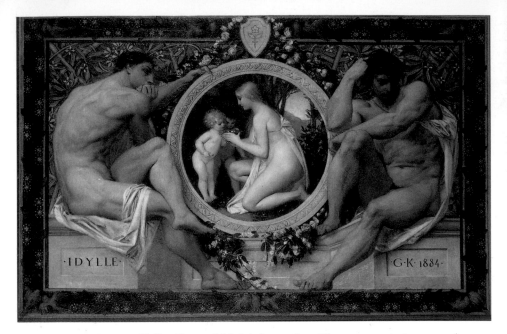

·IDYLLE· ·G·K·1884·

29, 30 *Idyll*, 1884, and (right) *Love*, 1895. These two paintings reveal
Klimt's tentative move away from traditional allegory towards a symbolic
language with contemporary relevance.

There were no other, more urgent commissions during this period
which might have been responsible for these delays. In the six years
between the commissioning of the University paintings and the
completion of the first, Klimt produced thirty-nine, mostly minor,
works – on average less than seven paintings a year. What impeded his
progress were disputes with Matsch and, more importantly, develop-
ments in the artistic politics of Vienna which reflected his own changing
view of art. As we shall see in the next chapter, Klimt was at this time
instrumental in founding a new organization of artists who, like him,
had become depressed by the state of the visual arts in Austria and were
determined to improve the situation, and Klimt's involvement proved
major and time-consuming.

The plan for the University ceiling was conventional enough: four
38 rectangular panels, arranged around a larger central panel representing
the Triumph of Light over Darkness, would symbolize the four
traditional faculties of the University – Theology, Philosophy,
Jurisprudence and Medicine. In the spandrels such scholarly pursuits as

50

history, philology, anatomy and the natural sciences were to be depicted. Matsch was to be responsible for the central painting and for *Theology* while Klimt was to carry out the remaining three faculty paintings together with ten of the spandrel decorations.

It was an entirely historicist programme, similar in conception to thousands of others executed for public buildings throughout Europe and similarly unadventurous in its choice of themes. The intellectual life and social role of the University were to be celebrated by illustrating the pursuit of truth, bringing order out of chaos and light into darkness for the benefit of mankind. It was a traditional conception which was to be executed by two artists, one of whom had meanwhile become impatient with the existing conventions.

It is worth while to pause here briefly in order to consider several paintings that clearly announce this change in Klimt's attitude. The first is a work that Klimt produced for the villa of the industrialist Nikolaus Dumba on the Ringstrasse. Dumba commissioned Makart, Matsch and Klimt independently to decorate three rooms in the house: Klimt was responsible for the music room. There he painted a mural and two pictures for the spaces above the doors, *Music II* (1898) and *Schubert at the Piano* (1899). The latter reveals an artist slowly distancing himself from historicism. Instead of packing the composition with assiduously researched, historically accurate details, Klimt gave the women modern dress and placed particular emphasis on the subtle effects of candlelight. Schubert's face is a good likeness, yet the main point of the composition is neither the portrait nor the reconstruction of an actual event, but the creation of mood.

Nuda Veritas (1899) reveals Klimt's new stance with even greater clarity. It shows a naked woman holding up the mirror of truth while the snake of falsehood lies dead at her feet. It includes in elaborately stylized lettering a quotation from the German dramatist Schiller: 'If you cannot please everyone with your deeds and your art, please a few. To please many is bad.' Truth, it suggests, is the province of the artist and cannot be recognized by the ordinary man. Indeed, the more popular a work of art, the less likely it is to have quality. Klimt, who had previously worked hard to please his public, now acknowledged no standards but his own, and was soon to take the consequences.

By 1900 even the first of Klimt's University paintings – *Philosophy* – had not assumed its final form. But Klimt decided to show it in public nevertheless and its exhibition gave members of the University their first opportunity to see something of the way their ceiling would look. They and the general public clearly expected from the artist responsible for the scene from *Romeo and Juliet* at the Burgtheater an anecdotal

31 *Schubert at the Piano*, 1899

treatment of the subject of philosophy, something in the manner of Raphael's *School of Athens*. But instead of an instantly comprehensible narrative celebrating the great philosophers of the past, they were confronted by something that disappointed, perplexed and offended most of them.

Philosophy consists of a towering column of naked figures who writhe and embrace against a background of limitless space from which emerges, like some gaseous nebula, a sleeping or meditating head, whose vaguely defined, luxuriant hair tumbles down to form a twinkling galaxy of stars. At the bottom of the painting is a female head, its hypnotic gaze directly confronting the spectator; the hair obscures the lower half of the face like a cloak. In the exhibition catalogue she is described as 'Knowledge'. What did the painting mean? What possible relevance did it have to the practice of philosophy?

Although Klimt had not employed conventional, widely intelligible symbols, his intentions did seem clear to a small number of those who saw the painting, among them the critic Ludwig Hevesi. For him *Philosophy* depicted forms as they are continuously emerging from chaos and thus symbolized the fermenting universe yielding up its secrets to the enquiring, philosophical mind.

One thinks of cosmic dust and whirling atoms, of elemental forces which first seek things out in order to become tangible through them. Swarms of

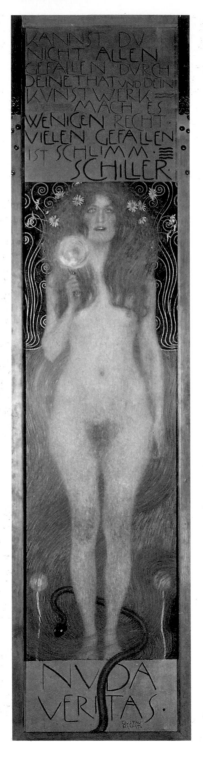

33 *Goldfish*,
1901–02, almost
certainly intended
as a cheeky reply
to the critics of
Klimt's University
paintings.

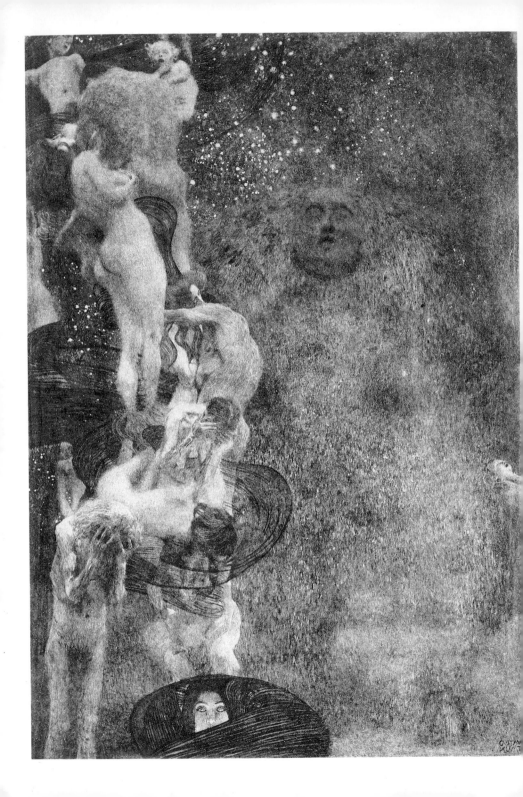

34 *Philosophy*, 1899–1907 (left); and (35, 36, above) preparatory sketches for *Philosophy*, 1899, and *Jurisprudence*, 1897–98, the latter, unlike the finished composition, approved by the authorities

sparks fly about, each spark a red, blue, green, orange-yellow or flashing gold star . . . The artist conjures up for us a colour harmony in whose peculiar nuances the eye loses itself, dreaming. At one point of this rolling wave of colour a green fog accumulates . . . A stony, motionless visage emerges, as dark as that of a basalt Egyptian sphinx . . . It is the riddle, the image of the cosmic riddle, an allusion to it. And flowing from top to bottom past this silent, veiled visage is a bright stream of life . . . Shining children, bodies in the full bloom of youth which embrace, experience desire and misery, work, conflict, struggle, the suffering of human life and finally its passing. The lonely old man who, with his head in his hands, sinks down to the depths like an impotent shell . . . Klimt . . . had to paint an allegory of the most mysterious branch of knowledge and found this truly painterly solution to his problem.

Hevesi added that the painting would not be properly understood at first. He was right. Within days of the exhibition opening, eighty-seven members of the University, the Rector among them, had publicly protested about Klimt's picture and petitioned the Ministry of Education to cancel the commission. They accused Klimt of presenting 'unclear ideas through unclear forms': instead of making an unambiguous statement about the virtues of philosophy he had produced a

puzzle which seemed to suggest that the mysteries of life were ultimately impenetrable and that human existence consisted of nothing more than the infinitely repeated cycle of birth, copulation and death.

Wilhelm Neumann, the University Rector and a theologian, complained to a reporter from the *Neue Freie Presse* that the practice of philosophy, 'which today takes its lead from the exact sciences, does not deserve, especially now, to be represented, in nebulous, fantastic imagery, as an enigmatic sphinx'.

Other critics suggested that the subject was simply far beyond Klimt's intellectual range. How could someone who had left school at fourteen after a rudimentary education hope to grasp something as complex as philosophy? Karl Kraus, Vienna's most trenchant journalist who was to be a life-long critic of Klimt's art, thought that in this case the ignorant painter should have sought the advice of experts: 'An unphilosophical artist may well paint philosophy, but he must allegorize it in the way that the philosophical minds of his time see it to be.'

Kraus himself was rarely prepared to bow to the superior knowledge of anyone. Klimt's education had indeed been only basic, and the Viennese phrase *malerblöd* – stupid as a painter – nicely describes the widespread perception of most artists' intellectual attainments. But the criticism Kraus levelled at Klimt may have been unwarranted; the kind of imagery Klimt was now using suggests that by this time he was well read, not only in the classics, but also in philosophy, and that he was especially impressed by Schopenhauer and Nietzsche. It may even be that Klimt's attitude to art was changed by Nietzsche's cultural theory.

Klimt had other supporters apart from Hevesi, however. His most distinguished advocate was the University's professor of art history, Franz Wickhoff, who, in a lecture entitled 'What is Ugly?', declared that an uncritical reverence for the past results in blindness to the beauty peculiar to the present. And the influential writer Hermann Bahr, a leader of the modern movement in Vienna (who owned *Nuda Veritas*), organized a protest against the protesters.

The controversy caused by *Philosophy* attracted much public attention, lasted for several months and quickly embraced issues far wider than those immediately raised by the painting. The freedom of the artist to follow the promptings of his own imagination – even when carrying out commissions financed by the tax-payer – was now debated, as was the relationship of the artist to his public – issues which, although quite new to Vienna, had been regularly argued in Paris for more than half a century. The debate provided the first clear evidence that an avant-garde had finally appeared on the Danube.

It is easy nowadays, with the benefit of hindsight, to sympathize with Klimt and to perceive in a way that his contemporaries could not have done that he was attempting to jettison an ossified and empty allegorical language in the interests of a fresh and vital pictorial statement of difficult ideas. We also know that Klimt, like such French Symbolist painters as Moreau and Redon, strove for ambiguity, believing that the deepest mysteries of life could only be addressed by means of suggestion and allusion.

Klimt's detractors, reactionary though they were, did make some valid criticisms. *Philosophy* does resist interpretation and it did not satisfactorily meet its purpose. It may have looked impressive hung vertically on the walls of an art gallery, where its details could be closely observed, but they would have been indistinguishable when the painting was moved to the place intended for it, high up on the ceiling of the Great Hall of the University.

Klimt's painting annoyed virtually every ideological faction in Vienna: the academics found the symbolism too vague, and the Catholics took exception to the nudity. The painting also revealed a rift between rationalists and aesthetes: to the rationalists, *Philosophy* seemed to be attacking the positivist interpretation of the world in which reality consisted exclusively of demonstrable facts.

One of Klimt's contemporaries was the physicist and philosopher Ernst Mach. He proposed the existence of an egocentric world, made up exclusively of information provided by sensory impressions. 'The world consists only of our sensations', Mach wrote, 'in which case, we have knowledge *only* of our sensations.' An artist like Klimt was therefore expressing more 'reality' than the positivistic scientist ever could. For Klimt, for whom the validity of the sciences was seemingly in doubt, this was a seductive doctrine and it was in conflict with the view shared by most academics who, like the Rector of the University himself, tried to take their lead, even in the Humanities, from the exact sciences. Doubts about the nature of reality as defined by science, even about the ability of language to communicate anything precisely, troubled the minds of several of Klimt's contemporaries, most notably the fin-de-siècle poets. The writer Hermann Broch later memorably described the atmosphere of late Habsburg Vienna where, he said, all meaningful communication was impossible. Austria-Hungary was a Tower of Babel whose political and cultural fragmentation had been extended by its intellectuals into all spheres of rationality. As rational communication and the sense of society it implies were considered more and more elusive if not totally false, languages of art – in other words, style – as well as language itself were condemned as both meaningless and false.

Despite the conflict in philosophical thought that the painting only served to highlight, and the general disapproval with which it was met, demands that the University commission should be cancelled came to nothing. Dr Ritter von Hartel, the Minister of Education, courageously supported Klimt – a rare example of a politician championing an unconventional artist – and although Klimt seems to have been affected by the controversy he was not deeply wounded by it and continued to work on the two remaining paintings. He finished and exhibited the second of them, *Medicine*, a year after he had shown *Philosophy*. Since this picture was intended to occupy the corner of the ceiling opposite *Philosophy*, it had a roughly similar composition but in reverse. It, too, includes a column of writhing, naked figures beside which, floating in space and shown from below, is a young naked female with full breasts and a prominent pudendum. At the bottom of the picture, confronting the spectator with her gaze, is the figure of Hygeia, around whose arm a snake winds while she holds in her hand the cup of Lethe.

Philosophers had found fault with *Philosophy*; now it was the turn of the physicians. They could scarcely have objected to the classical symbolism of the foreground figure. In Greek mythology, Hygeia, the daughter of Aesculapius, the first doctor, is the goddess of health and is traditionally represented holding a snake and drinking from a cup. What was deemed offensive was the apparent meaning of the column of figures amongst which lurks the skeletal representation of Death. Klimt seemed to be emphasizing the healing arts' powerlessness to prevent death. And he had omitted all reference to the prevention and cure of disease.

Accusations of pornography were also levelled at the painting. The nude woman on the left thrusting her hips forward so provocatively stimulated thoughts considered unworthy given the context and the intended function of the painting. The public prosecutor was called in, and although he thought it unnecessary to remove *Medicine* from exhibition, the controversy raged on and was even debated in parliament, the first time that any cultural issue had ever been raised there. The Minister of Education once again bravely declined to cancel the commission but was obviously embarrassed by the matter and feared that it could quickly assume politically dangerous dimensions.

Given the extent of the controversy, it is surprising that Klimt was once again elected to a professorship at the Akademie in 1901. Once again, however, the government refused to ratify the appointment. For the second time Klimt was denied his professorship. He was never offered, nor ever sought, a teaching post anywhere again. The Minister

28

continued to defend Klimt's University pictures – it was too late to do anything else – but at this stage he felt unable to defend the man himself.

Someone who was prepared to defend Klimt repeatedly was Hermann Bahr. The terms in which Bahr saw the controversy are revealing: it was part of a wider struggle in which the modern artist grappled with ignorant philistines. The fight was more than artistic, it was moral, and in a speech about Klimt which Bahr published as a pamphlet in 1901, he made it clear that the great, inspired artist was inevitably misunderstood by the majority and that great art was inevitably an elitist enterprise. The source and true purpose of art, Bahr claimed, have always been 'the expression of the aesthetic sense of a minority of noble and pure, higher and more sensitive people in a brilliant form from which the masses, following slowly after, gradually and with difficulty learn what the good and the beautiful are'.

Klimt's response to the way his University decorations were being received was saucy. In 1902 he exhibited a painting, almost two metres high, called *Goldfish*. It is dominated by a naked female figure depicted 33 from below so as to exaggerate the size of her bottom. Her expression is less one of blatant sexual invitation than of mischievous delight or even insolence. It is said that Klimt wanted to call the painting 'To my Critics', which is easy to believe.

Jurisprudence, the third and last of Klimt's paintings for the 37 University, was exhibited in an almost complete state together with the other two in 1903. In the highly individual nature of its symbolic language it was similar to the earlier paintings, but in style it was quite different – flatter, more abstract, much sharper in detail, bolder and simpler in its distribution of colours which were limited almost entirely to black, red and gold. It was almost as though it was the work of a different artist and, as a photographic construction of the ceiling as it 38 would have looked shows, it contrasted uncomfortably not only with the other two panels by Klimt but also and especially with Matsch's central painting.

Jurisprudence was now attacked as vociferously as the two earlier paintings had been. Its message seemed to have less to do with justice than with retribution, for Klimt's picture would seem to be an allegory not of the law but of the fate of its transgressors. In the far distance three female figures representing Truth, Justice and the Law look down on a scene in which three more female figures, gaunt and naked, torment an old man, also naked, who is passively accepting the suffocating, suckered embrace of some slimy, octopus-like creature from the depths of hell. The description of the monstrous cephalopod is laughably inappropriate, more Disney than Dante.

Another serious objection to *Jurisprudence* was that it departed radically from the oil sketch that Klimt had submitted to the authorities and that, apart from some minor objections, they had approved. Instead of retaining the conventional female figure of Justice, who in the sketch wields her sword above the head and tentacles of a vaguely and darkly described polyp, in the final painting Klimt had relegated her to the distant background and filled the foreground with a scene of merciless torment.

In the light of these reasonable criticisms it is surprising that the Minister of Education continued to resist the demands to cancel the commission. Equally surprising is the fact that when, in November 1903, the Artistic Advisory Committee of the Ministry met to consider the University paintings it decided to accept them. Realizing, however, that Klimt's work was entirely different in conception and style to Matsch's, and fearful of the likely reaction of the University should it be put to its original purpose, the Committee suggested that the paintings should not be fixed to the ceiling but permanently shown in the new State Gallery of Modern Art.

It was an intelligent compromise. But even though the Ministry was prepared to exhibit the pictures in Vienna, it was still afraid of the impression Klimt's work might give to a foreign audience. Early in 1904 it was proposed that Austria should be represented at an international exhibition in St Louis, Missouri, by a selection of work that would include the three University pictures. The Ministry refused to lend the paintings.

For Klimt this was the final straw. In 1904 he resigned the commission for the ten spandrel paintings (which he had not even begun) and in the April of the following year he told the Ministry of Education that he was not prepared to relinquish ownership of the three ceiling pictures and would return all the advance payments. The Ministry replied that the paintings already belonged to the State and Klimt was not entitled to keep them. More angry than ever and more vehement in his assertions that no one had the right to limit his artistic freedom, he then declared that the pictures were in any case unfinished. After further correspondence and a dramatic episode during which Klimt is said to have kept the Ministry's removal men at bay with a shotgun, the Ministry finally relinquished its rights to the paintings and Klimt repaid his advance. Soon after, the Minister of Education resigned.

Klimt never received a public commission again. Matsch, however, whose style and attitudes had changed little, continued to work for the State and for the Court. His most important patrons were the Empress

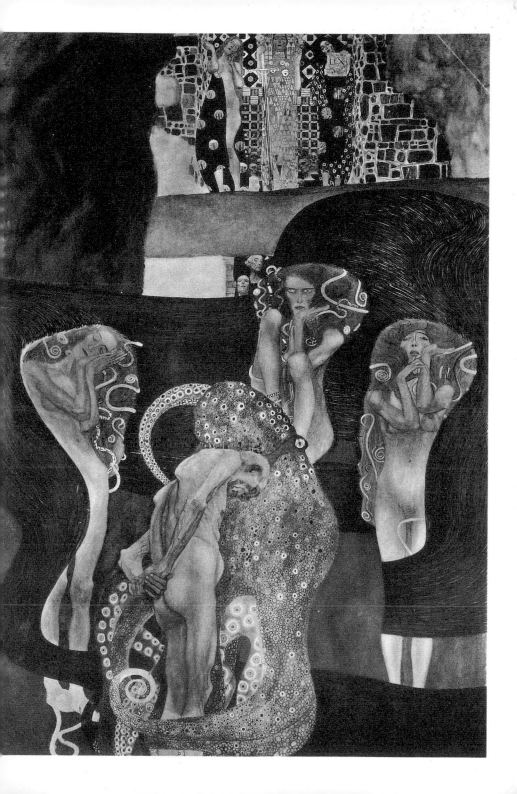

Elisabeth herself, who commissioned him to decorate her villa on the island of Corfu, and the celebrated actress Charlotte Wolter, who gave Matsch a studio in her house. In 1912 Matsch was raised to the aristocracy. He, like Klimt, became a successful portrait painter, but whereas Klimt painted the wives of the wealthy bourgeoisie, Matsch's sitters were genuine aristocrats.

Although the University paintings mark an important change in Klimt's art, it would be misleading to describe it as a watershed. His style changed, as did his attitude to his patrons and to his own status as an artist; but his view of the fundamental purpose of art did not. He may no longer have been willing to follow academic conventions, but he continued to believe, like every academic painter, that the highest goal of art was the expression of weighty ideas in monumental form. He was as eclectic as ever, but the models on which he now drew were exotic, outlandish and unconventional, and he continued to load what were unexceptional thoughts and ideas with heavy aesthetic baggage. He was a supreme talent devoted to the superaesthetic and the superaethereal with, in Hermann Broch's words, 'the goal of attaining the highest possible decorative effect through paintings crammed with symbolic platitudes'.

When Klimt regained ownership of his paintings the project was cancelled even though Matsch had completed the central panel, *Theology*, and the pictures for the spandrels, and was prepared to carry out the rest of the scheme himself. Klimt and Matsch never worked together again, but in spite of their differences, Matsch was never less than generous to his former friend and colleague. In an unpublished memoir, which was discovered after his death in 1942, Matsch described his 'comrade Gustav Klimt' as 'one of the most important leaders of the new movement, not only in painting but also the arts and crafts. Not since Makart had any artist achieved such a personal style'.

Klimt returned the advance payment of 30,000 Kronen to the Ministry of Education with the help of August Lederer, one of his most important patrons, who received in exchange *Philosophy* (to which he devoted an entire, specially designed room in his apartment). In 1911 the two remaining University paintings were bought by Klimt's friend and fellow artist Koloman Moser.

After Moser's death in 1918 *Medicine* was purchased by the Österreichische Galerie, while *Jurisprudence* passed into the hands of the Lederer family. It stayed rolled up in their flat until 1938 when the entire Lederer collection (which included many of Klimt's most important paintings) was 'aryanized' – compulsorily purchased by the Nazi State. In 1944 they went to the Österreichische Galerie. They were

38, 39 A reconstruction (by Alice Strobl) of the decorative scheme for the ceiling of the Great Hall, Vienna University. Matsch's *Theology* (39) is seen top left while his *Triumph of Light over Darkness* is in the centre. The remaining three paintings are by Klimt.

shown in public for the last time in 1943 in an exhibition marking the eightieth anniversary of Klimt's birth, organized by the governor of Vienna. Having been moved for safekeeping to a castle in Lower Austria, they were destroyed in May 1945 by retreating SS forces, who burned the castle down rather than allow it to fall into enemy hands. Thirteen other works by Klimt confiscated from the Lederer collection suffered the same fate. All that remains of Klimt's paintings are poor photographs of them. Matsch's bland *Theology* meanwhile languishes in an office in the Theology Department of Vienna University.

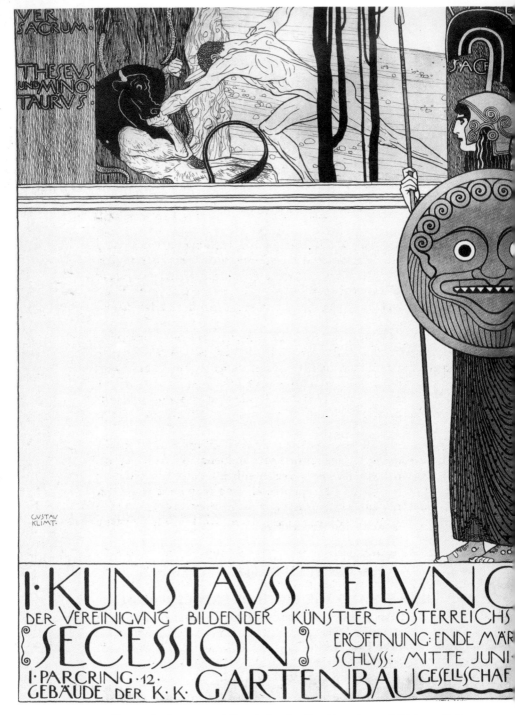

40 Poster (in its censored form) for the first Secession exhibition, 1898

Secession

The controversy over Klimt's University paintings reflected on a smaller scale the conflict taking place in every area of Viennese life. It was a conflict in which the modern was set against the traditional, the progressive against the reactionary. In architecture, painting and design, that conflict undermined the existing system of patronage and weakened the authority and influence of established artists' organizations.

From 1891 until 1897 Klimt had been a member of the leading association of Viennese artists, the Künstlerhausgenossenschaft, which, although founded as recently as 1861, enjoyed the status, power and influence which elsewhere in Europe were the prerogative of the long-established national academies. It was a young organization but no less conservative for that.

The Künstlerhaus organized exhibitions and sold the work of its members, protected and furthered their interests and acted as an intermediary between them and the public. Since it was the only such association in Vienna to have its own exhibition building and since there were few private galleries and dealers in contemporary art in the city, membership of the Künstlerhaus was essential to every artist determined to make a name and a living.

Klimt's changing attitudes towards art led him to believe that the Künstlerhaus had exerted an unfortunate influence on Austrian art, including his own. He and several other members now considered most Austrian art to be narrow and parochial. The main reason for the malaise was the Künstlerhaus itself which, they argued, had a responsibility to expose Viennese artists to the work of their foreign colleagues.

In fact the Künstlerhaus had already done something to change the situation. Writing in a special Austrian edition of the leading British art journal *The Studio* in 1906, Ludwig Hevesi began with a criticism:

For many years the exhibitions had prohibited the admission of all foreign contributions [to the Künstlerhaus], in order to preserve the market for the home artist. Thus the great public was kept in complete ignorance of the various transformations which Western art was undergoing . . .

but he then conceded that there were a few international exhibitions that gave some sign of recent developments in what he called 'the West'. Nevertheless:

This sign came not from France – which still sent nothing but officially approved works, naught of Manet and his school – but from England. For, in addition to Leighton, Herkomer and Alma-Tadema . . . one saw here for the first time the 'Boys of Glasgow' . . . whose open-air work caused a complete upset of existing ideas. The storm thus raised came to a climax in December of the same year [1894], when the entire 'Secession' of Munich appeared as guests in the Künstlerhaus.

It was not often that works by Frederick, Lord Leighton, P.R.A. and Sir Lawrence Alma-Tadema, R.A., 'raised a storm' anywhere; and the fact that the Glasgow plein-air painters ruffled feathers in Vienna so late in the day testifies to the narrowness of taste and knowledge of contemporary art in the city. And while it is true that the French Impressionists and Post-Impressionists remained little known even in Paris around the turn of the century, in some foreign parts they were already being recognized as major masters and some German museums, especially in Berlin, were already collecting their paintings.

The exhibition in 1894 of works by English and Scottish painters in Vienna also revealed an unusual pattern of geographical connections which continued to affect Austrian art for a decade or more. The strongest artistic links were not, as might be expected, between Vienna and Berlin or Paris, but between Vienna, Glasgow and London. Close connections also existed between the Austrian capital and Brussels and, less surprisingly, Munich.

But the small number of foreign artists invited to exhibit at the Künstlerhaus did not satisfy Klimt and his friends. During the autumn and winter of 1896, not long after the final scheme for the University paintings was submitted to the Ministry of Education, Klimt held conspiratorial meetings with the painters Carl Moll and Josef Engelhart at which they discussed ways of reforming the Künstlerhaus. They knew they could count on support outside as well as inside the association: Hermann Bahr had already written several scathing articles about the Künstlerhaus, its policies, exhibitions and, above all, what he saw to be its deadening effect on Viennese cultural life. According to Bahr, the autumn exhibition of 1896 had been even more parochial than any of its predecessors and demonstrated that the association was beyond reform. It was nothing more than

a market hall, a bazaar – let the traders set out their wares there. We shall have to look for a new means of serving the ancient art of painting in Austria. The

only solution is for a group of art lovers finally to get together, hire a few well-lit rooms somewhere in the city and let the Viennese see in small, intimate exhibitions what is happening to art in Europe.

Klimt and his friends were not yet quite ready to take the decisive step of organizing their own show. They still believed that the Künstlerhaus was capable of reform and in March 1897 established what would now be described as a 'ginger group' to urge change. Taking their lead from a similar organization in Munich, which had already gone much further and had broken away from its parent body (and had also exhibited at the Künstlerhaus), they called themselves the Vereinigung bildender Künstler Österreichs (the Austrian Association of Visual Artists), or more familiarly, the Secession.

It must have been clear from the beginning that such a group could not long remain part of the Künstlerhaus and at the end of May 1897 its committee passed a motion of censure on the Secession. Klimt and eight others walked out of the meeting without saying a word. The Secession, which quickly attracted some forty members, had become autonomous. Klimt became its first president and Rudolf von Alt, the 20 well-known watercolourist who was eighty-five years old at the time, acted as its figurehead. His honorary presidency was intended to advertise the fact that the Secession was neither the creation of young hotheads nor likely to prove a flash in the pan.

The Secession had three main aims: to provide young, unconventional artists with regular opportunities to exhibit their work; to bring to Vienna works by the best foreign artists (and to purchase some of them for public collections); and to publish its own magazine.

However, this is not to suggest that the Secession began life with a clear programme: it had nothing precise to say about the kind of art it wanted to encourage and support. There was never a Secession manifesto and its members never aspired to a group style. All they shared was a dissatisfaction with the Künstlerhaus and with the more entrenched forms of academic art. Naturalists and Realists co-existed, at first quite happily, with Symbolists, easel painters with architects and designers.

The Austrians had been so ignorant of developments abroad for so long that the Secession thought it necessary to include the work of more foreigners than Austrians in its first exhibition. Josef Engelhart travelled throughout Europe visiting studios, among them that of Whistler in Paris, in his search for exhibitors. In spite of Engelhart's efforts, however, the foreign artists invited to show in 1898 seem, at least with the benefit of hindsight, to have made a curious mixture of the first and second rate, of the academic and the avant-garde: France was

represented not only by Rodin but also by Puvis de Chavannes, while Whistler, Sargent, Walter Crane and Frank Brangwyn were the best known of the British contingent. Whistler, who was represented only by lithographs, and the Belgian Symbolist Fernand Khnopff (who showed no fewer than nineteen paintings), were to prove especially important for Klimt.

Such an exhibition was nevertheless unusual enough in Vienna and even more unusual was the way in which it was hung. Although the rooms (in the headquarters of the Vienna Horticultural Association, rented for the occasion) contained the potted palms and aspidistras seemingly vital to the appearance of every art exhibition at the time, all the paintings were displayed at eye level and not arranged in tiers from floor to ceiling as was usual. The work of each artist was grouped together, not capriciously distributed throughout the show, and everything was presented in an even, consistent light that was filtered through white sheets stretched beneath the ceilings.

The contents and organization of the exhibition challenged conventional Viennese taste but surprisingly did not seem to alienate the public. Most of the 57,000 visitors, among them the Emperor himself who, despite his conservative views was persuaded to attend, appear to have been favourably impressed and no fewer than 218 of the 534 exhibits were sold. Modern art – or what passed for it in such a conservative city – was introduced to the Viennese public without the controversies and scandals that had accompanied its advent in France. The first exhibition of the Secession demonstrated that in Vienna it was possible to be non-conformist without being revolutionary and that there was a public for what was new. Given the reception of the University paintings this was extraordinary and shows how fragmented and inconsistent the Viennese had become. Scarcely less extraordinary is the speed and extent of the Secession's success, not least with the authorities. By 1900 it and not the Künstlerhaus was being asked regularly to represent Austria officially at international exhibitions.

The support of the government for the Secession may seem startling. Elsewhere in Europe the authorities were generally hostile to anything that smelled of Modernism and in Germany the Emperor was an implacable opponent of what he called 'gutter art'. In Austria, however, there was political support for progressive ideas – at least in the cultural field. As early as 1903, for example, a publicly funded gallery of modern art was founded and the fact that not long afterwards it became dedicated exclusively to Austrian art provides a clue to the motives behind the government's cultural policy.

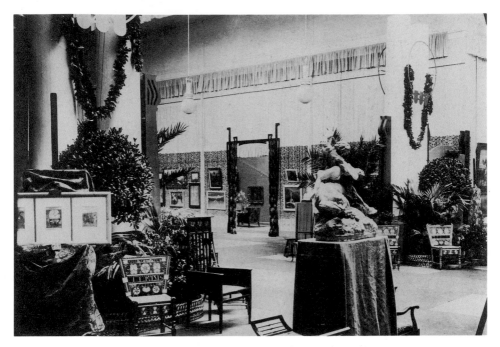

41 Central exhibition room at the first Secession exhibition, 1898

Austria was a fragmented state, the only remaining great power that was multinational, and it was repeatedly threatened by demands by minorities for national self-determination. It desperately searched for ways of uniting its racially, linguistically and culturally disparate peoples. The creation of a peculiarly Austrian culture in which a unity in variety might be achieved was a tantalizing aim and it seemed for a time as though the Secession might contribute to it.

Both the national and city governments were keen to support the Secession, no doubt because this demonstration of solidarity with the new created an impression of liberalism, and perhaps because they also believed that art, like bread and circuses, kept the populace happily distracted from the more serious matters of state. From the commission on the sales at its first exhibition the Secession purchased two paintings to present to the nation and set aside funds for a building of its own. To these was added money from one of the several wealthy patrons whose interest had been aroused by the first exhibition. The Secession was given a long lease on a plot of public land on the Linke Wienzeile, next door to the Akademie, on which to erect its own exhibition building.

43 Work began immediately and the building, designed by Joseph-
Maria Olbrich, a Secession member, was completed astonishingly
42 quickly. It opened in November 1898 with the association's second
exhibition. With this and the many other shows staged there during the
next few years the Secession replaced the Künstlerhaus as the leading
institution of its kind in Vienna.

Klimt was at the forefront of every area of Secession activities. He
was its president; his ideas helped shape Olbrich's design for the
building; he was one of the three members responsible for selecting the
contents of every exhibition until 1905; he was one of the main
contributors of graphics to *Ver Sacrum*, the Secession journal, and,
briefly, he was a member of its editorial board.

44 The building itself was a declaration of the Secession's attitude to the
art of both the present and the past. Free from the proliferating details
and decorations that characterized the recently completed buildings on
the Ringstrasse and far simpler than any of them in plan and elevation,

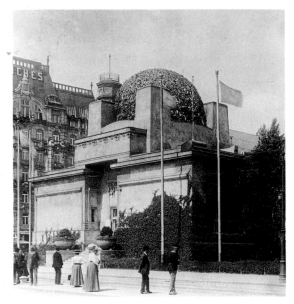

42, 43 Joseph-Maria Olbrich, poster
for the second Secession exhibition,
1898–99, and (above) the Secession
building, Vienna, which he designed.

44 Secession building, Vienna

it consists essentially of a cube surmounted by an open-work, wrought-iron sphere of intertwined, gilded laurel leaves. Its shape and its restrained classical ornament invite comparisons with an ancient Greek temple while the German motto in gilded letters over the main entrance paradoxically suggests that the tyranny of historical styles has been overthrown: *Der Zeit ihre Kunst, der Kunst ihre Freiheit* ('To every age its art, to art its freedom').

The interior was as simple as the facade and consisted of a single, naturally lit space which could be divided at will with the aid of movable walls and partitions. The very simplicity of the building was unusual and inevitably attracted the attention of Viennese wits who called it 'The Mahdi's Tomb', 'The Assyrian public convenience' and, alluding to its most prominent, crowning feature, 'The Head of Cabbage' – *Krauthappel*.

In 1899 Olbrich described something of the effect he had been aiming for. He wanted the building to be 'white and shining, holy and chaste. Everything had to be clothed in earnest dignity. Pure dignity of the sort which came over me and made me tremble as I stood in solitude before the uncompleted temple at Segesta . . .'

The reference here to a famous classical building confirms that, in spite of the ringing battlecry over the main door, the Secession's headquarters embody ideas not far removed from those which informed the buildings on the Ringstrasse: it, too, was essentially historicist; it, too, drew on existing prototypes in order to communicate the particular message which its architect had in mind all along; it, too, used style and ornament symbolically. What made it different was the nature of the historical models it chose and the restrained manner in which it employed them.

Many Secession artists drew extensively on both Greek and other classical art. The very name Secession derived from a Latin tag used to describe an unusual form of political dissent – *secessio plebis in montem sacrum* – and the title of the Secession journal was, of course, also Latin: *Ver Sacrum (The Sacred Spring)*.

Klimt frequently employed classical subjects and made classical allusions in his own work in order to evoke associations with a Golden *40* Age. His poster for the first Secession exhibition (which he was obliged to alter after the authorities had objected to the display of male genitalia) shows Theseus slaying the Minotaur; and one of his contributions to the second exhibition was an image of the Greek *54* goddess of wisdom, Pallas Athene. To anyone familiar with classical mythology the meaning of each work was clear: as Theseus had slain the Minotaur to rescue the children of Athens, so the Secession would rescue Viennese art from the monsters of the Künstlerhaus. And Pallas Athene, whom the Secession had chosen as protectress (and whose statue stands in front of the parliament house on the Ringstrasse), carries on her breastplate the golden head of Medusa, rudely sticking out her tongue at anyone disposed to attack the artists under the goddess's protection. In the background, in a style based on that of figured Greek vases, Hercules battles with Triton.

In Klimt's painting, however, Pallas Athene is not so much classically Greek as modern, a woman whose contemporaneity her helmet and armour do not disguise. And the Nike, the little figure of victory in her right hand, looks less like a statue than a real and living figure. She and the goddess are play-acting, and this impression unwittingly reveals a fundamental uncertainty not only in Klimt's intentions but also in those of the Secession: the contemporary was dressed up in theatrical, historical costume because it seemed too dangerous in itself – it did not as yet inspire sufficient confidence to permit its wholehearted acceptance as art.

An important part of the Secession's programme (although it did not have the complete support of all its members) was the emphasis placed

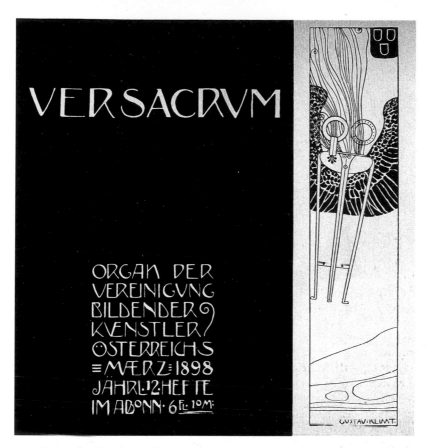

45 Cover for *Ver Sacrum* I, 1898

on architecture and its insistence on the equality of all the other arts under architecture's aegis. Influenced by the British Arts and Crafts Movement and the international style known variously as Art Nouveau and Jugendstil, the Secessionists no longer regarded craft as being subservient to painting and sculpture nor craftsmen as mere artisans: they were artists in their own right. Moreover, easel painting was no longer considered superior to architectural decoration. Several of the leading Secession members were architects and designers and many others were gifted not only as painters but also as illustrators, typographers, stage and book designers and creators of furniture and textiles. Their versatility and their interest in the unifying effects of style found expression in the way all the Secession exhibitions were staged.

46, 47, 48, 49 Illustrations for *Ver Sacrum* I, 1898, and (49, above) *Pallas Athene*, illustration for *Ver Sacrum* III, 1900

The interior design of the exhibition area was itself regarded as a work of art: individual rooms, and often the entire show, were designed by one of the members, who decorated the walls and furnished the spaces in a way that created a unified visual impression and showed off the exhibits to best advantage.

Thus the second exhibition – the first in the new building – was designed by Olbrich, who sought to create an environment sympathetic to the sculpture and painting on show. Even the posters and catalogue were devised to complement the dominant visual features of the whole exhibition.

Each Secession exhibition was a kind of *Gesamtkunstwerk*, a word at best, although not quite accurately, translated as 'total work of art'. Coined by Richard Wagner to describe his novel operatic productions, it expressed an idea that many artists around the turn of the century found attractive, a notion of a synthetic art form, greater than the sum of its parts, and it left its mark on painters, architects, musicians and writers as various as Kandinsky, Gropius, Schoenberg and even Brecht.

The *Gesamtkunstwerk* haunted the European imagination but its appeal was nowhere stronger than in Austria where, in the late nineteenth century, political, national and racial fragmentation made any kind of unity seem like an impossible dream. The *Gesamtkunstwerk* held the promise at least of artistic, aesthetic harmony.

50　*Fish Blood*, illustration for *Ver Sacrum* III, 1900

It is difficult to describe precisely the nature of the unified experience which the *Gesamtkunstwerk* sought to provide. It was similar to the intoxication of the Latin mass, celebrated in opulent Baroque churches to the music of choirs accompanied by full orchestras. With the perfume of incense lingering in the air, all of this was designed to ravish the senses of the congregation and through such sensory inebriety provide an intimation of the divine. In art, or at least the art aspired to by the Secession, it meant the complete avoidance of the bourgeois penchant for overloaded furnishing in a room, in a mass of unrelated

51 *Music*, illustration for
Ver Sacrum IV, 1901

styles. The building and all its parts had to express the same architectural
and decorative sensibility; the room and everything in it had to be
orchestrated into a euphonious whole; the painting had to have a
complementary, preferably specially designed frame; the book, from
its binding to its typography and illustrations, had to provide a unified
visual, as well as literary, experience.

Each exhibition of the Secession was an attempt to achieve a
45 *Gesamtkunstwerk* and *Ver Sacrum* was another. Published at first every
month and then fortnightly, *Ver Sacrum* was an outstanding example of
graphic design. High-quality printing, tipped-in colour plates, expen-
sive paper and small editions made it a collector's item from its first

52, 53 *Nuda Veritas* and (left) *Jealousy*, illustrations for *Ver Sacrum* I, 1898

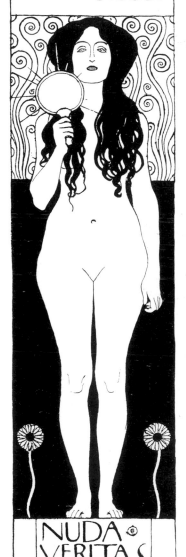

WAHRHEIT
IST FEUER UND
WAHRHEIT
REDEN HEISST
LEVCHTEN UND
BRENNEN

L · SCHEFER ·

NUDA
VERITAS
GVSTAV · KLIMT ·

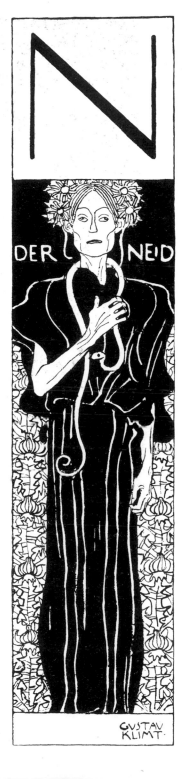

DER NEID

GVSTAV
KLIMT ·

issue. It introduced new ideas of layout and typography and treated the textual matter as another element in the creation of a coherent visual impression. It reproduced Klimt's paintings and drawings, but more importantly it illustrated drawings, vignettes and initials which he made specially for it.

By 1900 the Secession exhibitions had become more adventurous. They had shown the Belgian Pointillist Theo van Rysselberghe and his Symbolist compatriot Khnopff, the Swiss Ferdinand Hodler and even Degas. With the exception of Degas all these artists held particular fascination for Klimt and so, as we shall see, did Japanese art, to which an entire exhibition was devoted early in 1900. But schemes in which architecture, design and decoration were combined continued to be the dominant aim of the Secession exhibitions.

Klimt benefited enormously from the Secession. In 1919, looking back over Klimt's life, Hans Tietze, the eminent art historian, observed that 'when the Secession was founded Klimt's artistic personality seemed fully mature', and then asked, 'What could the new movement which brought a thousand strange impulses into the closed-off Viennese atmosphere, bring [an artist] . . . who, out of the traditions of his own city, had already developed to complete maturity?' In his opinion, the Secession had given Klimt 'everything; it tore him from the direction in which it seemed he would travel for ever, destroyed or awakened his most inner being and created the man and the artist Klimt whom we now know'.

Tietze describes the extent of Klimt's artistic transformation but does nothing to explain the reasons for it. Why and how Klimt the academic history painter became the artist now familiar to us remains a puzzle which the emergence of the Secession does little to clarify. But even if the Secession had given Klimt 'everything' it also owed him a great deal. When in 1905 Klimt and a group of his close associates resigned from the organization it never recovered from the loss. Sadly, the Sacred Spring was of only brief duration.

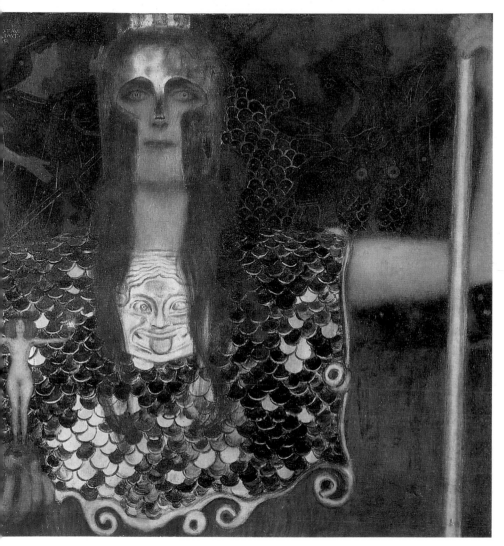

54 *Pallas Athene*, 1898. This picture portrays the Greek goddess whom the Secession adopted as their protectress. She holds the naked figure of victory in her hand while the head of the Medusa on her golden breastplate sticks out her tongue at the artist's opponents.

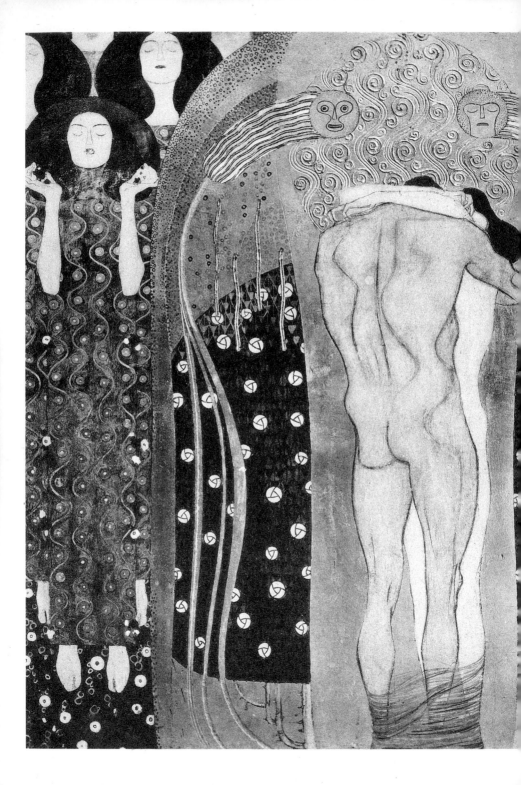

The Artist as God

The most spectacular *Gesamtkunstwerk* produced by the Secession and arguably the most significant of all its exhibitions was staged in 1902. This, its fourteenth show, consisted of a single sculpture presented in an *57* environment specifically designed and elaborately decorated for it. Even the luxurious, bibliophilic catalogue, with its lengthy commentary and illustrations, was intended to be an essential part of a total experience. The sculpture was a monumental, polychrome statue of *58* Beethoven by the German Max Klinger who was well known in Vienna and had regularly shown prints, paintings and sculptures at the Secession since its first exhibition.

The Secession's admiration for Klinger is revealing. Known chiefly for his etchings, which are by turns allegorical, realist and fantastic, Klinger also painted and made sculptures. All the work of this remarkably versatile artist exhibits that same uneasy mixture of classical imagery, personal allegory, langorous eroticism, contemporary subject-matter and kitsch found in French and Belgian Symbolism and later highly prized by the Surrealists. It is a mixture that many Secession artists, Klimt among them, found appealing.

With the exception of his Beethoven monument Klinger's sculpture features classical or biblical subjects – Cassandra, Amphitrite and Salome – and most of it is polychrome: not painted, but assembled from pieces of variously coloured, patterned and textured stone. Beethoven's torso and feet are of pure white marble, his robe of brownish alabaster and the rock on which he is enthroned is of dark red and blue marble. The eagle on the rock is of a darker red marble. The bird's eyes are of amber, the angels' heads on the massive bronze throne of ivory, while their wings are mosaics of natural glass, agate, jasper and mother-of-pearl mounted on a base overlaid with gold leaf.

This riot of ornament, colour and texture and the ostentatious display of semi-precious materials were one of the sculpture's main attractions for the Viennese. The contrast between the polished surfaces, the funereal associations of veined marble and the earnest expression on the composer's face may, nevertheless, strike the modern eye as vulgar. They distract the attention from the monument's other, more important qualities – not least from its originality, for it differs to

55 Beethoven frieze (detail) on right wall: the choir of heavenly angels

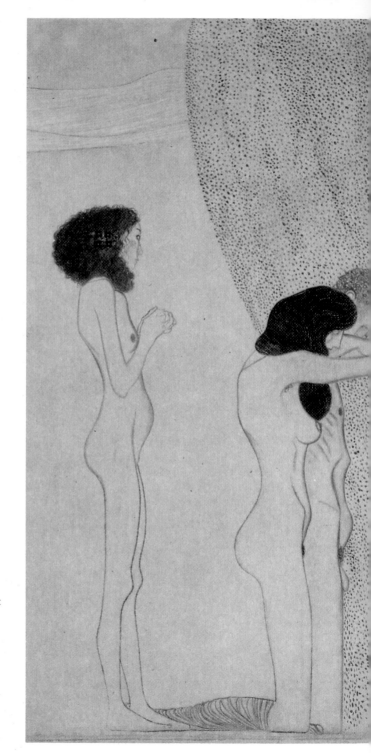

56 Detail of
Beethoven frieze on left
wall: the sufferings of
feeble mankind; the
well-armed strong one;
Compassion and
Ambition, 1902

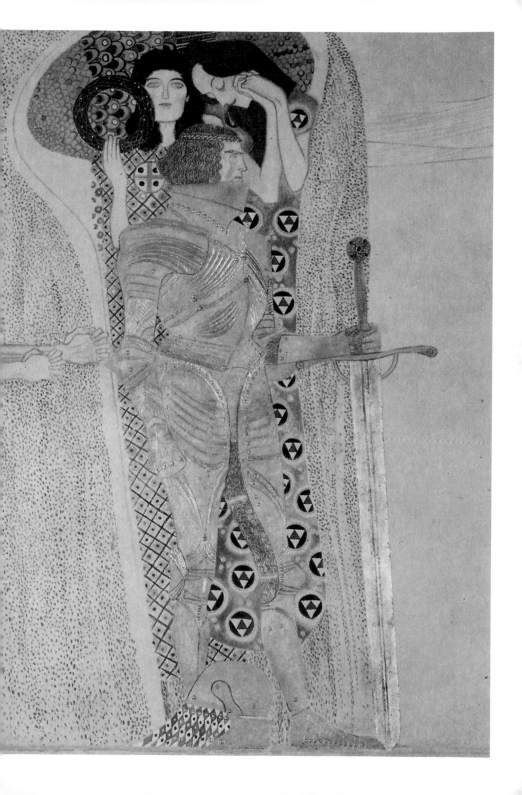

57, 58 Alfred Roller, poster for the fourteenth (Beethoven) Secession
exhibition, 1902, and (right) Max Klinger, *Beethoven*, 1902

such a great degree from most other contemporary monumental
statues.

Although the head is a fairly accurate portrayal of what is known of
Beethoven's features, Klinger did not resort to the obvious and tired
device of illustrating his subject's achievements by equipping him with
a laurel wreath, a lyre, a music stand, score sheets or a quill pen. Indeed,
he shows Beethoven not as a composer at all but as a god, and elucidates
the significance of his divine music with the aid of symbol and allegory
which, part invented, part classical, simultaneously work on a variety
of levels. The allusions in Klinger's Beethoven – to Prometheus, to
Zeus, even to St John the Divine – are as rich and varied as the materials
of which the monument is made. They contribute to an image of a
supremely gifted, inspired and suffering individual, an image of the
artist, of genius in general, which had a peculiar hold over the late
Romantic imagination.

86

The notion of the artist as a god, or perhaps as a kind of secular priest administering the life-giving sacraments of beauty and truth, was widespread around the turn of the century. In Vienna, as elsewhere in Europe, the aesthetic cult had usurped the place of religion; and it was almost as if Beethoven had been ordained to take the place of God. His compositions were thought to be much more than mere music: they had the force of revealed truth; they provided insights into the very nature of existence and assisted an understanding of man's earthly predicament by providing him with a glimpse of Paradise.

To the members of the Secession Klinger's monument was of such importance and significance that they thought it worthy of unusual tribute. Klinger had based the figure of Beethoven on Pausanias' famous description of the statue of Zeus for the Olympeium at Olympia by Phidias. It was therefore decided to create a temple for the artist-god Beethoven who had, of course, composed his most important works in Vienna. A temporary but elaborate shrine was installed in the Secession building, creating an artistically sanctified environment intended to enhance and extend the meaning of Klinger's monument. At a special opening organized to honour the creator of the statue, Gustav Mahler (a supporter of the Secession and the husband of Carl Moll's stepdaughter, Alma) conducted his own wind arrangement of selected motifs from the fourth movement of the Ninth Symphony, and for the following three months the Secession building became a temple consecrated to the cult of Beethoven. The temple did not lack a congregation: 58,000 visitors made this the most popular of all the Secession exhibitions.

59 Main room of the fourteenth Secession exhibition, 1902

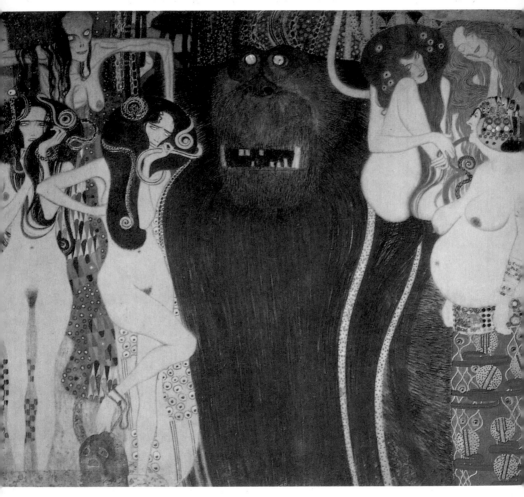

60 Detail of Beethoven frieze on narrow wall: the hostile powers

More than ten Secession members were engaged on this extra-ordinary project. Josef Hoffmann, one of the most versatile and brilliant architects in Vienna, created a church-like interior which consisted of a central 'nave' and two side 'chapels'. He also designed some geometric abstract reliefs which complemented paintings, mosaics and other decorations by, among others, Alfred Roller, the painter, illustrator and stage designer, Adolf Böhm and Ferdinand Andri. These works were of variable quality and, to judge from photographs, largely overshadowed by Klimt's contribution, a frieze (painted on plaster *al secco*) which ran along three sides of the 'chapel' through which visitors entered the exhibition and which provided glimpses of the statue beyond. The catalogue described the arrangement and intended meaning of the work:

First long wall facing the entrance: The longing for happiness. The sufferings of feeble mankind: its appeal to the well-armed strong one as an external, and to compassion and ambition as internal driving forces motivating mankind to fight for happiness. Narrow wall: the hostile powers. The giant Typhoeus, against whom even the gods fought in vain: his daughters, the three gorgons. Disease, madness, death. Debauchery and unchastity, excess, nagging grief. The longings and desires of mankind fly above and beyond them. Second long wall: longing for happiness finds repose in poetry. The arts lead us into the kingdom of the ideal where alone we can find pure joy, pure happiness, pure love. Choir of heavenly angels. '*Freude, schöner Götterfunke. Diesen Kuss der ganzen Welt.*'
(The last two phrases are, of course, quoted from Schiller's *Ode to Joy* which the choir sings in Beethoven's Ninth Symphony.)

Klimt avoided direct references to Beethoven's compositions as Klinger had done and, if the catalogue is to be believed, attempted to suggest both formally and allegorically the emotional meaning not only of Beethoven's music but also of all great art. Unlike Klinger, however, Klimt disregarded all conventional sources for his imagery and invented his own. The result is personal, ambiguous and appears to have nothing whatever to do with Beethoven. Nevertheless, its formal qualities do suggest a musical analogy: the relationship between each part of the frieze and the next roughly follows the arrangement of movements within a symphony. The development of form and colour begins quietly and gives way to dissonance which it then resolves before building up to a harmonious climax. The forms progress from gently undulating horizontals through marked verticals and aggressive, acute angels to the final arrangement of curves, circular and spiralling motifs against which the couple depicted embraces to the suggested accompaniment of a heavenly choir.

89

61 Adolf Böhm, frieze, *Dawning Day*, which faced Klinger's statue

This progression orchestrates the sequence of figures which, according to the catalogue, moves from a depiction of the universal longing for happiness to the hero, who fights to secure it, to the dark forces who oppose him, to the solace of poetry and finally to the salvation of man.

Although Klimt's symbolism is invented and personal, we can discern the broad outlines of an episodic story with a clear allegorical function. At the time the frieze was criticized by some for its lack of any obvious connection with Beethoven or his music while others were inevitably offended by the naked female figures embodying lust and lasciviousness and by the couple in intimate embrace. One critic described the realism with which Klimt portrayed this couple as a kind of 'artistic self abuse', while another suggested that the mural was less suited to a temple for Beethoven than to the building in the Prater pleasure gardens which housed waxworks sensationally depicting every known venereal disease. Yet another critic thought that Klimt's frieze would be more appropriate in 'a temple for Krafft-Ebing', the famous sexual psychopathologist.

Certainly, as always with Klimt's allegories, there was and is much that cannot be satisfactorily interpreted. The artist himself, when asked about the meaning of his frieze, is said to have testily retorted that he

62　Left side 'chapel', with frieze depicting the hostile forces

knew nothing of 'such matters'. We need not take him at his word: the work is a statement of Klimt's belief not only in the redemptive power of art but also of the spiritual strengths and responsibilities of the artist. The knight in his gold armour resolutely confronting the creatures of darkness and ignorance is (in spite of claims that it is an idealized portrait of Gustav Mahler) most probably a highly dramatized version of Klimt's view of himself, not least since it was produced at a time when he believed that he was beset by insensitive and malevolent philistines and required great courage to continue what he saw to be his artistic mission.

The exhibition of *Medicine*, with which the controversy over the University paintings reached a crucial stage, had taken place immediately before preparations for the Beethoven exhibition began. *Philosophy* and *Medicine* had been justifiably criticized for paying scant regard to the setting for which they were intended. This is certainly not true of the Beethoven frieze, the design of which was conceived to fit perfectly into the narrow space of the entrance hall to the exhibition, its decorative, non-naturalistic, almost emblematic treatment respecting the flatness of the walls. In fact, the spectacle provided by the frieze is quite extraordinary. The eye is delighted and fascinated by the interplay of colour, texture and reflection, by the contrast between

28

34

richly detailed areas and daringly blank plaster, by the effects achieved by the use of gold, silver, semi-precious stones and mother-of-pearl and even, given the temporary nature of the enterprise, nails, mirrored glass, buttons and fragments of costume jewelry. The formal progression of shape and ornament, too, is deeply satisfying.

But what delights the eye does not necessarily satisfy the mind, and the formal orchestration and animated surfaces are not enough to distract from the unintended bathos of some of the imagery. With the gaps in his teeth and his twinkling opalescent eyes, the gorilla representing the giant Typhoeus is more theatrical than threatening; and Excess, the comically obese woman on the right, suggests a brothel madame, not the embodiment of a deadly sin. The apparent – totalitarian – message here, that man's salvation can only be achieved through the intervention of a supremely powerful, charismatic individual is, moreover, deeply objectionable.

But perhaps there is another, less obvious message. The interpretation of the frieze given in the catalogue – the liberation of humanity through art – is not entirely supported by the imagery. It is not only the figure of the knight that can be taken to represent Klimt (although the features are not his own). So, too, can the naked male who embraces the woman in the final section. There it is not so much humanity in general that achieves freedom, but the female in particular; and she does so through coition, by submitting to the male. This message is reinforced by aesthetic means: the woman's body is almost hidden behind the massive masculine form, and, as the figures merge, the cords which bind them seem to slip down around their ankles. As Werner Hofmann, the distinguished Austrian art historian, asked, 'This kiss – is it really meant to be "for the whole world"? or only for the elect who submit to the spell of the aesthetic religion? There is no escape from the protective space. This fulfilment is paid for with renunciation, by renouncing the world. In its motionless finality it seems to verge on the *Liebestod*.'

Despite the visual qualities which demonstrate that Klimt had become a surpassing master of decorative painting, the Beethoven frieze is, in some respects, difficult to take seriously. Like the monument it was conceived to complement and the *Gesamtkunstwerk* of which it was an integral part, it seems to belong to another age, the age of Makart pageants and history paintings bloated from too varied a diet of message and meaning.

The Beethoven exhibition was necessarily temporary: after three months, Klinger's statue was returned to Leipzig. There it was quickly acquired by the city museum where it can still be seen. What seems

63 Detail of the Beethoven frieze: the longing for happiness, 1902

extraordinary to us now is that everything else in the exhibition was considered expendable. Created specifically for a particular environment, the murals, reliefs and other decorations were thought to have no validity on their own and almost all of them were destroyed. Klimt's frieze was clearly not meant to be preserved: it was painted on a plaster ground mounted on straw and nailed to laths. It was nevertheless saved at the eleventh hour by a collector who undertook the difficult work of removing the plaster in seven pieces from the wall. In 1970 the frieze was acquired by the Austrian State and painstakingly restored. In 1985 it was shown for the first time since 1902 and can now be seen in the basement of the Secession building. It is the only one of Klimt's decorative schemes to be preserved in his native city.

Life as Art

The Beethoven exhibition demonstrated extravagantly the conviction of most of the Secession members that the individual artist, whether painter, sculptor, architect, craftsman or designer, was most fruitfully employed on collaborative schemes. It held as its ideal the concept of a building whose overall design and that of everything in it – from the bathtub to the doorknobs – achieved a visually and spiritually satisfying stylistic unity.

The Secession shared that conviction with many foreign artists whose work can be loosely described as 'Art Nouveau'. Some of them, most notably the Belgian Henry van de Velde, C.R. Ashbee's Guild of Handicrafts and the circle around Charles Rennie Mackintosh, showed work at the eighth Secession exhibition in 1900 and, as a comparison between chairs by Mackintosh and Josef Hoffmann indicates – the latter was actually designed for Klimt –, had provided the Viennese with many ideas of their own. Klimt, as we shall see, derived something of his decorative style from the work of Mackintosh's wife, Margaret Macdonald. *65,66*

Klimt collaborated often with Josef Hoffmann, providing portraits for specific settings in houses that the architect designed. He even worked with his friend Emilie Flöge on the design of clothes and fabrics and dreamed of commissions for projects more elaborate than the frieze for the Beethoven exhibition. Such a commission was not long in coming.

From the beginning there were close links between the Secession and the Kunstgewerbeschule, where Klimt himself had studied. In 1897, the year of the Secession's foundation, a new director sympathetic to the dissidents was appointed to the School. This was Felicien von Myrbach; and one of his professors, Alfred Roller, was already a Secession member. During the next three years another three were appointed to the staff: Koloman Moser, Arthur Strasser and, most important of all, Josef Hoffmann, a man with an acute business sense and, with Klimt, a dominant force in the politics of the Secession.

The influence of the Secession on the students at the School quickly became visible in their work and the informal links between the two institutions multiplied. Hoffmann and Moser realized that it was not

64 Cartoon for the Palais Stoclet dining-room frieze, 1905–09

65, 66 Chairs, designed by Hoffmann (for
Klimt), 1904, and (right) by Mackintosh, 1902

easy for their students to find the kind of employment that would
enable them to continue to work in the new, relatively simple style
favoured by the Secession and that their own designs – for furniture,
textiles, ceramics and so on – could only be carried out by a new kind of
craftsman sympathetic to their ideas. An organization was needed that
would not only provide such craftsmen with workshop space but also
with commissions and other opportunities to sell what they made.

 In 1903, largely inspired by the example of Ashbee's Guild of
Handicrafts and financed by a wealthy textile manufacturer, Hoffmann
67 and Moser founded the Wiener Werkstätte, the Vienna Workshop.
Following a programme which in some ways anticipated that applied

at the Weimar Bauhaus by some sixteen years, the Werkstätte set up a number of workshops under one roof, for metalwork, bookbinding, carpentry and other crafts. And Hoffmann merged his architectural practice with the Werkstätte so that the craftsmen there could create the furniture and fittings for the houses, shops and other buildings that he designed.

The Werkstätte exhibited its work both in Vienna and abroad, opened its own showroom in the centre of the city and carried out commissions for private and public customers. It designed furniture and cutlery, jewelry and fabrics, teapots and stained-glass windows, and, for its less wealthy patrons, charming picture postcards and illustrated children's books. It even designed stamps and banknotes for *68,69* the government.

The Werkstätte was an almost immediate success, especially with the members of the wealthy and discerning middle class who wanted to live and dress elegantly but in a style less heavy and eclectic than that favoured by their parents. They commissioned Hoffmann to design their villas which were fitted out by the Werkstätte, they frequented the Cabaret Fledermaus (the spectacularly furnished restaurant and *70* nightclub created by the Werkstätte in 1907, intended to provide a focal point for the Viennese avant-garde), and the women among them wore hats, dresses, shoes and jewelry designed and made by the fashion *72* department of the Werkstätte. In their new apparel they had their portraits painted by Klimt.

DIE SCHUTZMARKE UND DIE MONOGRAMME DER WIENER WERKSTÄTTE

DIE REGISTRIERTE SCHUTZMARKE

DAS MONOGRAMM DER WIENER WERKSTÄTTE

DIE MONOGRAMME D. ENTWERFER

PROFESSOR JOSEF HOFFMANN

PROFESSOR KOLOMAN MOSER

67 Wiener Werkstätte trademarks and monograms, 1905

68 Carl Otto Czeschka, two-page illustration for *The Song of the Nibelungs*, 1908

69 Joseph Diveky, *The Werewolf*, 1911

The main creed of the Werkstätte was the same as that of the Secession – or at least of those of its members committed to the integration of the arts and crafts. Well-designed, visually appealing and stylistically unified environments would dignify the lives of those who inhabited them. The quality of life would be enhanced by the absorption of life by art. Life itself would become an art form.

This was as much a social as an artistic programme. But there was a contradiction at its heart – as there had been in the programme of the earlier and similar British Arts and Crafts Movement. All life was to be dignified and humanized through art, but where the need was greatest, the means of satisfying it were least. Only the rich, those who were already aesthetically aware and who used art to make statements about their status and discernment, could afford the important products of the

70 Josef Diveky,
Cabaret Fledermaus,
Vienna, c. 1907–08

Werkstätte, which was chiefly interested not in utility but style.
Everyone else had to be content with the postcards and children's
books.

Art and beauty succeeded not so much in benefiting the rich
spiritually as in protecting them from the harsher realities of existence.
The most advanced cultural movement in Vienna and that city's
greatest contribution to the development of modern art was part of a
process, discernible in every cultural and intellectual field, in which
whatever was unpalatable and disturbing was disguised or made
harmless with the aid of exquisite taste. According to the American
cultural historian Carl E. Schorschke, 'the Viennese burghers had
begun by supporting the temple of art as a surrogate form of
assimilation into the aristocracy', but they later used it as 'an escape, a

refuge from the unpleasant world of increasingly threatening political reality'.

The Werkstätte provided the houses and interiors into which the middle class could flee. It indulged and entertained those members of society who, like Stefan Zweig, read the feature pages in the newspapers in preference to the news items. When Zweig and his friends read the papers they preferred to pass over the reports of the Boer War, the Russo-Japanese War and the recurring Balkan crises to concentrate on the *feuilletons*, those typically Viennese, highly personal musings which dignified the transient and trivial by means of a studied and frequently overblown literary style. Almost the only inkling that Zweig and his class had of something rotten in the state of Austria-Hungary was provided in 1913 by the Colonel Redl affair, so sensational that no newspaper reader could overlook it, which revealed that the deputy director of Army intelligence had spied for the Russians in order to finance his clandestine homosexual affairs.

Klimt was deeply involved in the business of the Werkstätte. He was a member of its board of management and although he did not regard himself as a designer, produced a small number of designs for Werkstätte craftsmen to carry out. One of the earliest commissions was for the fashion house owned by Emilie Flöge and her sister. Klimt conceived their trademark which they used on labels, letterheads and their shopfront and it seems likely that he even designed some of the dresses made up from Werkstätte fabrics and sold in the Flöge sisters' salon. But by far the most important project on which Klimt, Hoffmann and the Werkstätte collaborated was the Palais Stoclet commission in Brussels, where Klimt was finally able to demonstrate his greatness as a decorative artist.

It was in 1904 that Josef Hoffmann received this, the most exciting commission of his career. Adolphe Stoclet, a young Belgian industrialist and coal magnate, had just inherited the family fortune and asked the architect to design a house for him on a plot of land on the Avenue de Tervueren in Brussels. Stoclet had spent some time in Vienna and greatly admired the villas Hoffmann had designed on the Hohe Warte, an exclusive area of Vienna where several successful artists and wealthy industrialists lived. One of these villas was owned by the Secession member Carl Moll, who introduced Stoclet to Hoffmann. Money was no object and consequently Hoffmann made sure that money was spent – on the finest and most expensive materials, on extravagant decorations and on fixtures and fittings which, in efficiency and elegance, were the most modern available. So much money was lavished on the house that Adolphe Stoclet was reluctant to admit how

71

71 Trademark of the Flöge sisters' fashion salon
72 Mela Köhler, postcard depicting a woman wearing a Wiener Werkstätte dress, 1911

much he was spending. Even today the Stoclet family has no precise idea of what the house cost to build.

The Palais Stoclet provided Hoffmann with an opportunity to realize his ambition of creating an integrally designed building on a grand scale. He personally designed not only the three-storey, forty-room house itself but also almost everything in it, from the furniture to the cutlery, the light fittings to the door handles. In Carl E. Schorschke's words, the exterior, 'with its molded bindings to contain the marble-clad blocks of which the house is composed, is a veritable jewel box for the precious and cultivated life it was to house'. 73

The interiors are dominated by the typically Hoffmannesque interplay of black and white achieved with white marble and black Swedish granite. Schorschke continues: 'From the marquetry floors and specially loomed carpets through the kid-suede covering of the chairs and the variegated marble, onyx and malachite inlays of the walls gleaming beneath crystal chandeliers, this was a tour de force of symphonic orchestration.'

But the Palais Stoclet was not entirely the expression of a single artistic personality. The Wiener Werkstätte was involved in producing sculptures and decorations, not all of them to Hoffmann's original

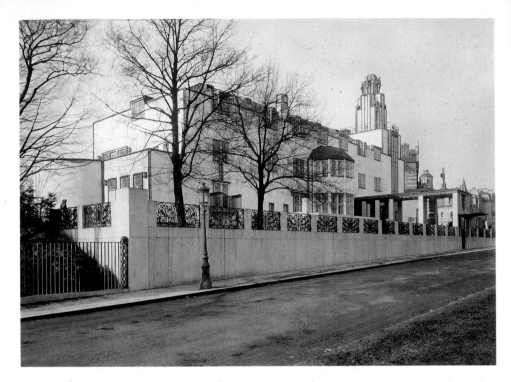

73 Front facade of the Palais Stoclet, designed by Joseph Hoffmann

designs. The Werkstätte also followed its regular practice of commissioning minor pieces of work from students at the Kunstgewerbeschule and the Akademie. Thus Oskar Kokoschka, then a student at the former, was asked to design six needlework panels based on his own illustrations for his fairy tale *The Dreaming Youths*, while Egon Schiele from the Akademie was entrusted with the design of a stained-glass window. The work of both these young artists, in whose lives Klimt would shortly play an important role, was rejected by Stoclet, however, and the designs then entrusted to two more experienced Werkstätte collaborators.

The Palais Stoclet was a bonanza for Hoffmann and the Wiener Werkstätte which, it must be said, treated the extravagance of its patron in cavalier fashion. Work was slower than it might have been (commissioned in 1904, the building was not completed until the summer of 1911) and some of Stoclet's advance payments were used on other projects closer to home, such as the Cabaret Fledermaus. When eventually he became aware of how his funds were being used, Stoclet

paid bills only on the completion of contractually agreed stages and the cash-flow problems which resulted caused even further delays.

In the end, Stoclet's patience was rewarded. The house is one of the masterpieces of Art Nouveau. Every room is magnificent. Even the *76* master bathroom, with its black marble floor, its tub fashioned out of the same grey-veined white marble that covers the walls, its advanced plumbing, high ceiling and space large enough to accommodate a couch and easy chairs, is palatial. There was also a marble-clad music room which no longer exists today, with a small stage and an electric organ, the sound of which could be heard throughout the acoustically sophisticated house. But the most splendid room of all is the dining *74* room, for which Hoffmann designed a table and chairs to seat twenty-two people.

He asked Klimt to collaborate with him on the room's decoration. The result is the finest decorative work Klimt ever produced and, in his own words, 'probably the ultimate stage of my development of ornament'.

Given an unlimited budget, Klimt planned a mosaic made from costly materials which include enamel, a variety of metals, glass, coral, mother-of-pearl, semi-precious jewels and stone. (The bill, just for the mosaic, was 100,000 Kronen, no less than fifty times the annual salary of a junior civil servant at that time.) Even the full-sized watercolour and gouache cartoons and the working drawings for the frieze are *75,77* magnificent. Handwritten notes on the latter reveal the care with which Klimt supervised the making of the mosaic. Criticizing a sample he had been sent, Klimt explained:

I intended the gold areas [of the flowers] to be made from more thinly beaten metal. The fillets between the colours can be gold and at the same time somewhat thicker the samples of the enamel flowers for the ground are even less good – not all the accidental effects need to be imitated. The colours should have been more beautiful, perhaps here and there you could mount coloured glass on metal . . .

The mosaic itself was made by Leopold Forstner and was completed in 1911. It consists of two major parts, each seven metres long, which run along the two longest walls of the dining room, and of a single, much smaller, vertical panel on the end wall by the entrance doors. This panel has a composition consisting of a variety of geometric devices *64* already familiar from Klimt's paintings, but there is no figurative representation. It is entirely abstract, decorative and, as such, is unique in the artist's work. It faces windows at the other end of the dining room, and so it is almost as though, as Eduard F. Sekler has suggested, this extraordinary mosaic panel:

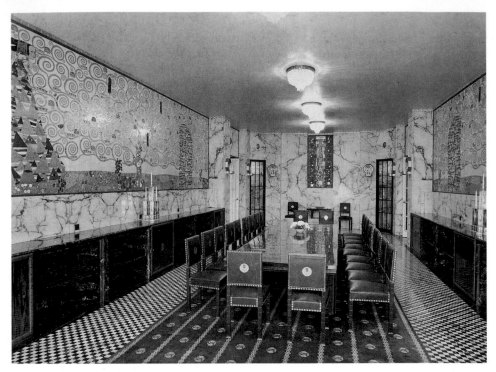

74 Dining room, Palais Stoclet

75 Expectation, cartoon for the frieze in the Palais Stoclet, 1905–09

can itself be seen as a symbolic window out into the counterpart of the real world which unfolds as the garden in front of the room's windows . . . If the meaning of the abstract composition is ever satisfactorily explained, we shall understand with what Klimt wanted to confront the guests at their communal meal, here in this, the most protected part of the room.

This was the work by Klimt that was most admired by such artists as Theo van Doesburg who, during the next two decades, designed interiors of his own with abstract decorations. It is tempting to argue that Klimt's panel is one of the first abstract compositions and that his importance as an artist is greatly enhanced by this piece of pioneering work; but that would be to detract from the purpose of the Stoclet mosaics: they are not paintings but decorations and no less remarkable or important for that.

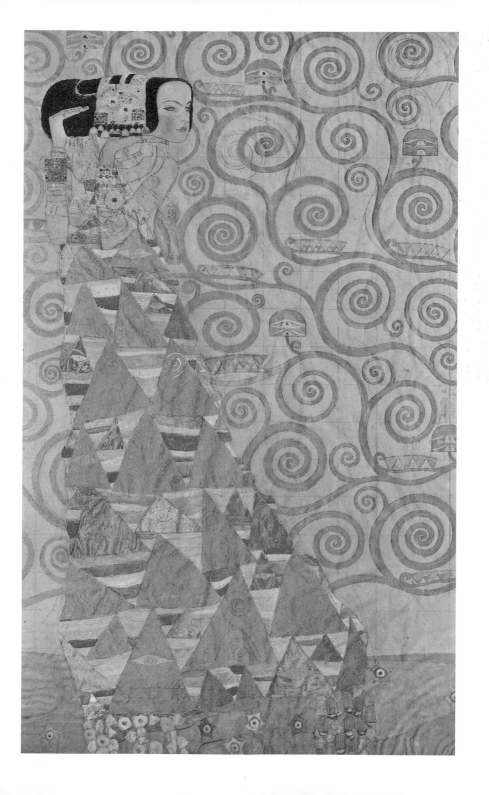

The two longer mosaics are figurative, but barely so. As with the portrait of Adele Bloch-Bauer on which Klimt was working at the same time, the only truly figurative elements are the faces and hands of the figures which, in the case of the dancer, gesture theatrically. The rest consists of nature radically stylized to the point of abstraction, literally petrified or become metal. And the process of decoration is taken further here than in any other work by Klimt. If, in the Beethoven frieze, there is a nicely judged relationship between the images and the blank plaster ground, here the figures and ground achieve total unity. They are virtually indistinguishable.

The figures are integrated into a dominant design of interrelated spirals which represent the curling branches of an enormous tree. On one wall the single female figure, her face almost in profile, her body turned to the front in the manner of ancient Egyptian painting, is intended to symbolize Expectation while immediately opposite on the other wall, Fulfilment is represented by a couple in close embrace. The figures stand in a meadow thick with flowers, butterflies flutter nearby and falcons, which resemble representations of the god Horus in Egyptian art, sit in the golden branches of the tree.

The geometric devices that decorate the robes of the figures are sharply distinguished. Expectation wears a dress covered with triangles, of which some are striped, and some are of gold containing spiralling motifs in relief; others still contain an eye stylized in Egyptian fashion. This decorative scheme is quite different from that of Fulfilment. The man who, seen from the rear, holds the woman to him wears a robe covered with circles, a square filled with rectangles of different sizes and two further squares in which brightly coloured birds appear.

Klimt could scarcely have intended to make a great allegorical statement similar to that of the Beethoven frieze for the dining room of a private house. His first intention was to delight the eye. Nevertheless, the Stoclet mosaics celebrate physical and spiritual love, anticipation and consummation, not only by means of sensuous, precious materials (visual gratification standing for the enjoyment of all the senses) but also of the ornament which Klimt clearly intended to have symbolic force.

Since the mosaics were made in Vienna there were many suggestions in the press and elsewhere that they should be publicly exhibited before their final installation in the Palais Stoclet. But Klimt, still smarting from the reception of his earlier decorative schemes, and mindful of the fact that his greatest commission had come not from a public but from a private, foreign patron, refused to let the Viennese see the mosaics: No! I shall forego the chance to see my work ridiculed and dismissed . . .,

76　Hall, Palais Stoclet

work which probably represents the ultimate stage of my development of
ornament to which I have devoted years of probing, struggling work, a
work in which craftsmen have invested their best with so much quiet,
sacrificial industry. My friends can see the frieze in my studio. Otherwise on
this occasion what I say is this: 'Away from Vienna!'

The Palais Stoclet, which still exists in changed form, was then a
magnificent building, the most spectacular example of that exquisitely
refined taste which characterized all of the most advanced Viennese art
before 1910. But the taste was tyrannical. Since Hoffmann had designed
the entire house and its contents as a complex unity, a change even in a
minor fixture would have been destructive, an iconoclastic act. The all-
embracing conception of the architect imposed conditions on the
house's owners which literally ruled their lives. If a more comfortable
chair were found, it could not be introduced. Alterations made
necessary by changes in life-style could not be accommodated. Even the
bars of soap in the bathroom had to complement the dominant colour
scheme.

Adolf Loos, briefly a member of the Secession but by then one of its most implacable critics, once wrote an essay called 'The Poor Rich Man' which, although published before the completion of the Palais Stoclet, wittily identifies what was wrong with Hoffmann's entire attitude to design and especially with this, his most representative building. The poor rich man, having commissioned an architect to design his home, is obliged to consult him about any change he subsequently wishes to make and often meets with the architect's anger. During one of the architect's frequent visits of inspection his patron notices him glaring at the slippers he is wearing:

The rich man looked at his embroidered slippers and breathed a sigh of relief, for this time he was entirely innocent. The slippers had been made after an original design by the architect himself. So he retorted, 'My dear architect! Surely you haven't forgotten? You designed these slippers yourself.'

'Certainly I did', thundered the architect. 'But I designed them for the bedroom. In this room you ruin the whole atmosphere with those two ghastly patches of colour. Can't you see?'

The rich man could indeed see. He quickly took the slippers off, and was overcome with relief to discover that the architect seemed to have no objection to his socks. They went into the bedroom, where the rich man was allowed to put his slippers on again.

There is a story (perhaps apocryphal but ringing with truth and testifying to Loos's perspicacity) about an employee of the Wiener Werkstätte who once visited the Palais Stoclet. He was outraged to find Madame Stoclet wearing clothes which, designed in Paris, struck a discordant note within Hoffmann's scheme. It was this regrettable *faux pas* which caused the Wiener Werkstätte to establish a fashion department. Never again would a lady be embarrassed because the appropriate clothes were not available. If it had had its way the Werkstätte would no doubt have insisted that every area of life became a work of art by designing and making everything from cradles to gravestones.

Nowhere in the Palais Stoclet was there space for personal expression. Everything seemed so perfect that the house could not be lived in comfortably, only admired. Such buildings were not intended for creative people but for a class of aesthetes who, in spite of all their good intentions, were forced to become gallery attendants in their own houses.

The attempt to restructure life through art, and to limit nature and the human personality by means of tyrannous ornament lies at the heart of Klimt's paintings and, as we shall see in Chapter Eight, nowhere more obviously than in his portraits.

77 Fulfilment, cartoon for the frieze in the Palais Stoclet, 1905–09

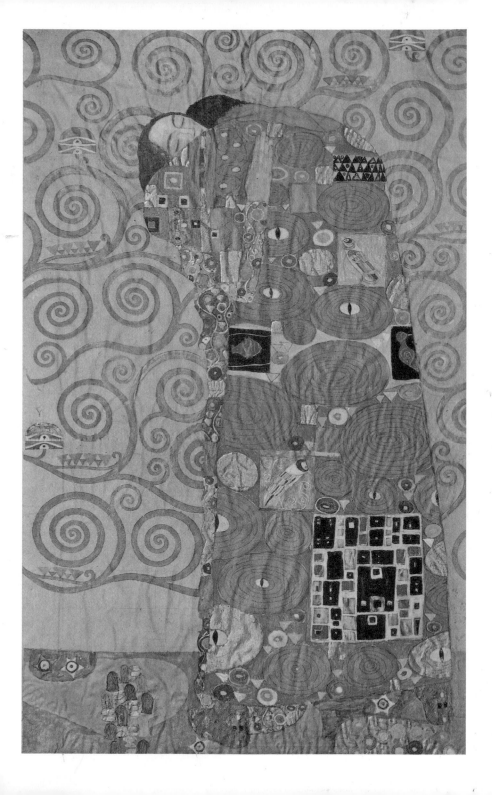

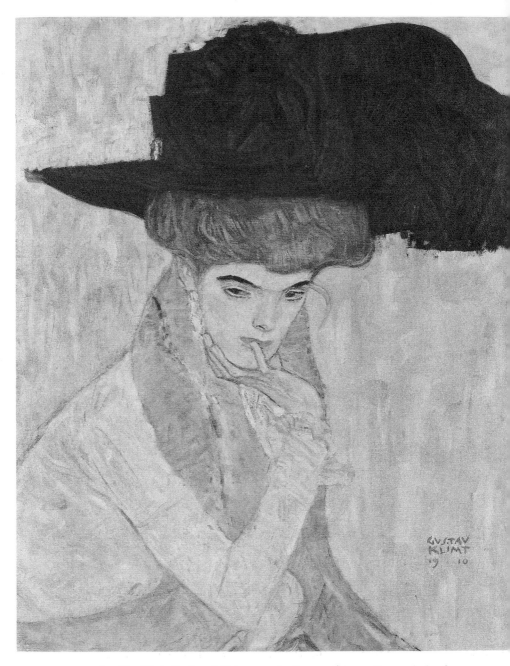

78 *The Black Feathered Hat*, 1910. In its use of truncation and clearly defined flattish areas of paint, this portrait of an unnamed woman demonstrates Klimt's debt to Japanese art: compare illustration 88.

Another Rebellion

Not every Secession member by any means cherished the ambition to integrate all the arts under the aegis of architecture. The organization was from the first an uneasy alliance of at least two main and, as it proved, only temporarily reconcilable factions. On the one hand there were the *Stilisten* – the stylists – led by Hoffmann and Klimt, and on the other the *Nurmaler* – the 'mere painters' – who, with Josef Engelhart at their head, were never interested in collaborative projects and came to believe also that the Secession was being run in a way which furthered the careers of a clique around Hoffmann and Klimt. They also feared that it was being compromised by commercial interests.

The *Nurmaler* had a point. Hoffmann and his allies were the most powerful personalities in the Secession, where they occupied all the strategic positions. They also dominated the organizations closely related to it: they were amongst the most influential professors at the Kunstgewerbeschule and they ran the Wiener Werkstätte. From 1905 they also controlled the only Viennese private gallery of any consequence, the Galerie Miethke.

Although there was tension between the two groups from the beginning, it was largely invisible to the outside world until 1903 when *Ver Sacrum* ceased publication – officially, but not convincingly, because it had succeeded in its aim of making the Secession known. At the same time four members resigned from the association. Until 1904, however, the strain was bearable. In that year a universal exhibition was staged at St Louis, Missouri, where countries worldwide presented their achievements in science, industry and art in a series of national pavilions. At first Austria-Hungary had no wish to participate, but when it was realized that every other major country apart from Turkey would be promoting itself at St Louis, it hurriedly invited the Secession to mount a display demonstrating the current vitality of the nation's art.

The Secession suggested it contribute one of Hoffmann's installations, another *Gesamtkunstwerk*, whose focal point would be Klimt's University paintings, but the Ministry of Education, to which they legally belonged, refused to lend them. The Secession then failed to agree on what it might exhibit instead. Many of its members, Engelhart

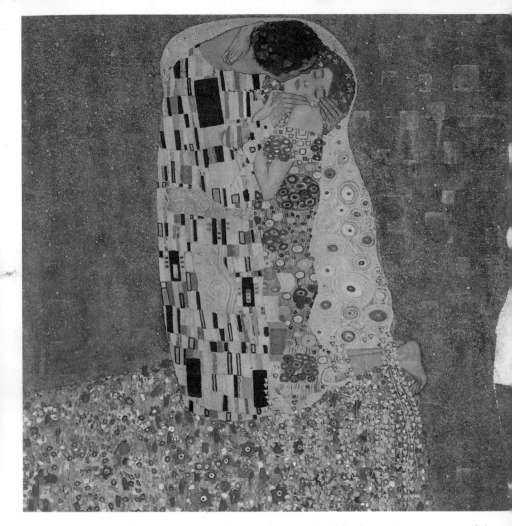

79 *The Kiss*, 1907–08. The eroticism and richly decorative treatment of the subject is highly characteristic of the work of Klimt's 'Golden Period'. Closely related to parts of the Beethoven and Stoclet friezes, this, the most celebrated of all the artist's paintings, seems to embody Klimt's belief in the transforming power not only of sexual love but also of art.

and his allies among them, wanted a catholic and extensive selection of paintings, but Hoffmann and Klimt, the latter particularly angered and frustrated by the Ministry's decision, insisted that the Secession should refuse to participate at all. They had their way and Austria-Hungary was represented by artists from the Polish part of the Empire. Those outside Klimt's circle saw themselves as the victims of *folie de grandeur*, and thought that the time had come for the leadership of the Secession to be wrested from the grasp of the selfish coterie of 'stylists'.

During the spring of 1905 relations between the two factions deteriorated further when Carl Moll, Klimt's friend and one of the most talented painters and designers in the Secession, became advisor to the Galerie Miethke following the death of its founder. The Engelhart faction thought that too cosy a relationship with any single commercial concern was dangerous and that Moll's well-paid position sat uneasily with his membership of the association. They well knew that another Secession, the one in Berlin, was controlled not by its artist members but an astute and successful dealer, Paul Cassirer, who exploited it in the interests of his business. The Viennese were determined to prevent a similar situation from occurring.

Engelhart therefore organized a ballot of members. The Klimt faction, which argued for the links with the Galerie Miethke, lost by a single vote cast by a friend of Engelhart who returned hot-foot from Germany where he was then living. It did not seem possible simply to accept defeat and remain within the Secession, so Klimt and eighteen of his allies resigned. The organization never recovered from the loss of its leading artistic and entrepreneurial talents. With their removal the leadership of the Secession was inherited by Engelhart, the other sentimental observers of Viennese life and the painters who specialized in a tame variety of French Impressionism. The Sacred Spring was at an end.

Engelhart's self-regarding memoirs were published in 1943. Austria was then part of the Third Reich and the writing is blemished by anti-Semitic remarks. It also displays a reactionary attitude to modern art which, for Engelhart as for the Nazis, was 'decadent' and 'culturally Bolshevik'. But Engelhart's criticisms of Moll's commercial interests and of the dominance of the Secession by the Klimt group are justified to some extent. It was true that the easel painters who had no interest in collaborating with Hoffmann were at a disadvantage and it was understandable that they welcomed the opportunity to assert themselves.

Engelhart remembered that, after the resignation of the Klimt group, 'certain newspapers treated us as the rump Secession'. But he

went on triumphantly to record that 'this rump Secession has meanwhile celebrated its fiftieth anniversary while the new association, the *Kunstschau* founded by our opponents, staged only three shows'.

In fact, there were only two *Kunstschau* exhibitions; but that aside, his observations were strictly accurate. The Secession did survive (indeed it still exists today) although the subsequent eclipse of the reputation of Engelhart and painters like him reveals more about the fortunes of the association after 1905 than do any statistics.

Vienna did not possess the lively art market to be found in Paris, Berlin, Munich or in most of the other large European cities. There were few commercial dealers or galleries and the influence of such associations as the Secession was correspondingly great. The resignation of the Klimt group was therefore seen by some observers to be foolhardy: denied the building in which they had regularly exhibited, they now had almost nowhere else in Vienna to show their work. In 1907 Klimt did exhibit all three of his University paintings (which he only now considered completely finished) at the Galerie Miethke, and regular shows were staged by the Wiener Werkstätte, but neither of these venues provided more than a temporary and even then unsatisfactory solution to the problem.

Within three years, however, the group around Hoffmann and Klimt managed to solve the dilemma in a manner which recalled the beginnings of the Secession. The municipal authorities offered them temporary use of a plot of land on the Schubertring earmarked for a

80 Emil Hoppe, postcard published by the Wiener Werkstätte showing the garden facade of Hoffmann's pavilion for the 1908 *Kunstschau*

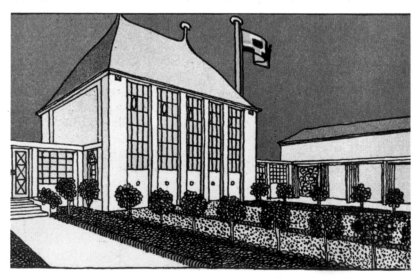

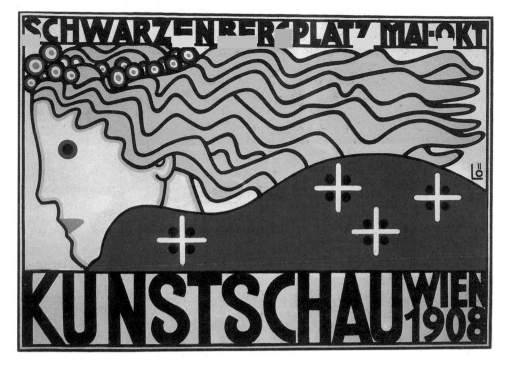

81 Berthold Löffler, poster for the 1908 *Kunstschau*

new concert hall (and where the Konzerthaus now stands), and
Hoffmann, who had much practice in designing temporary exhibition
spaces, conceived a complex of prefabricated buildings which consisted *80*
of a main exhibition hall containing fifty-four rooms. This was
surrounded by terraces, courtyards and gardens in which could be
found a café and an open-air theatre. There was also an architectural
exhibit: a two storey, five-roomed country cottage, also designed by
Hoffmann. Soon after the resignation of Klimt and his friends from the
Secession the words 'To every age its art, to art its freedom' were
removed from its headquarters. Now they reappeared over the
entrance to Hoffmann's exhibition buildings where, in May 1908, the
first and simply named *Kunstschau Wien* ('Art Show, Vienna') was *81*
opened.

The *Kunstschau*, at which only Austrian artists were represented, was
advertised as a contribution to that year's celebrations of the sixtieth
anniversary of the Emperor Franz-Josef's accession to the throne. More
importantly, it marked the public re-emergence of those architects,

artists and designers who had lately revitalized Austrian art. Klimt referred to their recent lack of exposure in his opening speech:

It is well known that we by no means regard the exhibition as the ideal way of establishing contact between the artist and his public. For us, one incomparably preferable way to do this would be to carry out public commissions. But for as long as public life is dominated by economic and political considerations the only way remaining open to us is the exhibition. . . . We must be thankful . . . for the opportunity to show you that we have not been idle during those years without exhibitions, but – perhaps precisely because we have been free from worries about exhibitions – we have worked on the development of our ideas even more industriously and inwardly.

The inclusion of Hoffmann's country house together with a theatre and restaurant made the exhibition unusual enough. Yet there was also a room devoted to posters, at that time not universally regarded as an art form, and another to the work of amateurs – from Adolf Böhm's private art class for ladies. But for all its variety the 1908 *Kunstschau* was essentially a kind of apotheosis of Klimt who was intimately involved

82 in its planning and organization: an entire room, designed and hung by Moser, was devoted to no fewer than sixteen of Klimt's paintings.

115,1 These included the portraits of Fritza Riedler, Adele Bloch-Bauer and

107 Margaretha Stonborough-Wittgenstein, and what remains perhaps his

79 most famous work, *The Kiss* (which was immediately acquired by a Viennese public collection). There was also a selection of landscapes, of allegorical compositions (among them *The Three Ages of Man*), and of

119,118 allegorized erotic subjects such as *Danae* and *Water Snakes*.

All the themes and subjects on which Klimt had been concentrating since the University paintings were clearly in evidence: as well as portraits and landscapes, there were scenes allegorizing human life and women as the centre of an erotic mythology. These, together with Klimt's erotic subjects, will be discussed in later chapters; but something must be said here about *The Kiss* since in many ways this spectacular picture represents the culmination of his work as a painter

34,28 during the years after the controversy over *Philosophy*, *Medicine* and

37 *Jurisprudence* had ended his association with public patrons, and had caused him to go his own, independent way. Exhibited for the first time at the *Kunstschau* of 1908, it is, in the eroticism of its subject, its use of gold and silver leaf and splendid ornament, perhaps the most characteristic painting of this crucial period in Klimt's career. It has also become the icon of fin-de-siècle Vienna.

30 The subject is quintessentially Klimt: he first used it in *Love*, but the immediate antecedents of *The Kiss* are to be found in the Beethoven

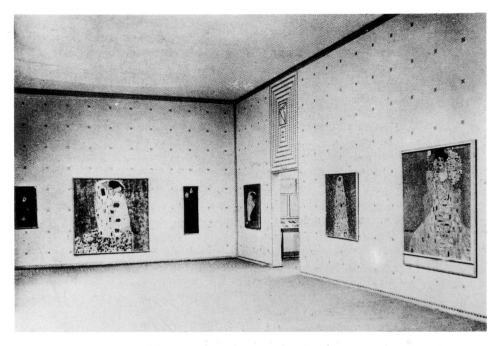

82 Klimt room, designed by Koloman Moser, at the 1908 *Kunstschau*

frieze and the Stoclet mosaics. We can see in this painting a more richly
decorated version of the couple in the final section of the Beethoven
frieze and a less radical transformation of the figures representing
Fulfilment in the Stoclet mosaics. But in *The Kiss* the man and woman
have sunk to their knees and the woman's ecstasy and the tenderness of
the moment are revealed in her face and the positioning of the hands.

The extraordinarily rich and varied ornament, some of which is in
relief, is not arbitrary, nor is it intended simply to delight the eye. The
predominantly rectangular, black, white and silver devices against the
gold of the man's robe are intended to embody and convey masculine
qualities while the brighter colours and circular motifs on the woman's
dress express feminine attributes.

There was nothing new about such an emblematic representation of
temperamental and sexual differences. Relatively recent psychological
experiments (on whose findings Seurat had based his expressive
imagery) suggested that angular forms are innately masculine while the
curvilinear evokes the feminine. This was something many painters had
always felt intuitively: David's *Oath of the Horatii* is merely one of the
many examples in older art of the use of contrasted straight lines and

curves to dramatize the different emotional responses of men and women to the same event.

In *The Kiss* the areas dominated by the contrasting types of ornament are separate but juxtaposed and subsumed into a dominant, gold (and even phallic) form. This encloses the embracing couple and suggests not only consummation but also self-absorption. The form is an extension of the secular haloes found in the portraits of Fritza Riedler and Emilie Flöge. The background, suggestive of stars, and the carpet of flowers on which the figures kneel, intensify the intoxicating sensuality of their union. The sharp edge of the meadow also suggests an abyss and thus the precariousness of the couple's happiness. A mood and a meaning are established by the representational parts of the picture and they are enhanced by ornamental, abstract means.

These means most obviously include the use of gold and silver leaf. Gold not only stands for wealth but also has magical associations. Precious materials and opulent decoration heighten the sensuality of the imagery and increase its erotic charge. The sexual act is presented almost as a religious sacrament while the painting is like an altarpiece for a temple to the cult of physical love.

In that cult the male has the dominant role. As in the final section of the Beethoven frieze, the woman in *The Kiss* is absorbed by the man who takes her kneeling and apparently in a state of trance. In some of the preliminary drawings the man is depicted with a beard and it has therefore inevitably been suggested that the male figure is Klimt himself and the woman an idealized portrait of Adele Bloch-Bauer whose affair with Klimt was supposedly continuing when *The Kiss* was painted. The only evidence for this, however, is the awkward position of the woman's right hand (but this masks the fourth, and not the disfigured middle finger). The painting is not autobiographical but a symbolic, universalized statement about sexual love. ˀ

The American art historian Kirk Varnedoe has pointed out that Klimt's painting dates from about the same time as Brancusi's sculpture 83 of the same title. To compare them is to see instantly the differences between Klimt's work and that of another, more completely modern artist. Both Klimt and Brancusi were attracted by various forms of primitive, exotic and folk art and both used them as a means of combating Naturalism and achieving formal and spiritual intensity. But whereas Brancusi simplifies, reduces and rarefies, Klimt complicates, allows his ornament to proliferate and adds layer after layer of effect and allusion.

Brancusi's sculpture speaks with a clear and knowingly unsophisticated voice while *The Kiss* is eclectic, an exquisite distillation of

83　Constantin Brancusi, *The Kiss*, 1908

84　The Empress Theodora, detail from the
mosaic of the Basilica of S. Vitale, Ravenna,
6th century

elements taken from Europe, Byzantium and Japan. One of its
European sources is the work of Margaret Macdonald who, with her
husband Charles Rennie Mackintosh, had exhibited at the Secession.
The shape enclosing Klimt's couple and, above all, the flowered pattern
on the woman's dress are reminiscent of the hair of a female figure at the
right of Macdonald's *The Opera of the Sea* (*c.* 1903) which she produced
for the music room of one of Klimt's friends in Vienna, Fritz
Wärndorfer, who was the financial backer of the Werkstätte. Of
greater importance, however, were the Byzantine mosaics at Ravenna
which Klimt knew well (he visited Ravenna twice in 1903) and which
had already provided inspiration for his own mosaics in the Palais
Stoclet. More important still is the influence of certain kinds of Oriental
(and especially Japanese) art which Klimt collected.

84

85 Klimt in the garden of his studio in Hietzing

85 The young artist Egon Schiele remembered visiting him in his studio, the last he would occupy before his death. It was situated in a secluded side street in Hietzing, Vienna's XIIIth district, and surrounded by mature trees and densely planted flower beds. Inside, around the walls, visitors could see 'Japanese woodblock prints and two large Chinese pictures . . . African sculptures stood on the floor and, in the corner by the window, there was a black and red Japanese suit of armour . . .'. Along another wall 'was a large built-in cupboard containing the most beautiful Chinese and Japanese costumes'.

86
87 Klimt's distinguished collection of Oriental art also included Noh masks, *netsuke* and porcelain from China and Korea as well as Japan and all of it repeatedly influenced his compositions, decorative devices and even subject matter. He sometimes used the extreme vertical format, familiar from Japanese 'pillar prints' in his paintings and graphics, established bold relationships between figure and ground in many of his compositions and often employed decorative schemes in his portraits
88
90 reminiscent of those which appear in *bijin-e*, Japanese 'pictures of beautiful women'. Many of his decorative devices recall the *mon*, or

86 Illustration for
Ver Sacrum I, 1898
87 Isoda Koryūsai,
*Musician teasing her dog with
her samisen, c.* 1770
88 Chokosai Eishō, *The
Courtesan Misayama*

89 Kimono probably designed by Klimt, 1910

90 Ogata Kōrin, *Red and White Plum Trees*

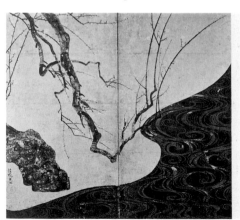

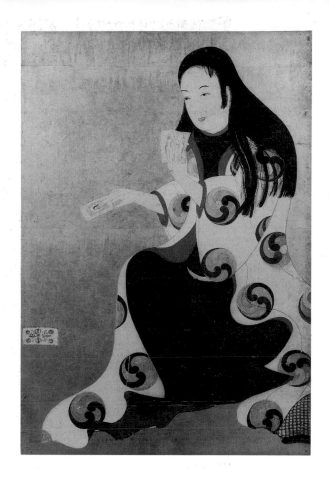

91 Unknown artist,
Matsuura byōbu,
first half of the 17th century

family crests, which appear on Japanese dress. His use of gold and silver 91
might also have been suggested by those prints which employ
burnished metallic powders to produce a shiny ground. The appear-
ance of those areas of *The Kiss* which were made by scumbling gold
over gold is very similar to that of the background in some prints by
Sharaku, for example. Even the robe Klimt wore while painting recalls
the Japanese kimono and he may have actually designed kimonos to be
made up from fabrics produced by the Wiener Werkstätte.

There were no Japanese *byobu* (folding screens) in Klimt's collection,
but in its initial impact *The Kiss* is startlingly like some of the work of
the early eighteenth-century screen painter Ogata Kōrin, in which gold 90
and silver leaf contribute to a decorative treatment of nature where
water, trees and plants become part of exquisitely judged, almost
abstract compositions.

92 Campaigns of Sennacherib, on an Assyrian palace relief, *c.* 705 BC
93 Detail from *Judith and Holofernes*

Klimt was by no means the first European artist to succumb to the allure of Japanese art. Indeed, during the last four decades of the nineteenth century, many painters – Manet, Degas, Van Gogh, Gauguin and Whistler, whom Klimt particularly admired – had been influenced by it. But by the time Klimt had fallen under the spell of Japanese art, most of his French contemporaries had become more interested in African woodcarvings. Klimt's late use of Japanese models nevertheless produced what was perhaps the most spectacular marriage of East and West in European painting.

Klimt's interest in the Japanese aesthetic was combined with a much broader taste for many other unusual and exotic things: for the art of ancient Babylon, Egypt and Mycenae, and for Celtic manuscript illumination. He was also interested in a wide variety of Central European folk and peasant art. One of his most striking borrowings, first pointed out by Alessandra Comini, occurs in the background of the first *Judith and Holofernes*. There the trees are derived from an Assyrian relief in the Sennacherib at Nineveh. Klimt's use of it was not

93
92

arbitrary: Holofernes, whom Judith decapitated to avenge the murder of her husband, was the commander of the Assyrian army. Like the historicists before him, Klimt plundered the past, but unlike them, he did so in the search for something new: a personal language of form and colour capable of expressing moods, emotions and even ideas.

Klimt was raising the status of ornament in his work at a time when decoration in general was becoming of major interest to art historians. In 1901, one of the greatest of them, Alois Riegl, published a book in Vienna which would not only crucially affect the practice of art history but also of art itself: *Die spätrömische Kunstindustrie nach den Funden in Österreich-Ungarn* (*Late Roman Art Manufacture based on the Finds in Austria-Hungary*) was both a radical re-examination of the nature of stylistic change and a plea for a more serious consideration of the 'lesser arts' which had been neglected in favour of painting and sculpture. Riegl argued that what he called the *Kunstwollen* ('will to form') – what gives each age and culture its distinct visual personality – is often found at its purest not in the fine but in the applied arts, and that it is often expressed in abstract ornament and decoration more clearly than in representational imagery. Riegl's book therefore provided a theoretical justification for abstract art, but it was also read as a plea to take the crafts more seriously.

The nature and purpose of ornament, and even its moral implications, were the major issues of a debate to which by no means only Riegl contributed. In 1908 Adolf Loos gave a famous lecture, later published as a pamphlet, *Ornament und Verbrechen* (*Ornament and Crime*), in which he argued that ornament is a sign of cultural degeneracy. Primitive people and criminals tattoo themselves, Loos reminded his audience, and the time a craftsman takes to decorate an object is wasted since it could be spent more profitably in some other way.

Loos was a prophet of simplicity and honesty in everything and, as we might expect, he was alarmed by Klimt's ornate surfaces. But in a passage which might have been written to elucidate Klimt's art rather than to condemn it, Loos asserts:

All art is erotic. The first ornament to have been invented, the cross, was of erotic origin. It was the first work of art . . . A horizontal stroke: the woman lying down. A vertical stroke: the male who penetrates her. The man who created this sign experienced the same impulse as Beethoven, was in the same heaven as that in which Beethoven created the Ninth.

The acquisition of *The Kiss* by a public collection marked the beginning of a reconciliation between Klimt and the authorities. In

1905, still angry at the treatment of the University paintings, Klimt declared that he would 'never, certainly never take part in an official exhibition under the aegis of this Ministry [of Education]'. But the purchase of *The Kiss* three years later and, in 1912, of a landscape by the same gallery, did much to change his mind. In 1911 he contributed to the official Austrian section at an international exhibition in Rome where he was awarded first prize.

Although in one sense the first *Kunstschau* was an earthly apotheosis of Klimt, in another it provided an intimation of the fragility of his artistic reputation. In the midst of all the critical enthusiasm, all the full-throated songs of praise to Vienna's greatest painter, one voice hinted that Klimt's art was so much part of its time that it would die with it. The voice was that of Otto Stoessl and it was raised in the pages of *Die Fackel*, the journal which never ceased to undermine the assumptions on which Klimt's art, the Secession and the Wiener Werkstätte were based. Behind Klimt's obvious and outstanding talent, Stoessl wrote, a monster was lurking. The monster was 'taste and it shares the fate of everything that is so relative and general: to pass away in time'.

Klimt and his friends were not the only exhibitors at the *Kunstschau*. Among the 179 participating artists were students from the Kunstgewerbeschule. Klimt was keen to use the *Kunstschau* to expose the work of young artists to the public and he was invariably generous in his support even when their work was quite different from his own. One of the students whose gifts Klimt recognized was Oskar Kokoschka who exhibited there for the first time.

At that time Kokoschka's work consisted mostly of illustration and graphic design. Although plainly influenced by the Wiener Werkstätte, it was intentionally harsher in style than most of the workshop products. The Werkstätte commissioned Kokoschka to design post-cards and to write and illustrate a fairy-tale for children which was offered for sale at the *Kunstschau* and which was entirely unsuitable for them. In its disregard for syntax, its lack of an obvious plot and its violent and erotic imagery, its appeal was very limited. The *Kunstschau* gave Kokoschka his first big chance and he was grateful for it: his fairy-tale, *Die träumenden Knaben* (*The Dreaming Youths*) is 'Dedicated to Gustav Klimt in Admiration'.

Kokoschka's contribution to the *Kunstschau* attracted almost as much attention as Klimt's, although the critics were considerably less flattering. By comparison with Klimt's refined imagery and technical perfection, Kokoschka's bold forms and bright colours seemed to mark him as a primitive, a wild man bent on outraging the sensibilities of his audience. Some critics, however, perceived a real and serious talent

94 Oskar Kokoschka, poster for the 1908 *Kunstschau*
95 Kokoschka, dedication and title page for *The Dreaming Youths*, 1908

behind Kokoschka's work and sensed that, at his hands, Austrian painting would shortly undergo an exciting and new development. They asserted that it was time for a radical change in Austrian art: they had their fill of refinement and, above all, of what Otto Stoessl called 'the monkey of art: taste'. Richard Muther, writing in *Die Zeit*, reflected that 'anyone who acts so much like a cannibal at the age of twenty-two might possibly be a very original, serious artist by the time he is thirty'.

Klimt was too generous, too aware of Kokoschka's talent and too conscious of the fact that artistic change generally was a sign of vitality, to criticize the young artist himself. Indeed, he defended Kokoschka in precisely those terms in which he himself was being attacked. When Ludwig Hevesi was discussing the *Kunstschau* and Kokoschka's contribution to it with Klimt, he admitted that the young man was very gifted but added that 'He lacks that most important thing: taste. He hasn't got a penn'orth of taste.' To which Klimt is said to have replied: 'But a pound's worth of talent . . . Taste is good for a connoisseur of wine, for a cook. Art, however, has nothing to do with taste.'

Kokoschka also exhibited at the second (and, because of financial problems, last) *Kunstschau* which took place in the same buildings in 1909 and which, unlike the first, was international in scope: it included three of the pioneers of Modernism – Van Gogh, Gauguin and Munch – together with many of their most important successors – Bonnard, Vuillard, Vlaminck and Matisse. The Austrian contribution was again dominated by Klimt, who showed seven paintings, among them his
6,130,131 second version of *Judith* and his two versions of *Hope*. Once more Kokoschka attracted much attention, not least for his play, *Mörder, Hoffnung der Frauen (Murderer, Hope of Women)* which was performed
96 at the little open-air theatre at the *Kunstschau*. Kokoschka's poster for the play was but one of the signs that Viennese art was moving away from the direction in which Klimt had taken it. Among the others was

96 Oskar Kokoschka,
poster for the artist's play
Murderer, the Hope of Woman
performed at the 1908 *Kunstschau*

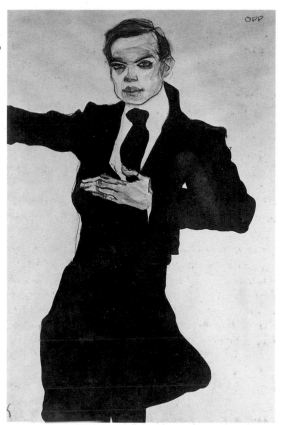

97 Egon Schiele,
Max Oppenheimer, 1910

the work of Egon Schiele who exhibited at the second *Kunstschau* and
who would soon transform two of Klimt's preferred subjects – the
portrait and the allegory – almost beyond recognition.

Kokoschka and Schiele were on the verge of taking Viennese
painting into an area which Klimt was almost certainly unable to
understand. Although he supported them both publicly and privately,
Klimt may even have feared that his own reputation might soon be
overshadowed by that of these precocious young men.

Years later, the critic Berta Zuckerkandl, who was one of Klimt's
greatest admirers, remembered that he had once told her:

the young ones don't understand me any more. They're going somewhere
else. I don't even know if they think much of me at all. This is what generally
happens to an artist, but it's a bit early for it to happen to me. In its first
onslaught, youth always wants to tear down whatever exists. But I'm not
going to lose my temper with them on that account.

97

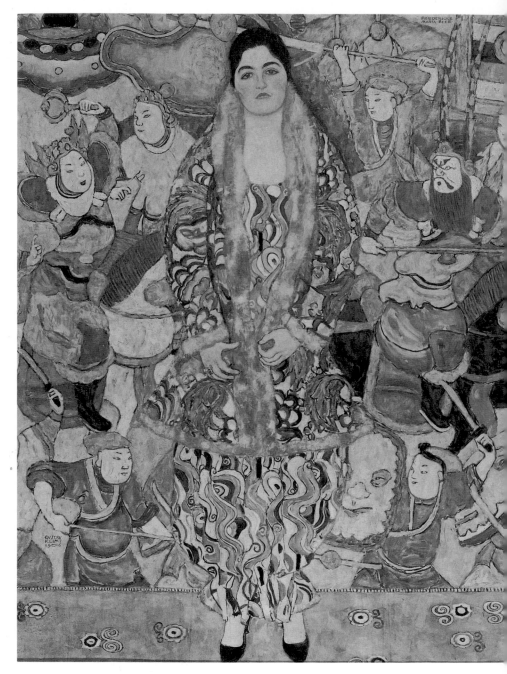

98 *Friederike-Maria Beer*, 1916

Portrait and Personality

In 1915 Friederike Maria Beer, the daughter of the owner of two of the most famous Viennese nightclubs and one of the best customers the fashion department of the Wiener Werkstätte ever had, decided that she wanted a portrait by Klimt. She had already been painted by Egon Schiele and would try unsuccessfully to persuade Kokoschka to do the same, but in 1915 she thought it time to be portrayed by the master. She knew that the picture would cost a great deal of money but that agreeing a price would be the least of her problems. Klimt did not paint just anyone who could afford his services. He was offered far more commissions than he had time to carry out and he was in any case highly selective in his choice of sitter. It was therefore with some trepidation that Friederike Maria Beer visited the artist in his studio.

He wore a big monocle in one eye and looked me sedately up and down without saying anything! That was rather unsettling. Finally he said to me: 'What do you want to come to me for? You have just had your portrait done by a very good painter.' I was afraid that he was going to turn me down and so I answered quickly that, yes, this was certainly true, but that through Klimt I wanted to be made immortal, and he accepted that.

It may have been Friederike Beer's charm or her exotic appearance (quite different from that of most of the women Klimt was usually asked to portray) which persuaded him to paint her. He may even have been intrigued to receive a commission from the sitter herself rather than, as was usually the case, from her husband or father. He certainly charged her, or rather her boyfriend Hans Böhler (himself a painter and heir to a steel fortune) who was paying for the portrait, a great deal.

Klimt always worked very slowly and this painting was the result of 98 six months of regular and lengthy sittings (three hours, three times a week). It is one of the most sumptuous of Klimt's later paintings. Friederike Beer stands, rigid but resplendent in her Wiener Werkstätte jacket and trousers (the former turned inside out, at Klimt's request, to reveal the richly decorated lining), against an Oriental battle scene copied by Klimt from a Korean vase in his collection. The variety of pattern and colour is remarkable but never bewildering. The richness of the visual spectacle, the complete integration of the figure into a lively

decorative scheme, make this one of the most unusual twentieth-century portraits. It has done what its sitter wished it to: it has made her, or at least her appearance and her name, immortal.

Few major artists this century have wanted to take portrait commissions and few commissioned portraits have managed to rise above the pedestrian. Almost all the memorable twentieth-century portraits are of the artist himself or his friends, for during the last 150 years the nature of the art has changed.

The English painter Sickert once suggested that it was 'the retouched photograph' which had 'massacred serious portraiture' and, as though to prove his point, painted many of his own portraits after photographs. The camera was obviously a major factor in the decline of a once considerable art form, more important perhaps even than the changes in the pattern of patronage. The seemingly unchallengeable authority of the photographic image forced the artist to search for and disclose those other kinds of reality – emotional, spiritual, atmospheric – that are largely inaccessible to the lens.

The decline of portraiture has been continuous but inconsistent. Around the turn of the century the art underwent a renaissance at least in one of its branches: that which created memorable and authentic images of members of the *haute bourgeoisie* and aristocracy which eloquently speak of the glittering, privileged and hedonistic society, later to be destroyed for ever by the First World War.

99 In England John Singer Sargent, on the Continent Giovanni Boldini, Jacques-Emile Blanche and Anders Zorn all specialized in portraits of society women and made their fortunes painting them. They were for London and Paris what Klimt was for Vienna. In their pictures well-bred and plainly hypersensitive women stand or lounge in their impressive jewelry and fashionable dresses, the sleeves puffed, the skirts narrow, the breasts and waist moulded by stays and padding. The women contrive to be haughty, yet at the same time inviting. It is difficult to tell whether they are amused or condescending as they fix the viewer, often from between half-closed eyelids, with a challenging or enticing glance made more ambiguous still by their moist, half-open mouth. Today such portraits seem to belong to a past age because they betray no interest in the complexities of human psychology. This explains why a Rembrandt portrait seems more modern than a Sargent, and why any of the lunatics painted by Gericault seems more fully one of our contemporaries than the young women portrayed by Boldini.

The modern understanding of personality and character was first defined in Vienna around 1900 by Sigmund Freud; and it was in Vienna

99 John Singer Sargent, *Lady Agnew of Lochnaw*, 1892–93

that a second renaissance in portraiture occurred. Between 1907 and 1911 Richard Gerstl, Egon Schiele and Oskar Kokoschka produced images of men and women which in some ways can be regarded as illustrations from psychoanalytic case histories. Klimt's portraits, superficially more like Sargent's than Kokoschka's, are difficult to place in this context. As with his other work, they occupy the middle ground between the past and the present.

Two of the factors which make Klimt's portraits different from those of his contemporaries are their ornamentation and lack of movement. Klimt's women are invariably static, as though wisdom or experience has brought them poise. But they also seem to be subject to external forces. They are trapped between and beneath layers of decoration; they are in the process of becoming spectacular fossils, petrified into lustrous and intricately patterned agate. They are like the mosaic case of the caddis fly, their external trappings protecting these fatally vulnerable and exotic creatures from the unwelcome attentions of predators.

Klimt did more than persist with portraiture at a time when the art was falling increasingly into the hands of the hacks and journeymen. He took it as seriously as he did his other painting and worked hard to negotiate the path between his desire for self-expression and the conflicting demands of his clients. In Klimt's portraits there is evidence of conflict and of compromise in the highly visible tension that was the result of ultimately incompatible motives.

The majority of Klimt's portraits date from the period after the University paintings controversy. But he did produce a small number
100 before then, most of them, like the *Portrait of a Woman* (1894), heads of unnamed females in a highly accomplished but unremarkable style. Klimt had also populated his history paintings with figures based on members of his family and friends, many of them copied from photographs. These pictures demonstrate his outstanding ability to capture a likeness, even though they are not portraits in the proper sense of the word.

The earliest portrait to suggest something of Klimt's later, highly
108 characteristic manner dates from 1898. Its subject is Sonja Knips, the daughter of a brigadier in the Imperial Army and the wife of Anton Knips, an industrialist. Like so many of Klimt's later sitters, she knew many of the leading members of the Secession and was later to patronize the Wiener Werkstätte and Josef Hoffmann. In 1903 she commissioned Hoffmann to decorate her flat in Vienna and to build her a house in the country. As so often, Hoffmann incorporated Klimt's portrait into his design for the sitter's flat.

Photographs show that she was a very beautiful young woman and Klimt seems to have been fonder of her than of most of his sitters. While he was working on her portrait he gave her a number of his red leather-bound sketchbooks, one of which contained a small and flattering photograph of himself.

In this painting Klimt's interest in purely aesthetic effects is already as strong as his desire to achieve a convincing likeness. The square format

(one of Klimt's earliest uses of it) is divided into two roughly equal and carefully balanced areas, one dark, the other light in tone. The dark area represents the shadowy, indeterminate space behind her, while the tonally lighter part describes the figure herself who seems to be about to rise from her chair to greet a visitor. The pink and white of her diaphanous dress contrast sharply with the dark, brownish background and the points at which they meet create a sharp outline. The subtle, finely judged tones in the picture are brusquely interrupted by small patches of local colour: on the flowers behind the sitter's head and on the small vermilion book (a sketchbook which he gave her to hold) in her right hand.

The picture is markedly flat. The way in which the bottom of the sitter's dress and the arm and back of the chair are cut off by the edges of the canvas contradicts any illusion of space or form. Even the single flower in the top left-hand corner of the painting repeatedly draws the eye towards it, thus also to the extreme edge of the picture. Like the rough square in which the signature appears at the opposite corner, the vermilion book and the flowers behind the sitter's head, that single flower is a finely judged compositional device, essential for the overall structural balance of the painting.

Klimt himself must have thought principally in these terms when he conceived the picture, for what strikes the eye before anything about the sitter herself are the qualities of design, of placing and arrangement. Sonja Knips was young, charming and beautiful, but her personality and appearance are less important than the painting's own personality – its style.

Sonja Knips recalls some of Whistler's portraits: *Miss Cicely Alexander* (1873), for example, in which the subtly judged tonal contrasts, the firm compositional structure and the strategically placed details are as, if not more, important than the description of physical appearance or character. Klimt knew Whistler's paintings, but at this time seemingly only from black-and-white reproductions in art periodicals. The affinities are nevertheless striking and Whistler's influence on Klimt remained obvious for some while. Whistler occasionally used the square format, cunningly introducing contrasting squares and rectangles into his composition. He frequently achieved a subtle balance between the negative and positive shapes of the figure and ground, and he also turned his signature into an emblem which he used as an important compositional device, a crucial element in the balancing of tone and form.

Between 1899 and 1901 Klimt was almost fully occupied by the University paintings and produced no portraits. Then, he was

commissioned by the artist and writer Hugo Henneberg to paint his
wife Marie (1901–02). The circumstances of the commission are *102*
revealing of the way Klimt was increasingly to work. Henneberg,
clearly a man of means, had asked Josef Hoffmann and Charles Rennie
Mackintosh to design a villa, together with all its furniture and
decorations, for a site on the Hohe Warte. The villa was completed in
1902 and Klimt's portrait of Marie Henneberg was placed above the
mantelpiece of an open fireplace in the entrance hall. Contemporary
photographs give the impression that the painting was made specifi- *103*
cally for that position or that the fireplace was especially designed to
take the painting. The portrait, which in its setting must have looked
something like an altarpiece, would have been the first thing that struck
visitors when they entered the house.

137

102 *Marie Henneberg*, 1901–02

103 The entrance hall of the Henneberg House, Vienna

In spite of its square format and predominant single colour (lilac), it is more conventional than the earlier portrait of Sonja Knips. Broken brushwork – short, directional strokes of various colours – suggests the solidity of the figure, the armchair on which she sits and the space around them. This style, which Klimt employed in many paintings (and especially his landscapes) at about this time, is a variation of

Pointillism, derived ultimately from Seurat. Klimt, however, did not concern himself with the Pointillist creation of a more complete illusion of light and the enhancement of colours, but used the technique to different ends. For him, short, broken brushwork was rather a means of complicating the picture surface in an interesting way. Indeed, the textures thus produced are often not far removed from decoration.

If the portrait of Marie Henneberg marks a pause in Klimt's development as a portraitist, *Emilie Flöge* (1902) provides evidence of a significant shift towards a highly individual, intricately decorated style. Because the sitter was the woman to whom Klimt was closest for most of his life, and also because the picture was not commissioned, he could allow himself to abandon the conventions of his earlier work which he still observed in his more formal portraits and concentrate on the decorative aspects of the composition. He did not produce another portrait like this for several years.

112

The format, a pronounced vertical, is more assertive than the square and the standing figure is reduced to an elaborately decorated, flat, sinuously contoured shape which exists on the same plane as the background and is integrated into a scheme of clearly defined, separate areas. The head and hands alone are painted naturalistically. There is no sense of a rounded body beneath the dress and the area behind her head, suggested obviously by a large-brimmed hat, has become a richly decorated, abstract shape whose purpose is to emphasize the head and provide a counterpoint to the decoration on the dress. It is a kind of secular halo and, patterned with triangles, circles and spots, it contrasts with the split ovals on the bodice and the squares, circles and tendril-like lines on the rest of the dress.

These decorative devices make such an irresistible claim on our attention and possess such a pronounced character of their own that it is tempting to see in them the same kind of symbolic ornament which 60,63,79 Klimt introduced into the Beethoven frieze and *The Kiss*. Is it significant, for example, that the split ovals, so obviously sexual in implication, appear again in Klimt's portrait of another of his close 1 friends, Adele Bloch-Bauer? If the portrait of Emilie Flöge does not set out to convey an idea of the sitter's personality by conventional means, it may well be that Klimt intended the colours and forms to do so in another, more subtle – even subliminal – way.

Other important elements in the composition are the two squares at the lower right, one containing a signature and date, the other Klimt's monogram. These devices are reminiscent of Whistler's butterfly motif and, in a similar way, call Japanese signature seals to mind. Indeed, the 104 entire painting owes much to Japanese woodblock prints of women displaying their richly patterned kimonos.

Emilie Flöge did not care for the portrait and Klimt promised to paint her another, which he never did. We do not know why she disliked it, but she may have been taken aback by its sheer novelty. Certainly Klimt produced no portrait as radical as this for a further 111 three years. His likeness of Hermine Gallia (1904) is considerably less adventurous and even provides an intimation of space by means of a patterned carpet shown in perspective and an atmospheric background. (The relatively dull colours are misleading, however. Time has not been kind to Klimt's paintings, scarcely one of which has not lost something of its original brilliance and lustre.)

107 In 1905, with the portrait of Margaretha Stonborough-Wittgen-stein, we are again confronted by an image of a woman who has been removed from reality to another, purely aesthetic plane and who, by means of precisely judged structure and decorative devices, has been

104 Eizan Fude,
Oiran on Parade, c. 1820

turned into a kind of icon. The pure white dress, clasped hands and expression on the face suggest a nun, or woman dedicated to the contemplative life surprised by a moment of spiritual revelation, an impression heightened by the relative sparseness of decoration and the austere background which consists largely of a few interlocking squares and rectangles.

Of all the many sketches and studies Klimt made in preparation for this portrait, not one is just of the sitter's face. Indeed, the drawings that *105,106*

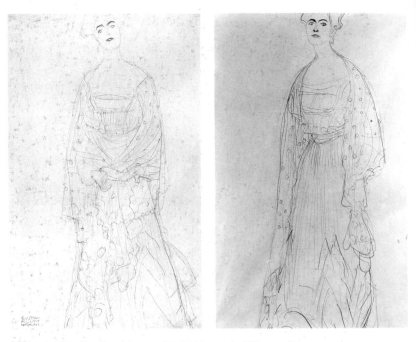

105,106　Studies for *Margaretha Stonborough-Wittgenstein*, 1904–05

are known pay as much attention to her dress and the way she is standing as to her features. This is also true of the studies for Klimt's other mature portraits: he approached what is conventionally regarded as the most important element in any portrait without benefit of careful preparation, concentrating in his sketches on details of pose and costume.

The impression of Margaretha Stonborough-Wittgenstein created by Klimt's portrait does not accurately reflect what we know about the subject, a remarkable member of a remarkable family. One of her brothers was the philosopher Ludwig Wittgenstein and another the concert pianist Paul Wittgenstein (who was to lose an arm in the First World War and for whom Ravel would compose his famous concerto for the left hand). Margaretha, who in 1905 married the American physician Thomas Stonborough (Klimt's portrait was intended as a wedding present from her parents), was not at all like the subjects of most of Klimt's other portraits. Intellectually emancipated, she was well read in philosophy (especially the new logical-positivism of Moritz Schlick and the Vienna School) and in the dramas of Ibsen, Strindberg and Sudermann which were then regarded as shocking and

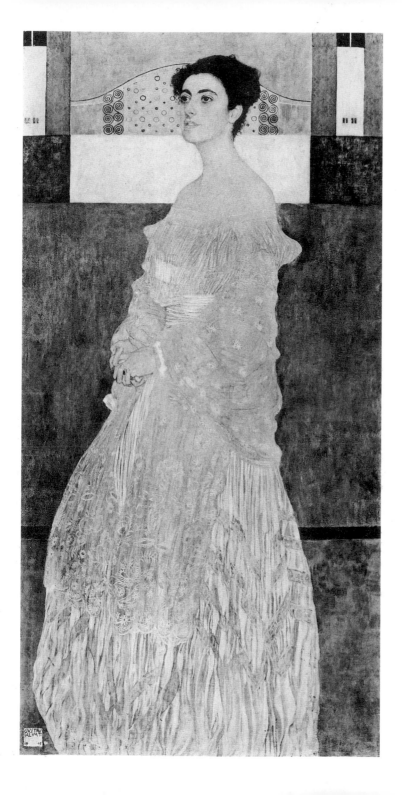

unsuitable for refined young ladies. She had even read Weininger. She knew and supported Freud (whom she was to help emigrate to London in 1938) and was interested in the new, radically simple architecture of Adolf Loos at a time when most people thought it to be soulless and lacking in humanity. (She later commissioned her brother Ludwig to design her an extraordinary house in the most severe modern style in Vienna.) She was, in short, like very few women of her class.

There were constant tensions between the strong-willed, independently minded Wittgenstein offspring and their parents. Their father, Karl Wittgenstein, was an enormously rich steel magnate and a patron of the arts, especially music – he was a friend of both Brahms and Mahler. But he was also interested in painting, had supported the Secession financially during its early years, was a great admirer of Klimt and owned several of his paintings and scores of his drawings.

Born in 1847, Karl Wittgenstein was an outstanding example of the kind of Jewish *haute-bourgeois* Viennese who became assimilated into society and prospered during the Ringstrasse era, and who then found in art and music a purpose in life. But in his taste and attitudes he remained essentially conservative and was unable or unwilling to understand the artistic and intellectual interests of his children. The gap between the two generations of Wittgensteins was a version of the larger rupture between the young and old, between the traditional and progressive, that was becoming manifest in every area of Viennese life.

This may go some way to explain why Klimt's portrait failed to satisfy Margaretha Stonborough-Wittgenstein. In style it was modern, but in its representation of the sitter as an innocent and compliant creature, it was old fashioned and had little to do with the way she saw herself. After the portrait was finished, it was shown only briefly at the Wittgenstein villa before being hidden in the attic of Margaretha's country home. Later it was lent to the Neue Galerie at Linz and then sold to the Neue Pinakothek in Munich.

What is known about the sitter obviously affects the way a portrait is seen and much is known about Mrs Stonborough-Wittgenstein. We know considerably less about Fritza Riedler, who sat for Klimt in the following year (1906). She was born in Germany and was the wife of a privy counsellor in Vienna. In this portrait Klimt adopted a structure of rectangles as the basis of the composition similar to that in the Wittgenstein picture, but the decoration is considerably more elaborate. There are two areas of gold at the left and smaller areas of silver are distributed throughout the picture. The chair, covered by shapes reminiscent of the 'eyes' on a peacock's wheel, is scarcely recognizable as such and the area behind Fritza Riedler's head, simultaneously

144

108 *Sonja Knips*, 1898

suggestive of a small stained glass window, a Tiffany lampshade and of the kind of head-dress worn by one of Velazquez' infantas, is an elaborate, mosaic-like pattern of geometric devices. It provides the most concentrated area of visual interest and suggests that the naturalistic rendering of the sitter's face was not in itself compelling enough to fix the viewer's attention. The conflict between Naturalism and Abstraction, the compulsion to subject the personality of the sitter to the tyranny of ornament, has resulted in the suppression of her individuality.

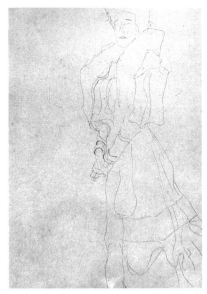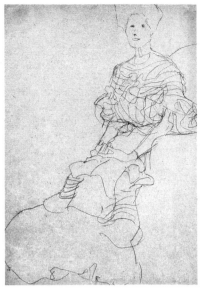

109, 110 Studies for *Fritza Riedler*, 1905–08

109,110 Once again, the preparatory drawings for this painting pay scant attention to the face. As surprising, given the precisely calculated structure of the picture, is the lack of any compositional studies. Should we believe that Klimt arrived at the subtle interplay of squares and rectangles into which the figure is locked during the process of painting? It seems highly unlikely.

Werner Hofmann describes the figure of Fritza Riedler as being 'like an inlay upon the surface and yet raised above it; in her ornamental aura she is offered up to us as a precious work of art, yet withdrawn from us as a human being . . . Klimt has painted a human being fitting in with her own decor in order to become a work of art'. We are, Hofmann suggests,

confronted by three separate yet interacting forms of artistic reality. A work of art – the painting itself – portrays a work of art within a work of art: the human being as a work of art in surroundings realized by the painter as an artistic scene – the mosaic wall and the armchair. Painter and model both belong to the *Künstlerschaft* [artistic community] which unites creators and consumers.

The work of art within a work of art: it might be a description of Mme Stoclet at home in Brussels for whom, thanks to her surroundings, life had become primarily a matter of accommodating a style.

146

Style and ornament could be construed as symbolic of the status and social conventions behind which the sitters hide. They do not meet us as equals or even as fully rounded human beings. So often raised above us and looking down, they maintain their distance and are permanently inaccessible.

In the portrait of Fritza Riedler, as they are in all the portraits of this period, the head and hands exist disturbingly as naturalistic elements in essentially decorative compositions by which they resolutely refuse to be absorbed. These portraits are among the most telling examples of Klimt's art. The unity of life and art towards which Klimt aspired was ultimately as unachievable in painting as it was in architecture and design because the human element refused to bend to the artist's will. In spite of all attempts to subject the individual to artistic transformation, nature stubbornly resists. In the portraits the sitters cannot sacrifice the individuality betrayed by their facial expressions, just as in Josef Hoffmann's elaborate interiors, whether or not decorated by Klimt, perfection can never be achieved because people and not marionettes must live there.

The most elaborate example of the tyranny of the decorative in Klimt's work is the portrait of Adele Bloch-Bauer (see pp. 9–16). One of his most revealing paintings, it is a unique and curious hybrid, with *The Kiss* the masterpiece of what has inevitably become known as his 'Golden Period'. *Adele Bloch-Bauer* exists at the limits of Klimt's decorative style. Like Picasso, who around 1910 produced Cubist portraits which are virtually illegible, Klimt was faced by a difficult choice: to move still further towards Abstraction, or in the opposite direction of Naturalism.

Klimt painted Adele Bloch-Bauer again in 1912 (she was the only woman who sat for him more than once) and the second portrait reveals which direction Klimt chose to take. The change in style is marked. Although pattern still proliferates, it is of a different kind and every part of the picture can be read as representing reality. The palette is different, too: above all there is no sign of gold or silver. There is a gap of five years between these two paintings. As the decoration has become less tyrannical, the personality is better defined.

Fashionably and expensively dressed in a fur-trimmed creation that was almost certainly a Wiener Werkstätte original, Adele Bloch-Bauer stands on a richly patterned carpet and against a wall hung with tapestries, one of them Oriental. She gazes directly out of the picture but her eyes do not quite meet the spectator's. She seems haughty, self-assured, as though intent on preserving her dignity by avoiding contact. The erotic charge of the likeness of 1907 has been spent.

1

79

116

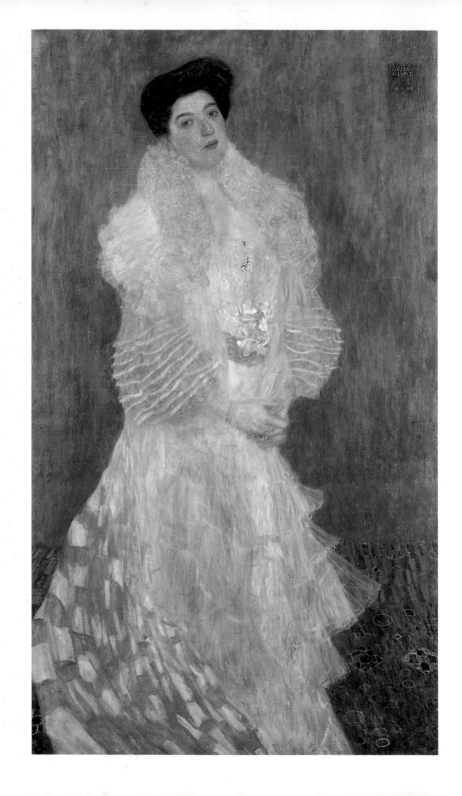

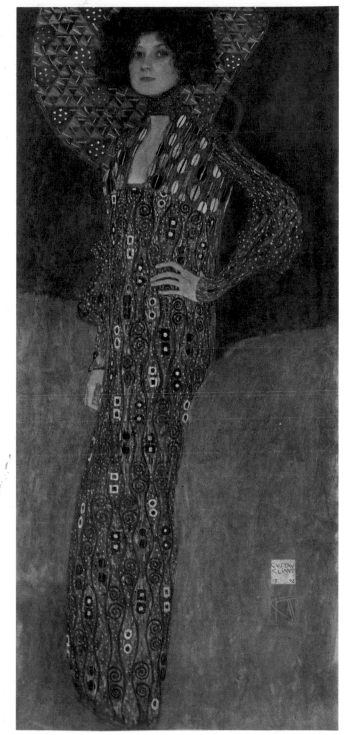

The full-length figure in this later portrait is flat, integrated into the brightly coloured decorative scheme which dominates the painting. But the figure is distinguished from the background – it does not merge into it as it does in the earlier painting; and instead of the matt surface of such earlier portraits as the one of Fritza Riedler, Klimt's paint now has a thick, creamy quality.

In spite of the character of the paint itself, the interest in ornament, the brilliant colour and tight structure, the later Bloch-Bauer portrait is of a real human being, of a recognizable social type and even of a complex personality. Wealth has conferred confidence on the sitter. She has condescended to be painted. And the artist has portrayed her in her public image, almost as though she were receiving supplicants at a Court audience. The sense of confrontation with a real person which this portrait provides is almost unique in Klimt's work, however. Such later full-length and fully frontal portraits as the ones of Baroness Elisabeth Bachofen-Echt (1914–16) and Friederike Maria Beer are essentially gorgeous fashion plates. In these two works the emphasis on ornament can be read as an avoidance of such serious questions as the purpose of portraiture in general and the nature of a specific individual

113 Else and Berta Wiesenthal dancing the 'Faust waltz'

114 Emilie Flöge wearing a dress of her own design

in particular. Klimt avoided the questions by setting himself other, purely aesthetic problems. This was clear to many of his contemporaries. One of them, the critic Karl Kuzmany, conceded that the painter thought 'the desired likeness important' but nevertheless believed each successive portrait represented a challenge of a quite different kind. Each portrait is essentially

a purely decorative panel which is always clearly different from all previous ones. The clothes admittedly provide the starting point; but if one [dress] is of lace with white flounces, then he [Klimt] composes white in white, limitless in the subtlety of his nuances. And if another is of shimmering, embroidered silk, then he makes her [his sitter] gold and sets her against a golden background.

The clothes are of enormous importance in every Klimt portrait. A woman's dress serves the purpose in painting that it did in life: it enhances and glamorizes reality; it is an expression of status and of taste. And the taste revealed by the dresses in Klimt's portraits was anything but conventional. Around the turn of the century what most men and women wore was tight and constricting. The purpose of the whalebone corset, with its scores of hooks and eyes which produced the slender waist, of the elaborate coiffeur, which required the services of a live-in maid to engineer, and of the layers of underclothes, was to mislead. The more a woman wanted to seem like a lady, the less her natural form could be shown.

The female patrons of the Wiener Werkstätte and the Flöge sisters' salon – and Klimt himself – dressed differently. The robe he habitually wore in private and the loose dresses which Emilie Flöge designed for herself are free from the tight-waisted, high-collared restrictions which dominated contemporary fashion. By permitting bodily freedom, they suggest intellectual and even social emancipation. 114 ·

Klimt and Emilie Flöge were disciples of the relatively new 'Reform Movement' in dress which held that tight and narrow clothes produced tight and narrow minds. They were also interested in the new, 'free' artistic dance movement pioneered by Mary Wigman, Isadora Duncan (who performed in Vienna in 1902), the Wiesenthal sisters, Loie Fuller, 113 and even Mata Hari who is said to have danced once at the Secession.

The free-flowing dresses worn by the subjects of Klimt's portraits suggest a new, liberal attitude which, however, contrasts jarringly with the static effect of the all-pervading ornament. These contradictory intimations of freedom and repression correspond to what we know of Klimt's idea of woman and female sexuality. As we shall see in the next chapter, it was entirely typical of his time.

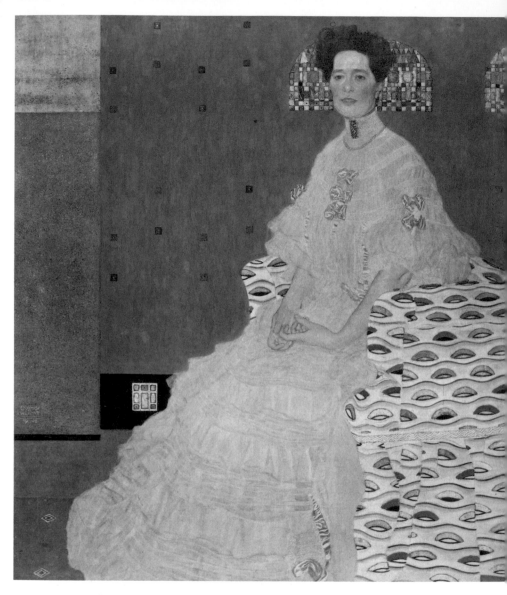

115 ` *Fritza Riedler,* 1906

116 *Adele Bloch-Bauer II,* 1912

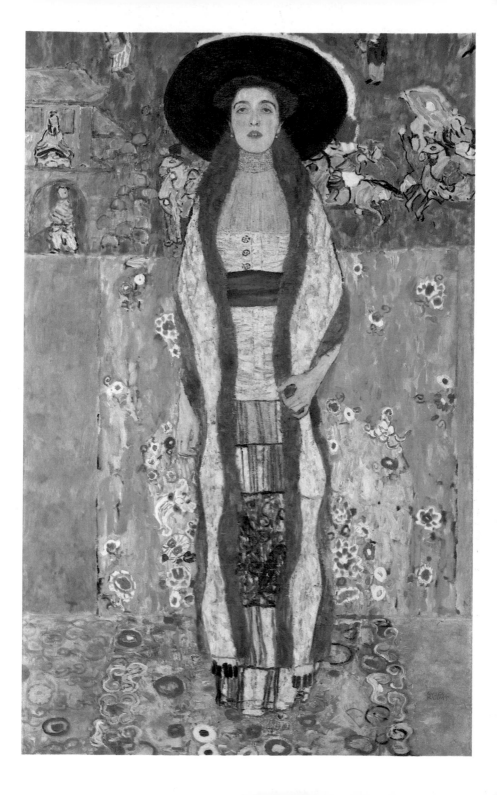

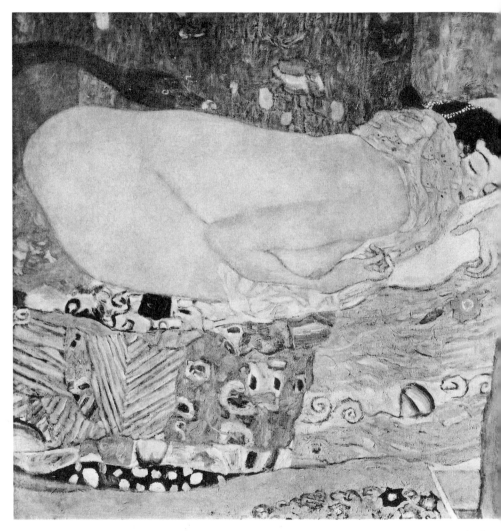

117 *Leda*, 1917. One of Klimt's most sexually suggestive paintings in which the ostensible, mythological subject scarcely hides the work's true intention. It was one of many pictures by the artist which were destroyed by fire in 1945.

The Eternal Feminine

Towards the end of the 1880s Arthur Schnitzler, the doctor and writer, asked his father how a young man might cope with the problem of sexual appetite without offending against morals, society or the requirements of hygiene:

Seduction and adultery were prohibited and dangerous, affairs with cocottes and actresses risky and expensive. Then there was the decent sort of girl who had already strayed from the path of virtue, with whom one could nevertheless in the words of my father 'get stuck', just as one could with any woman one seduced. So all that was left were whores and even when one knew how to protect oneself from disease they were a very disagreeable expedient.

The problem, by no means peculiar to young men in late nineteenth-century Vienna, was exacerbated by strict social and religious taboos, unreliable methods of contraception and the lack of a cure for venereal disease. Schnitzler's father advised his son 'simply and darkly' to 'shrug it off' – an expression that in German, and in context, plainly alludes to masturbation.

The young Schnitzler thought that no solution at all, ignored the advice of his father, risked 'getting stuck' and pursued the kind of girl who was essentially decent, poorly educated and starved of affection. She most typically worked as a maid or shop assistant and lived at home with her large family in miserable circumstances. She was the kind of girl Schnitzler described as the '*Süsses Mädel*' – the sweet young thing –, a phrase which, because of the general familiarity of the type and the memorable way Schnitzler employed it in his stories and plays, entered the German language. She was seemingly uncomplicated and fun-loving, flattered by the attentions of a sophisticated young man and genuinely grateful for the presents she received and the dinners and dances to which he invited her. She often believed that he was in love with her as she was with him. She gave herself to him gladly.

The *Süsses Mädel* went to bed with most of the men of Schnitzler's generation and class, but she was inevitably neither as fun-loving nor as uncomplicated as her patrons' conscience wished her to be. She was the object of exploitation, the compromised solution to the conflict

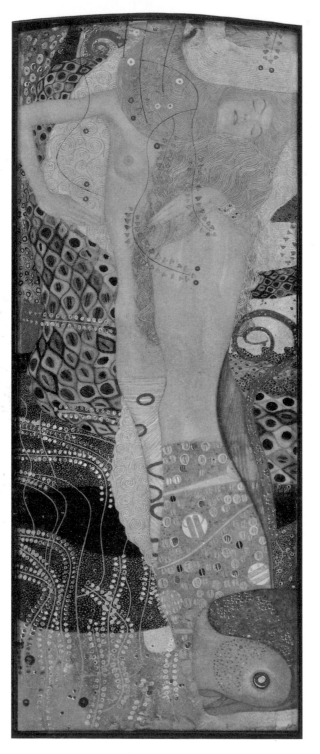

118 *Water Snakes,*
1904—07

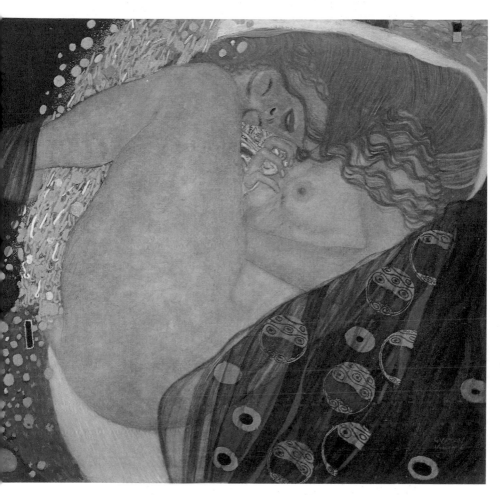

119 *Danae*, 1907–08. Klimt was fond of using mythology, sometimes invented, as a thin disguise for his sexual fantasies. The former seems to be a celebration of homosexual love, while the latter transforms the myth of Danae's impregnation by Jupiter into a description of orgasmic ecstasy.

between the promptings of the libido and the impediments to its gratification. She solved the problem, so clearly defined by Schnitzler, only to be abandoned when the time came for her lover to marry. As Stefan Zweig remembered, she was in reality a pathetic creature; 'badly dressed, tired out after a miserably paid, twelve-hour working day, unkempt (in those days a bathroom was still the privilege of rich families) and . . . with narrow horizons . . .'. She and the thousands like her 'were so far beneath their lovers that they were mostly too shy to be seen in public with them'.

Schnitzler's *Süsses Mädel* is one of the most enduring images of Habsburg society. A figment of the male fantasy of sex without consequences, she appears in both serious literature and such pornography as the anonymously written *Josefine Mutzenbacher* whose heroine is a child who early and gladly loses her virginity and then quickly discovers that she can make a good living from doing what she most likes to do.

Child prostitution was rife, and even quite eminent figures such as the writer Peter Altenberg made no secret of their passion for pre-pubescent girls – Adolf Loos was even taken to court for seducing a minor. But of course the world so amusingly described in *Josefine Mutzenbacher* was nothing like the degrading, corrupt and depressing reality. The nocturnal pavements of Vienna were so densely populated by women and girls selling themselves that it was often difficult to cross the street without being solicited.

In the matter of prostitution, double standards, which, as elsewhere in Viennese life, originated in the conflict between reality and fantasy, were predominant. A prostitute could work legally if she secured a licence of trade from the police and underwent twice-weekly medical checks. Yet the law could give her no protection, for example against a client who refused to pay. Only lower-class prostitutes found themselves in this predicament:

A ballet dancer who could be had by any man at any time in Vienna for 200 Crowns, as the street girl could be had for 2, naturally required no licence of trade. The names of the great demimondaines were even included among those of prominent people in newspaper reports of race meetings because they already belonged to 'society'.

The most fearsome aspect of reality was the physical consequences of promiscuity. According to Stefan Zweig, every sixth or seventh house in Vienna contained a doctor specializing in venereal disease; and the fear of infection was matched only by the fear of the methods used to cure it. Week after week the body of the syphilitic was rubbed with

120 A Viennese
prostitute, *c.* 1877

quicksilver; commonly the patient's teeth fell out and his health was
permanently damaged. When Zweig was young, most of his friends
existed in a permanent state of anxiety:

The one because he was ill or feared an illness, the second because he was
being blackmailed because of an abortion, the third because he did not have
the money for a cure without his family knowing, the fourth because he did
not know how to pay for the food for a child some waitress had said was his,
the fifth because his wallet had been stolen in a brothel and he did not dare
inform the police.

Was it any wonder that the male dream of insatiable, young and
perennially desirable girls was frequently transformed into nightmare?
The male libido was a stern taskmaster in whose service its subjects
sacrificed their freedom and sometimes even their life for the sake of
temporary release. Through processes of guilt transference and
abnegation of responsibility, the nightmare was born of the yielding,
uncomplicated girl who becomes an insatiable predator, the *Süsses
Mädel* transformed into Delilah, Messalina or Jezebel.

In the words of Robert Pincus-Witten, by the end of the nineteenth
century

we find a compartmentalization of the female into distinct roles: Baudelaire's
'natural, abominable and vulgar' female would be counterbalanced by ideal

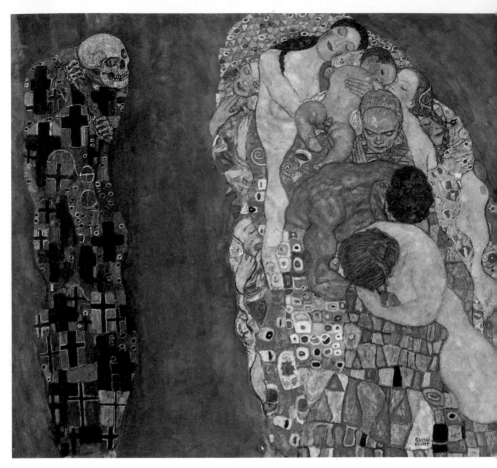

121 *Death and Life*, 1908–11, revised 1915–16. A reworking of a theme that
Klimt introduced in his University paintings, and that reappears in several of
his late allegories: a column of human figures is confronted by Death. In its
opaque symbolism and allusive use of abstract, decorative motifs, it is one of
the most characteristic of the late allegories. It also represents an important
shift in style. The painting, begun at the height of Klimt's decorative period,
originally had a gold background which the artist later painted over.

creatures, *demoiselles élues, blessed damosels* – princesses in the lands of porcelain, impressed upon the public's consciousness by Rossetti, Swinburne, Burne-Jones, Whistler and Armand Point.

European art and literature of the late nineteenth century seethe with irresistible, remorseless women, mythological monsters made contemporary flesh: harpies, gorgons and witches, Salome, coldly triumphant *122,123* over her male victims, and sin itself identified as the eternal, enigmatic feminine.

Frank Wedekind's plays *Erdgeist* (*Earth Spirit*) and *Die Büchse der Pandora* (*Pandora's Box*) made an especially powerful impact in Vienna. They are about Lulu, a child-woman, amoral, the embodiment of the sex-drive, who ruins all the men unfortunate enough to fall under her spell – and that was every man who ever met her. *Pandora's Box* was first staged in Vienna privately by Karl Kraus (who himself played a minor role). Later the plays formed the basis of Alban Berg's last opera. Lulu might have been invented by Otto Weininger, the Viennese philosopher, whose book *Gender and Character* (1901) sought to describe and account for the fundamental differences between the sexes: maleness is contemplative, intellectual, rational and creative while femaleness is instinctive, passive yet predatory, inseparable from sexual drives. 'W[oman]', wrote Weininger, 'is nothing but sensuality, M[an] is sexual and something more.'

Weininger's book, a brilliant, disturbing (and usually misunderstood) mixture of insight and prejudice, was merely the most famous of a host of books and pamphlets written to demonstrate the dangerous but inferior nature of the female sex. P.J. Mobius's book *Concerning the Physiological Mental Weakness of the Woman* was also published in 1903 and during the next two years went into no fewer than eight editions.

It was a doctrine which for many seemed designed to rationalize hypocritical male attitudes towards women. Pornography was a major industry. Men resorted to prostitutes; they seduced young working-class girls and they kept mistresses. Viennese restaurants had private rooms, the famous *chambres separées*, where couples could first enjoy dinner and then make love unobserved.

Woman as sexual object is one of Klimt's major subjects. He made hundreds of drawings in which nude or half-dressed women lie on *124–127* couches and beds invitingly presenting their bodies to the viewer. The pencil or crayon line with which they are described explores and caresses as though the act of drawing was itself part of the process of foreplay and intercourse. These women are exclusively sexual objects: typically, their faces are sketchily described, their features generalized

while the emphasis of the description falls on the pubic area where the hair and labia are exaggerated so as to form a focus for the viewer's gaze. Foreshortening, truncation, a lack of background all conspire to draw attention to their sex. So, too, do their stockings, garters and other details of dress. Like pin-up photographs, they use clothes not to cover but to disclose and dramatize. The women in these drawings have no identity as individuals. They are anonymous and largely passive. They exist only to whet the appetite of the male spectator who is not only a potential lover but also voyeur.

119 *Danae* (1907–08) is so passive that she actually sleeps while the golden
79 seminal stream flows between her parted thighs. In *The Kiss*, the woman is also passive, overwhelmed by the ardent attentions of the

122 Franz von Stuck, *Salome*, 1906

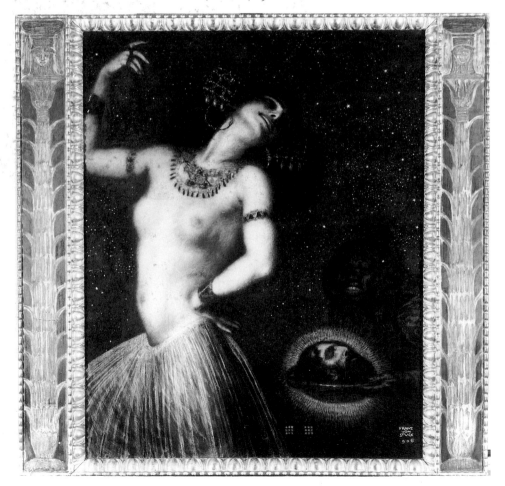

123 Max Klinger,
The New Salome, 1893

man, her feelings as dependent on him as her body is enclosed, swallowed up by his.

In spite of the respectable disguise conferred by classical allusion and allegory, many of Klimt's paintings are quite shocking. His *Leda* (1917) 117 is on her knees, leaning forward while the phallic head of the swan, apparently seeking to enter her from the rear, caresses her back. His *Water Snakes* (1904–07) are clearly not serpents, sprites, nymphs or any 118 other fabulous or mythological creatures but the fulfilment of a common male voyeuristic fantasy: a half-naked lesbian couple writhing in orgasmic ecstasy.

Like Rodin, Klimt always had two or three models at his beck and call. When they were not being drawn, they lounged around naked or

124 Drawing, 1912

125 *Nude with Clasped*
Hands, 1912–13

126 Drawing, 1909–10
127 Drawing, 1912–13

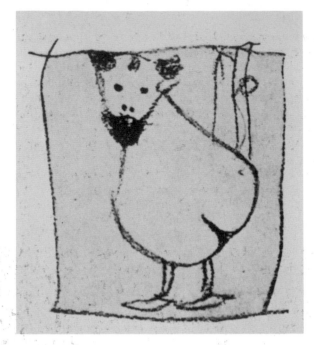

128 Self-portrait
as genitalia, *c.* 1900

in their underwear and invariably surprised any visitor who had never
been to the studio before. Klimt would stop painting and turn to one of
these models as the spirit moved him. At that time artist's models were
widely regarded as little better than prostitutes. Certainly most of them
were disadvantaged and poor, but those employed by Klimt could
sometimes count on his generosity. He is said to have paid for the
funeral of the father of one of his models and for the rent of another
threatened with eviction. What he generally paid them was a pittance,
however; he exploited them, saw them as bodies and little more, an
attitude revealed in Klimt's description of the backside of one of his
models. It was, he said, 'more beautiful and intelligent . . . than many
faces'.

Klimt also slept with several of his models and seems to have had a
powerful sexual appetite. A caricature of himself provides amusing
128 evidence of this. The drawing shows his face as a bull's head on a body
which at first sight looks like that of a bird, but on closer inspection
reveals itself to be a woman's bottom or a pair of testicles.

The drawings of aroused, naked women give a straightforward
picture of Klimt's attitude to sexuality. Many of his paintings suggest a
more ambiguous view, however. In such allegorical works as *The*

Three Ages of Women, *Hope* and *Death and Life* females appear at the 129,131,121 centre of a world constantly in change and decay.

The ambiguity of the title of *Hope* is admittedly absent in the German original – *Hoffunung*, a word which recalls the phrase *in guter Hoffnung* – 'expecting'. And the state in which the beautiful, wide-eyed, red-haired woman finds herself in the first version of the painting could not be more clear. But why is she accompanied by loathsome, repulsive creatures who seem to threaten her from all sides? Perhaps they represent the corruption to which all life is subject even at the moment of conception. Perhaps, on the other hand, they express a view of the sexual drive as a fatal snare: the appealing look of bewildered innocence might be a mask which, when removed, will reveal a

129 *The Three Ages of Woman*, 1905

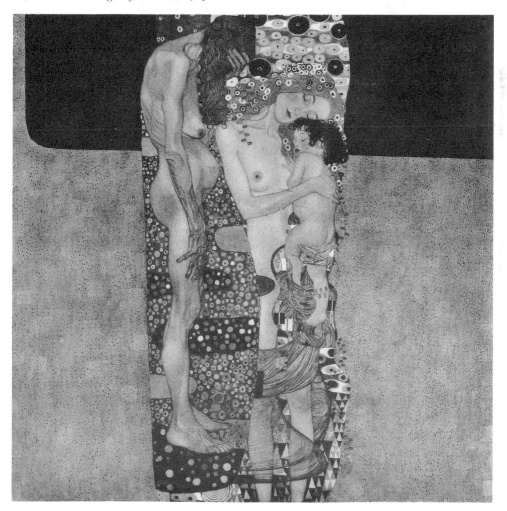

hideous visage similar to that of the female at the top left of the picture. Pregnancy is the evidence of woman's sexual triumph over the man and the child she will bear will perpetuate man's suffering.

37,60 In other paintings – in *Jurisprudence* and the Beethoven frieze, for example – women are unmistakably agents of merciless retribution or embodiments of evil while men are almost always their defenceless victims. Klimt seems to have been just as hypocritical and contradictory in his attitude to women as most men in fin-de-siècle Vienna.

5,6 In *Judith*, a subject Klimt painted twice, the woman is not the faithful spouse avenging the murder of her husband who appears in Hebrew literature, but the prefiguration of Salome who took bloody revenge when her sexual overtures were scorned. In Klimt's first version of *Judith* she appears as a femme fatale promising sex in exchange for self-abasement and life itself. In the words of Philippe Julian she is a 'Viennese Mona Lisa pictured against a gilded Byzantine background, wearing the jewels of Theodora'.

But what gives Klimt's *Judith* its unnerving magic is not its evocation of art historical masterpieces but the contemporaneity of its subject. She is not a mythological creature but the kind of woman one might have encountered on any day in Vienna. For Felix Salten (who, incidentally, was probably the author of *Josefine Mutzenbacher*), Klimt's Judith was

a beautiful Jewish society hostess . . . who, her silk petticoats rustling, attracts the eyes of the men at every première. A slim, lithe and supple woman with a sultry fire in her dark glances, with a cruel mouth and nostrils trembling with passion. Mysterious forces seem to slumber in this seductive female, energies and a violence which for the moment are suppressed, kept down to a slight, bourgeois flicker, but which, once ignited, could never be put out. Then an artist . . . presents her to us adorned in her timeless nakedness and – ecce Judith – the heroic women of days gone by rise up before our eyes, are given life and move among us . . . The body of this Judith is painted wonderfully, the boyish, tender, almost gaunt body which appears to extend itself and stretch. And the shimmering flesh colour, across which a thousand lights tenderly skim, the skin which looks as though lit from within, as though one could see the blood coursing through the veins. This entire pulsating body on which nothing is still, on which everything lives and quivers, seems electrified by the jewelry which twinkles around it.

In Klimt's second *Judith* the deadly sexual promise has given way to sheer predatory evil. The decapitated head hangs precariously from the woman's clawing fingers while her rigid facial expression, the black and white splintered forms decorating her robe and the sharp, secateur-like curves that represent its edges contribute to the atmosphere of remorselessness and menace.

Klimt's ambivalent view of woman as idol on the one hand and as deadly predator on the other was widespread. Around the turn of the century many men felt that their sexual identity was threatened by women's unprecedented demands for political and social emancipation. In the art and literature of the period the common, contrasting images of the female as 'woman' and 'lady', 'whore' and 'mother', unwittingly betray an unease and fear in the face of a growing challenge to conventional definitions of gender. Schnitzler's conversation with his father provides a particularly memorable example of one young man's bewilderment while Weininger's *Gender and Character* is the classic document of the crisis of the masculine identity. Seen in this context, the contradictions in Klimt's view of women become easier to understand. The purpose of his use of allegorical and mythological figures also becomes clear. Contemporary women are represented as witches, gorgons and sphinxes in order to embody Klimt's fears and desires. Paradoxically they are dressed up in theatrical costume in order that their true nature may be revealed

In life, Klimt's relation to women seems to have been scarcely less complex than the attitude that emerges from his art. We know as little about his relationships with women as we do about his private life in general. He never married. He always lived in the family apartment where he was looked after at first by his mother and then, after her death in 1915, by his two unmarried sisters. One of them once recalled the regularity of her brother's habits. He 'came to us every evening, ate his meal without saying much and went to bed early'. Klimt enjoyed a long and intimate friendship with Emilie Flöge, the sister of his brother's widow and a woman of great charm, beauty, taste and talent. Yet in spite of shared annual holidays in Kammer on the Attersee, there is no evidence – nothing, for example, in Klimt's laconic letters and telegraphically brief and emotionally neutral postcards (or in Emilie's letters to him) – to suggest that their relationship, which obviously met his emotional needs, was sexual. If it had been, Emilie's conventionally middle-class family would have been outraged. How could they have tolerated their unmarried daughter consorting so openly in public with a lover almost old enough to be her father?

Klimt's reluctance to commit himself to the woman he loved seemed strange to his contemporaries. In 1919 Hans Tietze published an article in which he described the artist's personality as having been riven by contradictions. Klimt, Tietze argued, had a great need for love but he denied himself its satisfactions:

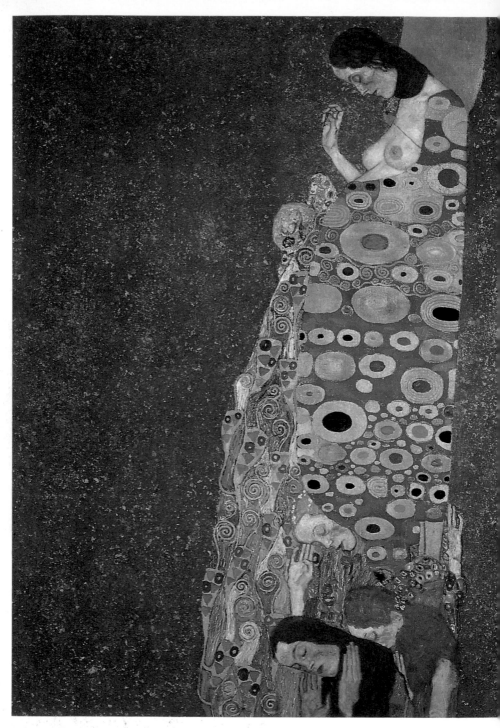

130 *Hope II*, 1907–08

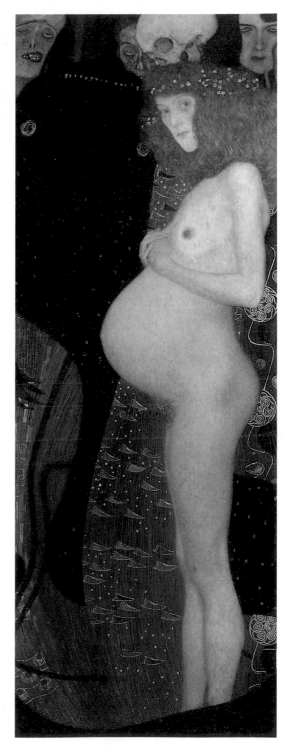

131 *Hope I*, 1903

We attempt to understand these contradictions . . . in order to come closer to his deep and mysterious art; even what is still kept secret must be touched upon . . . in the case of an artist in whose work . . . the enthralling magic of the female body occupies so large a place. Klimt's rough strength powerfully affected everyone, above all women, and his appearance seemed to give off the strong aroma of the earth. But . . . an inner flaw prevented him from abandoning himself to life unreservedly. For many years he was tied by the closest bonds of friendship to a woman, but here, too, he was unable completely to affirm [his love]. One suspects that that which trembles with erotic neurasthenia in his most sensitive drawings is filled with the most painful experience. Klimt did not dare assume the responsibility of happiness, and he crowned the woman whom he loved for years only with the privilege of attending his painful death . . . How acutely and secretly Klimt experienced the pangs of love was betrayed by every glance into his suffering eyes.

Tietze identifies the mystery and its relevance to an understanding of Klimt's art, but he does not begin to unravel it. Why was Klimt unable to commit himself completely to any woman? Why did he never marry Emilie Flöge? And if his feelings for her were at all physical, why, as seems certain, did he suppress them and seek sexual release elsewhere?

Klimt's reputation as a womanizer was widespread. At least one friend, Carl Moll, was alarmed by the attention Klimt paid to his stepdaughter Alma (who later married the composer Mahler). But, to her eternal regret, she never became Klimt's mistress and would have envied Adele Bloch-Bauer. Well-bred and socially distinguished, Adele Bloch-Bauer was unique among Klimt's mistresses who usually were of the same type and class as his models. One of them, Mizzi Zimmermann, who had two of Klimt's children, was probably a model for a time while Maria Ucicky, the mother of a third child (who later became the well-known film director Gustav Ucicky) was a simple laundress. After Klimt's death no fewer than fourteen people announced that they were his natural children and entitled to a share in his estate. This, however, probably had more to do with rumours of the artist's wealth than with his undoubted virility and only four had their claim recognized.

In his book *Gustav Klimt und Emilie Flöge* Wolfgang Georg Fischer devotes an entertaining and revealing chapter to Klimt's relationship with women. He sees Klimt as an entirely typical example of the Viennese middle-class male of the period who led several concurrent and discreetly separate lives. By all appearances respectable and reliable, Klimt led a secret life – although it was not always as secret as he would

have wished. While he was on holiday in the country with Emilie Flöge and her family, he was not always able to hide the letters which regularly arrived with desperate pleas for money from Mizzi Zimmermann, living with their children in a room in one of the most miserable districts of Vienna.

Klimt was far less disturbed by Mizzi's descriptions of her predicament than embarrassed by the delivery of her letters. The Flöge family had become aware that he was receiving mail from a woman because, as he complained to Mizzi, 'the postman arrives and blows on a small trumpet, everyone in the house runs to meet him summoned by this trumpet, take and distribute their letters, so the whole world knows from where a letter comes and where it is going'.

A clearer admission of the contradictions in Klimt's own life can scarcely be imagined. Seemingly married in all but name to Emilie but denying himself the pleasures of her bed, Klimt, like thousands of married men whose feelings towards their wives had cooled, sought sexual release away from the woman with whom he consorted in public.

Klimt's relationship with Emilie Flöge was like very many marriages at a middle or late stage. The husband looked to his wife to provide everything except sex. That he found elsewhere. It was another of those common sexual conflicts which Weininger identified and described. For every male 'the girl he desires and the girl he is able *only* to love but *never* to desire are of a quite different character. They are *two entirely different beings.*' Emilie was the woman Klimt was able to love but never to desire.

So, as Fischer concludes, 'Klimt ... disappears into the suburbs to the Mizzi Zimmermanns and Maria Ucickys and presents the world out beyond the Ring with little Gustavs. In the evening, however, he is also in the 'better districts', always gallant, again in a position to offer Emilie his chivalrous arm during visits to the . . . theatre; and please, she should not forget to bring the opera glasses.'

Klimt never married Emilie Flöge who remained faithful to him even after his death. When her fashion salon was closed down in 1938 she maintained a 'Klimt room' there in which his easel, his collection of kimonos, and hundreds of drawings were preserved. Its doors were kept permanently locked. Is it any wonder that Emilie herself was said to suffer from 'life-long hypernervosity'?

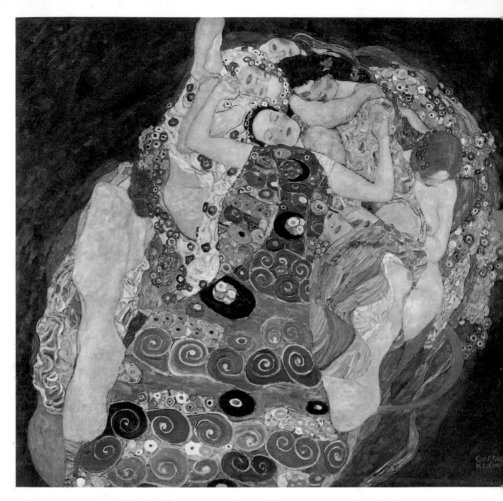

132　*The Virgin*, 1912–13. One of the earliest of Klimt's allegories (which are discussed in the final chapter), this painting, while difficult to interpret, seems to be about the state of langorous expectation before fulfilment and thus occupies a central position in Klimt's sexual mythology. The simple oval which contains the figures is the kind of dominant compositional device which frequently appears in Klimt's late work, while the bright colours and bold decorative motifs are also characteristic of his late style.

133 *The Bride*, 1917–18 (unfinished). This was one of the canvases which Klimt's death prevented him from finishing and which was left on one of the easels in his studio. Like *The Virgin*, it is an allegory whose meaning is impossible entirely to unravel. Yet the two works appear to belong together and to complement each other: their titles alone suggest this, and the appearance of a male figure in the later picture and the explicit pose of the bride herself imply a further stage in the sexual drama which fascinated Klimt so much.

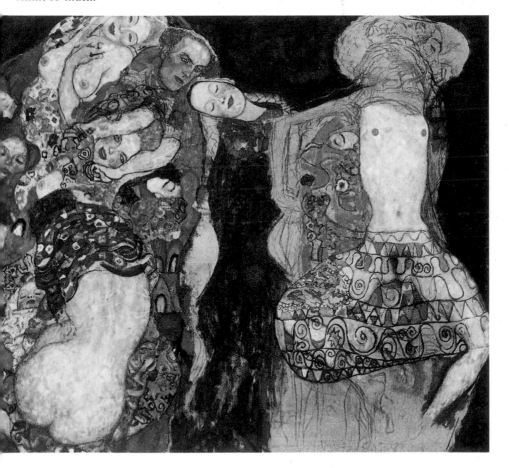

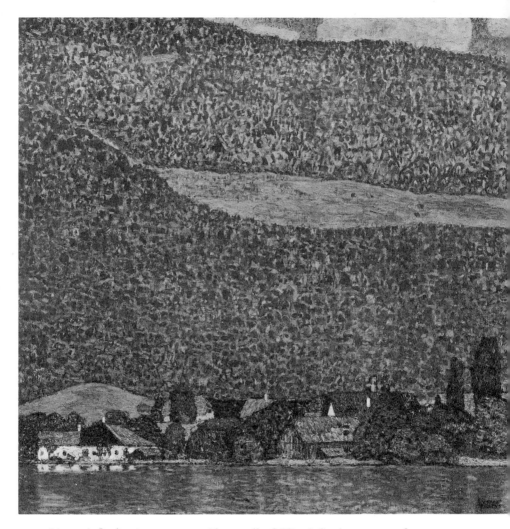

134 *Unterach on the Attersee*, 1915. Almost all of Klimt's landscapes are of
motifs from the Salzkammergut, the picturesque area of lakes and mountains
in western Austria. The artist regularly spent the summer months on a lake
called the Attersee, painting – sometimes from a boat – towns, villages,
meadows, forests and the lake itself.

The Pattern of Landscape

In Klimt's portraits the human being inhabits an entirely artificial environment. There is never a window or an open door to provide a glimpse of the world beyond. The light is artificial; there is no air; and there is no movement.

In Klimt's paintings of nature – his landscapes – it is the human being that is absent. In scarcely one of them does a figure, however tiny or unimportant, appear. It is almost as though nature must be insulated against human contact and human beings against nature in order to preserve their identity and purity. In their concentration of detail and absence of figures Klimt's landscapes have nothing to do with Northern Romanticism. There, in Caspar David Friedrich's paintings, for example, human beings are shown as part of nature; there, a transcendental dimension is suggested by seemingly infinite space whose vastness is conveyed in part by the tiny, anonymous figures who contemplate its incomprehensible immensity.

It might be thought that nature provided Klimt with subjects more congenial to his temperament and better suited to his style than portraits: the individuality of his sitters ultimately resisted all his attempts to subjugate them to the tyranny of decoration. Nature is more amenable to such treatment; lakes, flower beds, forests and meadows more obviously provide the basis for elaborate stylization and pattern-making than do human beings, no matter how extravagantly dressed. What is more, Klimt had not been trained as a landscape painter and could therefore address nature unencumbered by the conventions and prescriptions from which, in his other work, he had fought so hard to free himself.

Klimt nevertheless came to landscape painting late. His first landscape dates from 1897 or 1898 when he was already thirty-five years old. And although he continued to paint landscapes until the end of his life, he did so only intermittently: during the summer months when he was away from Vienna on holiday. He nevertheless produced about fifty-four of them, no less than a quarter of his entire output as a painter.

It is therefore surprising that relatively little attention has been given to Klimt's landscapes which remain generally less well known than his

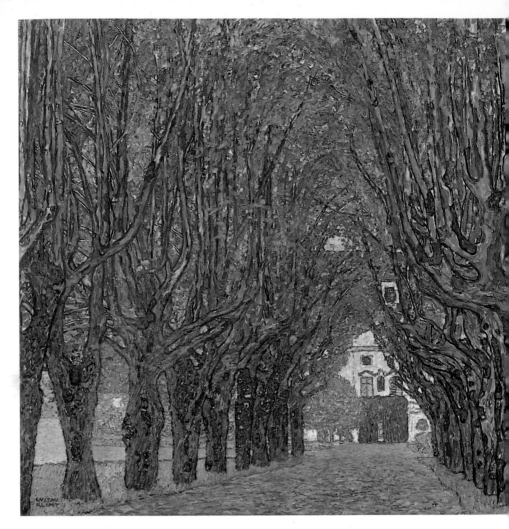

135 *Avenue in the Park of the Schloss Kammer*, 1912. Schloss Kammer is an eighteenth-century villa close to the small town on the Attersee where Klimt stayed during the summers of 1908–12. He painted the villa several times, both from the lake and, as here, from the land.

136 *Island in the Attersee, c.* 1901

other work. It has been suggested that since the landscapes were painted while Klimt was on holiday they are, as vacation work, less serious than his portraits or allegories. Nothing could be further from the truth. They are some of the most remarkable things Klimt ever did.

From 1900 to 1916 Klimt spent three months every summer (except in 1913, when he went to Italy) with Emilie Flöge, her two sisters and their mother on the Attersee, one of the lakes in the foothills of the Alps and at the heart of the Salzkammergut region to the east of Salzburg. It was a popular rural retreat for wealthy Viennese fleeing from the baking heat and the stench of the city and quieter than many others of its kind. There, away from his studio, his models and his mistresses, liberated from art politics and administration, Klimt could relax and enjoy the constant company of the woman with whom he felt most comfortable. Only on holiday did Klimt live under the same roof as Emilie Flöge.

138 Klimt took regular walks, rowed, sailed, made excursions in his motorboat (an unusual sight in those days) and took photographs of
137 Emilie in her specially designed summer dresses. Taking the air in his white suit, silk cummerbund and Panama, his face bronzed and glowing with health, he might have been a banker or a captain of industry on summer retreat rather than a painter so obsessed with work that he was making paintings every day.

In an uncharacteristically full (but characteristically ungrammatical) letter of August 1903 to Mizzi Zimmermann, Klimt described a typical day in the house on the Attersee:

Early in the morning, mostly about six, a little earlier or later – I get up – if the weather is good I go into the forest nearby – I'm painting a little beech wood there (in the sun) with a few conifers in between, that lasts until 8 o'clock, then we have breakfast, after that a swim in the lake, taken with due care – after that again a little painting, when the sun's shining a picture of the lake, when the weather's overcast a landscape from the window of my room – often I don't paint in the morning but instead study my Japanese books – outside in the open. So midday comes, after eating, a little nap or reading – until afternoon coffee – before or after coffee a second swim in the lake, not regularly but mostly. After coffee it's painting again – a large poplar at twilight with a storm coming on – now and again instead of this evening painting there's a little game of skittles in a small place not far away – but that's rare – then dusk – dinner – then in good time to bed and again in good time up the next morning. Now and again in this division of the day there's a little rowing in order to get my muscles toned up.

Although this letter does indeed create the impression that for Klimt on holiday painting was largely for relaxation, something to occupy his

137 Klimt and Emilie
Flöge in a boat on the
Attersee, 1905

138 Klimt and Emilie Flöge,
1905–06

139 *Field of Poppies*, 1907. A conflict between representation and pattern-making is evident in all of Klimt's mature work but nowhere more obviously than in his landscapes. In this painting the illusion of space and recession is repeatedly denied by the decorative elements created by the mosaic-like touches of colour and the organization of the composition into flat, interlocking shapes.

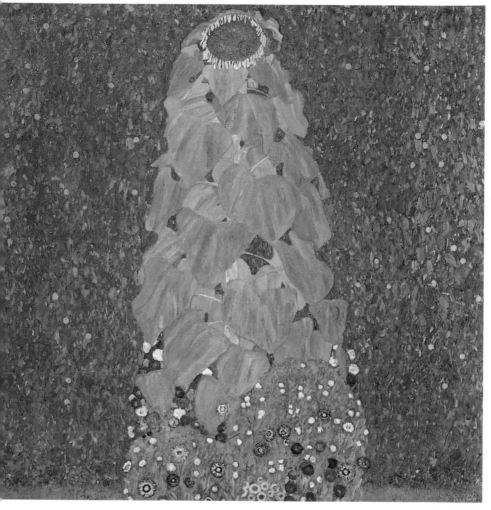

140 *The Sunflower*, 1906. The Viennese poet (and Klimt's contemporary)
Peter Altenberg once wrote that the artist painted landscapes as though they
were women. Klimt's 'portrait' of the sunflower is certainly reminiscent of
several of his figure paintings, most obviously of *The Kiss* (79). It is likely
that Klimt was moved to paint sunflowers by Van Gogh's pictures of the
same subject. Van Gogh's work was shown at the Secession in 1903 and at
the Galerie Miethke in Vienna in 1906.

time, the results are extraordinary. In one respect these landscapes are unlike all of Klimt's other work. They were begun and sometimes finished on the spot, mostly in the open air and apparently without the aid of the many preparatory sketches and studies on which Klimt habitually relied when painting his portraits and allegories. Not one of the thousands of surviving single-sheet drawings by Klimt is of a landscape motif, although it should be borne in mind that the two sketchbooks still extant contain a small number of landscape motifs and that at least some of the fifty or so sketchbooks known to have been destroyed in a fire in Emilie Flöge's apartment in 1945 may have contained many more studies from nature.

Like Daubigny and Monet, Klimt often painted from a boat, rowing himself out on to the lake, setting up his easel and peering at his motif through opera glasses now and again in order better to inspect the detail of a building or a clump of trees on or beyond the shore. Klimt would first carefully select his motif with the aid of a small square ivory viewing frame, searching for an appealing combination of forms and colours which would suit his preferred square format. Although many of the landscapes were finished in the studio in Vienna, all of them were begun in the open air, and if Klimt were not in his boat and wanted to continue working on the same painting next day, he would hide his paints and brushes in the bushes rather than carry them home. Klimt remained largely faithful to what he saw. Some of his landscapes are so accurate (and the Attersee area has changed so little since Klimt was there), that it is possible precisely to identify their subjects and the positions they were painted from.

This description of what would appear to be Impressionist methods raises expectations of Impressionist results. But Klimt was not chiefly interested in the faithful rendering of such optical impressions of the transitory effects of light and air. His paintings are faithful to what he saw, yet at the same time they go beyond it. They use design and texture, pattern and colour, in order to make the transitory permanent, to arrest the fleeting, to transform and fix a world that is constantly changing and decaying into an immutable paradise.

Apart from the four earliest landscapes, which date from before 1899, all of them are square and many of them are roughly the same size (about a metre square). The majority have an extremely high horizon line, or lack one altogether, so that their subjects, whether flower beds, woods or meadows, seem to unfurl before the eye from top to bottom of the canvas, more like tapestries or rugs than paintings, an impression which is strengthened by densely packed brushmarks of regular length which often call needlework or weaving to mind.

By choosing a standard, square format quite unlike the naturally horizontal field of vision and avoiding the use of a horizon line about a third of the way down the canvas – that pictorial convention which, more than any other, suggests depth and recession in space – Klimt contrived to bring everything in each of his landscapes close up to the picture surface. By means of decoration he also suggested something both natural and artificial, an aspect of the real world removed from reality and made inaccessible by pictorial devices which prevent the eye from entering it.

In *Farmhouse with Birches* (1900) the composition is dominated by its *141* least promising feature, an expanse of meadow. On it stand four slender saplings devoid of branches and foliage. One of them divides the canvas towards its right-hand edge. These roughly vertical, elegantly curving elements repeatedly pull the eye back towards the picture plane while by turns luring it into the picture only instantly to deny its progress. The dominant green of the grass is varied by both shorter and longer

141 *Farmhouse with Birches*, 1900

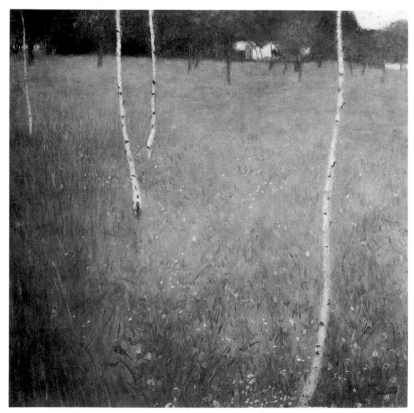

brushstrokes and also by the blues, pinks and yellows of wild flowers. At the left is a large area of longer, violet strokes which describe an area of a different kind of grass. The spatial ambiguity finally yields to a carpet-like flatness.

142 In one of several paintings Klimt made of the interior of a beech wood (1900) there is sky but it is unreachable, imprisoned behind the bars of the tree trunks, tantalizingly glimpsed in the far background behind the hints of green foliage. But once again the eye is repeatedly drawn out towards the edges of the canvas. The small, juxtaposed patches of different colours and the short brushstrokes of which this painting is made up are particularly reminiscent of Pointillism, the technique invented by Seurat and employed by many other painters around the turn of the century in order to heighten their colours and to achieve a more accurate description of light. Signac, Seurat's most important disciple, exhibited a number of paintings at the Secession in 1900 and several Viennese painters immediately succumbed to the charm of the dot. Klimt also used a modified version of Pointillism in some of his portraits, for instance that of Marie Henneberg. However, the scientific theories on which the rigorous Pointillist method was based held no interest for Klimt who rather saw in the broken brushstroke and dot a means of creating rich and varied textures: in other words, an additional kind of surface decoration. In spite of the way Klimt achieves the effect of dappled light as it is filtered through foliage and intermittently strikes the trunks of the trees, *Beeches* has little to do with either Impressionism or Post-Impressionism. Nature is made to yield to the decorative qualities of the composition which consists almost exclusively of roughly vertical elements. The eye is brought repeatedly back to the picture surface and to the intriguing play of forms and colours.

139 In *Field of Poppies* (1907) Klimt again takes a potentially confusing motif and confers on a bewildering number of relatively small elements a kind of clarity by compositional means. Especially in reproduction the picture at first strikes the eye as an incoherent mass of spots of colour set in a field of scarcely relieved green. Yet the confusion quickly yields to recognition and the spots of colour take on form, not only as the poppies of the title, but also as cornflowers, daisies, buttercups and other wild flowers. Two pear trees, their branches laden with fruit, also become visible.

In this picture the area closest to the horizon is easier to read than the foreground. This, too, is a flattening device, since it counters the tendency to read distance into the composition by persuading the eye to shift repeatedly from the bottom to the top of the canvas. The longer

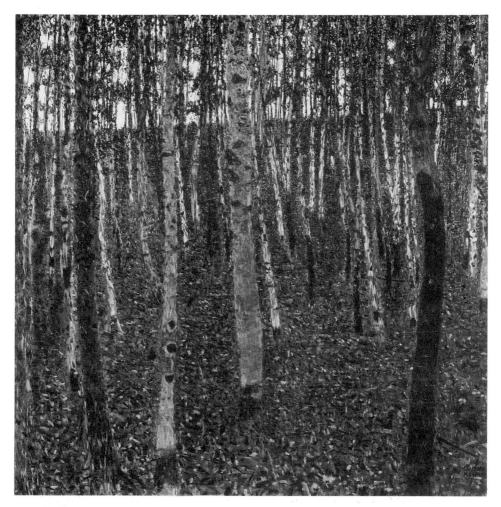

142　*Beeches*, 1900

one looks at this picture the more patterns emerge: full, organic shapes, their edges suggested by subtle shifts in colour and texture which interlock like the pieces of a jigsaw puzzle. And as each pattern emerges so it blurs at the edges and yields to another suggested by a different set of colours and brushstrokes.

This is also true of the enormous, seemingly solid mass of foliage which dominates nine-tenths of the picture surface of *The Park* (1909–　*144*
10). It is relieved only at the bottom by tree trunks, a narrow strip of

grass and a clipped hedge. It is to all intents and purposes an abstract composition, a mosaic of green, blue and yellow spots of similar size which only become representational with the aid of the key provided by the few relatively naturalistic elements at the bottom.

136 The same is true of an earlier painting, *Island in the Attersee* (*c.* 1901) which shows the Litzlberg Island opposite the inn where Klimt stayed between 1900 and 1907, and is one of only two Klimt landscapes that tackle the problem of giving compositional coherence to a large expanse of water whose surface is constantly changing. Klimt achieves that unity by means of a pattern of short brushstrokes which are more or less parallel and diminish in size towards the top of the canvas. The opalescent blues and greens, the subtle shifts of tone, the suggestion of air and movement together with the sheer minimalism of the 143 conception are reminiscent not only of Monet's paintings of waterlilies which date from about the same time but also of his pictures of rivers made in the 1880s. But in his search for pattern and structure Klimt also 145 anticipated Mondrian's *Pier and Ocean* drawings in which the movement of waves is rendered exclusively in terms of short vertical and horizontal strokes.

Here, in this extraordinarily early and daring use of a field of constantly changing colour, the originality and modernity of Klimt's sensibility is in evidence. But if the compositional problems are modern, the way the painting establishes a mood reveals another kind of sensibility. In spite of the affinities between *Island in the Attersee* and entirely abstract compositions, Klimt was as aware of the demands of representation in this painting as he was in his portraits. Nature here

143 Claude Monet, *The Seine at Port-Villez*, 1894

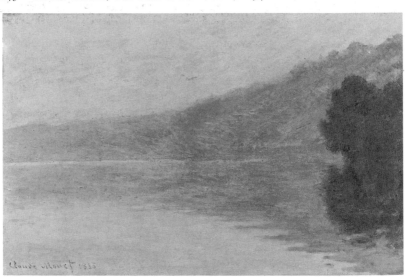

144 *The Park*, 1909–10

provides the only source of pattern and ornament, the purpose of which is to heighten an emotional response to the natural world.

The clearest example of an emotional dimension in Klimt's landscapes is *The Sunflower* (1906), a subject which may have been *140* suggested by Van Gogh (his paintings had been shown at the Secession in 1903 and at the Galerie Miethke three years later). It has the scale of a human figure and seems to be experiencing human emotions. The towering form, the base of which seems to rest on a cushion of flowers, is even reminiscent of that assumed by the embracing, kneeling couple

in *The Kiss*. In its perfection, *The Sunflower* evokes thoughts of the chill of autumn and its approaching death. Nevertheless it is rare in Klimt's work in suggesting such symbolism.

There is less change in the style of the landscapes than in any other group of Klimt's paintings. There is an increasing coherence of form, of the legibility of pattern and Klimt's palette becomes more varied and subtle. But the landscapes of every period share important characteristics. In spite of the fact that they were based on nature they are scarcely realistic descriptions of it. They rather describe a hermetic, alternative world which we are never able to enter. The mosaic of paint creates an impermeable wall. Any pictorial devices designed to lead the eye into the picture are immediately counterbalanced by others which lead it back to the surface again.

The world described in these landscapes is untouched by change. There is no sense either of the fleeting effects of light and atmosphere or of the passing of time or season. Nature is arrested at the point of blossoming, at its most perfect. It is always summer; it never rains. A world without space and air, it is claustrophobic. There are no wide vistas. Klimt's view of nature seems calculated to soothe the nerves of an agoraphobic. Every square inch of the surface is crammed with incident. Nature is made static by means of decoration just as in the portraits the human personality is suppressed by ornament. It is nature as imagined by a city dweller, a domesticated, urban view.

145 Piet Mondrian, *Composition 10: Pier and Ocean*, 1915

146 *Houses at Unterach on the Attersee*, 1916

In a sense what Klimt achieves in his landscapes is similar to
Cézanne's intentions in his. Both approaches emerge from the struggle
to understand the human response to nature and especially the process
of perception. But whereas Cézanne attempts to combine what is
known with what is seen, to reconcile an understanding of volume with
the flatness of his canvas, Klimt seems to see the process of perception as
involved with the recognition of pattern. The chaotic impression of
nature is resolved, becomes manageable in terms of the shapes and
forms the eye and mind impose upon it.

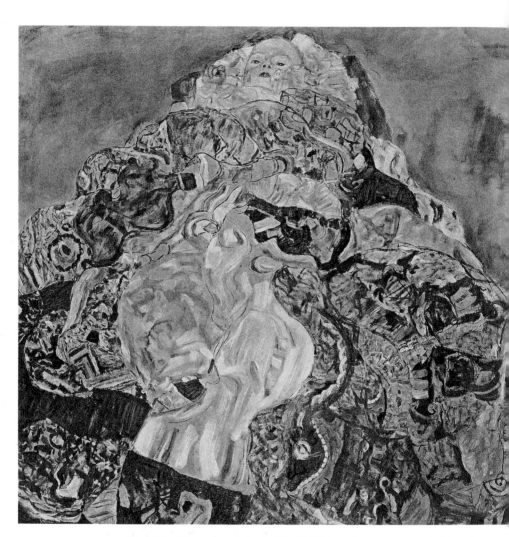

147 *Baby* (*Cradle*), 1917–18 (unfinished). This is the most remarkable of Klimt's late works. Obviously related to the theme of birth, death and regeneration which appears repeatedly in the major allegories, but seemingly lacking in any symbolic intention, *Baby* employs the kind of dominant and simple compositional device characteristic of several of the paintings of this period. In the bold foreshortening of the figure it is nevertheless unique in Klimt's oeuvre.

The Final Years

Neither the *Kunstschau* of 1908 nor that of 1909 was a financial success. Hoffmann's prefabricated, temporary buildings were taken down; the organizing committee counted the losses and disbanded. Everywhere in Vienna there was a sense of change, and not necessarily for the better. The excitement, the feeling that great things were happening, had gone. Several of Klimt's friends moved abroad and so, in 1910, did Kokoschka. It was clear to him, as it was to many younger painters, that Berlin was now more stimulating than Vienna had ever been.

Klimt remained in Vienna, however, his art increasingly isolated and seemingly immune to outside forces. His earlier work betrays the influence of a variety of artists, but the paintings from the last nine years of his life register nothing of the momentous changes that were occurring in art beyond the Austrian border. Klimt's work did develop, especially in style, but it did so not, as has often been claimed, under the influence of the Cubists, Fauvists or any of his other foreign contemporaries.

Soon after the last *Kunstschau* closed, Klimt travelled to France and Spain in the company of Carl Moll. He had been to neither country before and when he returned at the end of 1909, his friends were anxious to hear his impressions not so much of Madrid as of Paris – the 'new Rome of modern painting'. 'How did you like it?', he was asked. 'Not at all', Klimt replied, 'there's an awful lot of painting going on there.' Klimt's friends should not have been surprised. They should have known that he had never been deeply interested in French art and that a single visit to Paris would not have been enough to lure him from his artistic isolation.

There is a paradox here. Klimt's activities as an exhibition organizer and the international recognition his own work achieved had given modern Austrian painting a European dimension for the first time. Yet Klimt's art was neither entirely European in character nor even entirely of its time, a curious fact recognized by a younger painter, Anton Faistauer, who, attempting to sum up Klimt's achievement after his death, wrote that he was incomprehensible 'to the West . . . conceivable only in Vienna, better still in Budapest or Constantinople . . .'. The continuing popularity of Klimt's work, outside Austria as well as inside

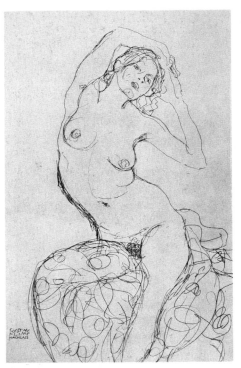 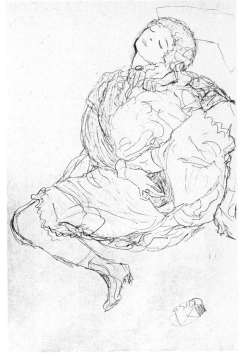

148 *Female Nude*, 1914–16
149 Sketch, possibly a study for *The Bride*, 1914–16

150 Drawing, 1912–14. The best of Klimt's masterly drawings are highly erotic and often explicit in their description of sexual acts. Indeed, by suggesting that the spectator is participating as voyeur, they verge on the pornographic.

its borders, contradicts Faistauer's intriguing assertion, but there was some truth in it nevertheless. Klimt's work was strikingly different from that of every other European artist, and as time went on it did seem increasingly to elude all the conventional artistic categories.

Between 1909 and Klimt's death in 1918, his work changed. The developments were not dramatic and they occurred in style rather than subject-matter. Although ornament remained very important, it now played a less dominant role and was derived more from nature than geometry. Klimt also abandoned the use of gold and silver leaf, perhaps the most striking characteristic of his work until then, and introduced a number of subtle mixtures of colour – lilac, lemon yellow, coral and salmon pink – which, because of the admixture of white, frequently

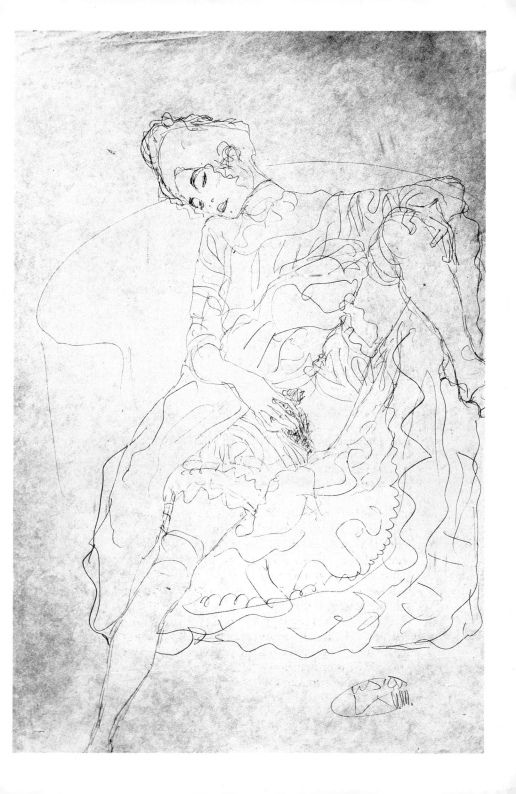

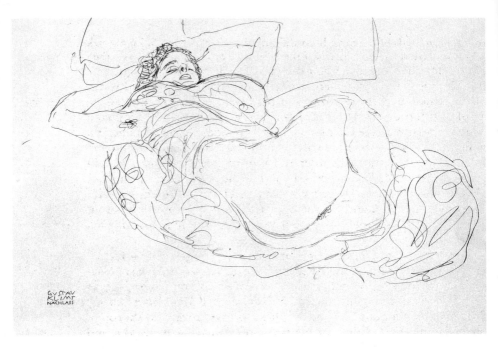

151 *Reclining Nude*, 1914–16

take on a dry, chalky appearance. He handled his paint more loosely, too, and as a result the graphic qualities – which had always been obvious – became more pronounced. It has been argued – not least by Max Eisler, the author of the earliest Klimt monograph – that there was a new unity between the graphic and the painterly in the late work and that stylistic changes in the paintings were anticipated and largely caused by developments in the drawings.

There can be no doubt about Klimt's greatness as a draughtsman. From the start of his career he was obsessed by drawing. He would interrupt work on a painting to draw something unconnected with it, as though drawing were a kind of recreation. Piles of sketches and studies littered his studio floor. He not only made drawings in preparation for paintings, he also used them to exercise his hand and brain. He rarely sold them and treated them with a casualness which amazed and horrified the critic Arthur Roessler when he visited the studio.

As I . . . rummaged around in a heap of hundreds of drawings, surrounded by eight or ten mewing and purring cats playfully chasing each other about and making the sketches . . . fly, I asked in surprise why he put up with them

ruining hundreds of the most beautiful drawings in this way. With a smirk Klimt replied: 'It doesn't matter if they crumple or tear a few sheets – they piss on the others and, don't you know?, that's the best fixative!'

Roessler's visit took place before 1904 when Klimt habitually drew in black chalk on cheap wrapping paper. But from around 1906 he employed more varied and more expensive materials. He adopted a larger format and used a much better, imitation Japanese paper on which he drew in pencil. He also introduced colour more often and frequently white, too, in order to emphasize and heighten certain passages. Many of these larger drawings are not sketches or studies but plainly works in their own right; and those of the figure reveal a growing interest in three-dimensional form. The large number of portrait drawings shows a new concern for physical likeness and even personality.

152,153

By far the greatest number of Klimt's later drawings are of the female nude and many of these are so erotic in character that they have been seldom reproduced or exhibited. Most of them, moreover, are in private collections. This is regrettable, since Klimt's most erotic drawings are among his best. These works reveal a thorough understanding of anatomy, an unerring sense of placing on the page and an extraordinary variety of mark – from the controlled line to the seemingly casual scribble – with which Klimt describes both the quality of flesh and the texture and patterning of cloth. Remarkable above all is the intensely sensual mood which Klimt establishes in these drawings. Several show a couple in the act of coition, but in most the woman is alone. The spectator is nevertheless made to feel present: it is for him that the woman is removing her clothes, for him that she is displaying her genitals, for him that she is waiting so expectantly – even though she rarely looks at him directly.

148–151

As we have seen, the later portrait drawings show a new concern for likeness and occasionally even for the personality of the sitter. There is a similar development in Klimt's painting. The second portrait of Adele Bloch-Bauer, unlike the first, depicts character with something approaching psychological insight. The central position of the figure and its uncompromisingly frontal pose are also new. These devices appear again in the charming portrait of the young Mäda Primavesi which Klimt completed in 1913 and which not only seems to have been a good likeness but also explores the developing personality of the sitter. She was the daughter of one of Klimt's wealthiest patrons, Otto Primavesi, who also supported the Wiener Werkstätte financially. The painting manages to hint at a highly strung, even a spoiled, wilful nature, without detracting from the dominant impression of spirit and

116

156

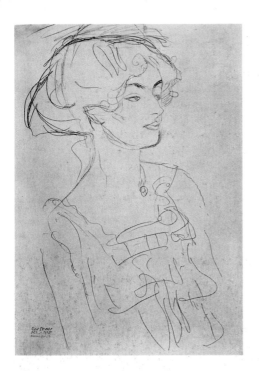 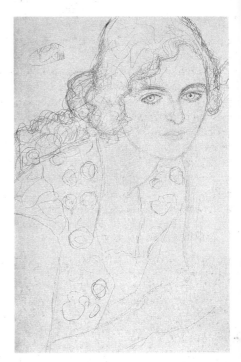

152, 153 *Portrait of a Lady*, 1916, and (right) *Portrait of a Woman*, 1914

energy. Although essentially flat – the edges of the white triangle suggested by the pattern in the centre of the Oriental carpet continue the contours of the dress and thus integrate the figure into the background –, the composition does not evoke the kind of airless, claustrophobic space of the earlier portraits and the loose handling of the paint suggests vitality and movement.

The portrait of Maria Munk was one of several canvases left unfinished in Klimt's studio when he died and the incomplete passages reveal something of the way Klimt achieved the fresher effects in his late work. The sitter's face and most of the patterned background are close to a final state while the body is little more than a rough, spontaneous but informative chalk drawing. Klimt obviously did not adopt the conventional practice of advancing each part of his composition simultaneously, but was initially anxious to achieve a balance between the sitter's face and the decoration which surrounds it. He made many studies for every portrait, but *Maria Munk* reveals that at this stage of his career at least, the process of exploration and comprehension through drawing continued on the canvas. He made marks, remade and

corrected them in charcoal before establishing more definitive outlines in paint.

Several of Klimt's later works occupy unfamiliar territory located somewhere between portraiture and allegory. Obviously based on real people who are not identified, they present them posed and dressed in a way which implies narrative and invites interpretation. One of these paintings is *The Friends* (*c.* 1916–17) which portrays what seems to be a lesbian couple, one exotically dressed, the other naked, against a background of birds and flowers stylized in an Oriental manner. The women gaze directly at the spectator, one of them tenderly. The relationship thus established is both touching and intriguing: we want to know more about these people and their lives.

154

154 *The Friends, c.* 1916–17

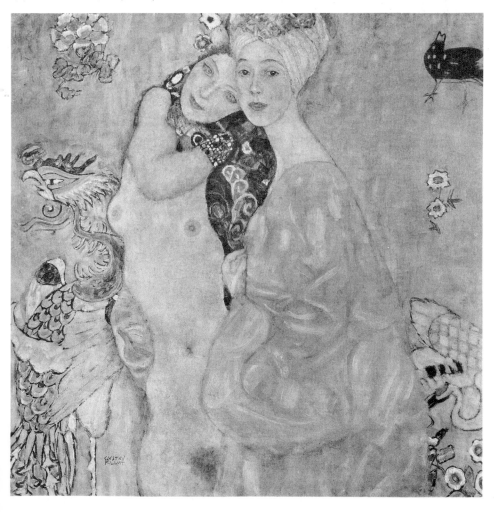

The face of the naked figure in *The Friends* also appears in some of the late allegories in which Klimt continued to explore the theme that had always fascinated him: the mysteries of human life. In these allegories the change in Klimt's style can be traced more clearly. His colours became bolder and brighter, his ornament larger and simpler, and he now organized groups of intertwined figures within large, dominant and elementary shapes which seem to revolve around a central axis and hover against a dark background suggesting infinite space.

132 The earliest of these late allegories is *The Virgin* (1912–13). The virgin herself lies, apparently sleeping and in an attitude of submissiveness, against a whirling mass of semi-naked, obviously young women, whose faces register longing, ecstasy and contentment. The meaning of this painting is impenetrable, however, as is that of Klimt's last allegory,
133 to which it is obviously related. *The Bride* (1917–18) was another of the canvases Klimt left unfinished. Two of the faces in the column of figures on the left are similar to two in *The Virgin*, and the face in the centre recalls that of the virgin herself, although it is more stylized and impassive in the manner of a Japanese Noh mask, on which it may have been based. There is also a male figure who gazes across at the opened thighs of the half naked woman on the right, the decorations on her dress emphasizing rather than hiding her sexuality.

 The Bride also includes, partly hidden at the lower left, a baby who is
147 the subject of another painting of the same date, *Baby (Cradle)*. In some ways this is perhaps the most remarkable of Klimt's late works. Devoid of allegorical intention, highly unusual in itself, it is in its foreshortening and strong composition an immediately arresting image. The domi-

155 Klimt's last studio showing two of the canvases – *The Bride* and *Lady with Fans* – which were left unfinished on easels upon his death in 1918

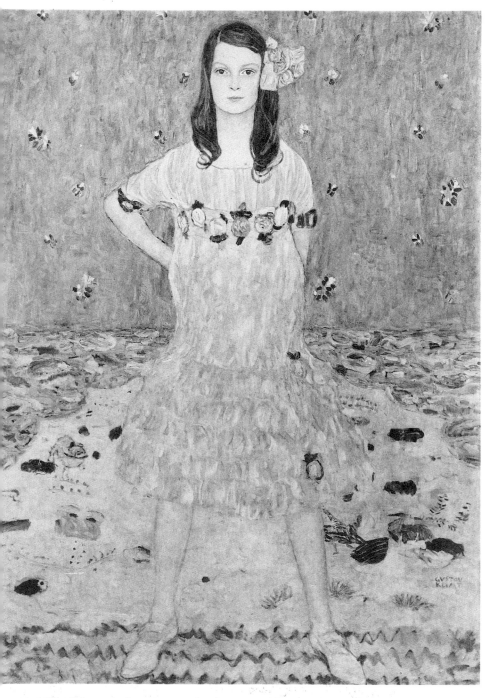

156 *Mäda Primavesi*, 1912

nant, almost equilateral triangle with the infant's head at its apex, its outline filled with a profusion of brightly coloured, richly patterned coverlets is one of the boldest pictorial devices Klimt ever used. Although it is difficult precisely to imagine how the picture would have looked had Klimt finished it, the broad handling of paint and the sheer extent and variety of the patterned areas allow us to speculate that, in the year he died, Klimt was on the verge of a development as major as any that he had previously accomplished.

Klimt found his late allegories difficult to sell. In general, however, during the last ten years of his life his work was more popular than ever and even his relationship with the cultural authorities improved – it was the Ministry of Education that bought *The Kiss* for the nation at the *Kunstschau* of 1908. For the next few years Klimt was at the height of his fame, not only in Austria but also abroad. In 1910 he was, with Courbet and Renoir, accorded the honour of an individual exhibition at the Venice Biennale. Klimt's contribution, shown in a room designed by the Wiener Werkstätte, received the greatest attention. The style Klimt had created was the talk of Venice. Fashion designers made clothes in imitation of those that appeared in his portraits and the city bought the second version of *Judith*. The painting still hangs in Venice, in the Palazzo di Ca' Pesaro on the Grand Canal.

However, even though Klimt's contribution to the Biennale was a great popular success, not everyone who visited Venice thought *Judith* to be a masterpiece, or Klimt an important artist. The Italian painter Ardengo Soffici launched an attack on what he described as Klimt's 'decadence' in the Florentine newspaper *La Voce*, and the Futurists Marinetti and Boccioni were similarly outraged by what they saw to be an irrelevant and self-indulgent manner. For the Futurists, Klimt's exquisitely refined style belonged to the past, part of a museum culture, and his paintings, like the museums themselves, ought to have been destroyed. By comparison with many of the artistic developments of the period, Futurism among them, Klimt's work did indeed seem part of an outdated and even moribund tradition.

That judgment seemed to be confirmed by a huge and highly important exhibition which was staged in Cologne two years later, in 1912. Organized by a group of artists who called themselves the Sonderbund, that exhibition presented an international panorama of contemporary art together with examples of the work from the immediate past which had given birth to Modernism. French and German art dominated the show which introduced many of its visitors to Fauvism, Expressionism, Cubism and Futurism. Klimt's work was

nowhere to be seen: Austria was represented by Kokoschka and Schiele, the two young painters who had made their debut in Vienna at the *Kunstschau*.

Had the Sonderbund show been staged only five years before it would have undoubtedly included Klimt's painting as a matter of course. By 1912, however, his work was not considered sufficiently modern to be exhibited in a show of that kind. For Hans Tietze, the Viennese art historian entrusted with selecting the Austrian section at Cologne, Klimt already belonged to another era.

Klimt may have been excluded from the Sonderbund exhibition, but he continued to show his work in Austria and abroad regularly. The number of articles paying him tribute multiplied, there was no shortage of collectors to buy his work and at least one of the directors of major foreign museums, Alfred Lichtwark of the Hamburg Kunsthalle, believed him to be one of the greatest painters of his generation. Nor is there any doubt that the significance of the Sonderbund exhibition and of the emergence of Kokoschka and Schiele may seem greater to us now than it did to most of Klimt's contemporaries or to the artist himself. Nevertheless the raw drama and desperation expressed in the work of those younger artists reflect the apprehension, even the fear felt by many in Vienna as the new century progressed.

The mood of pessimism was most memorably caught by the great satirical journalist Karl Kraus. In the issues of his magazine *Die Fackel* (*The Torch*), published between 1908 and 1914, Kraus repeatedly warned of catastrophe, and one event especially gave his warnings great urgency. When, in 1908, Austria risked war by annexing Bosnia, the wise saw the adventure as the desperate act of a geriatric empire attempting to delay its inevitable demise. A fuse had been lit in the Balkans and the eventual explosion would rock half the world, dismember Europe and blow the Habsburg monarchy away.

The old optimism had gone; apocalypse was in the air and the superstitious glimpsed the faces of its horsemen in a series of natural disasters and other portents which occurred during the next four years. The first was the earthquake which devastated the city of Messina, killing 84,000 people, in December 1908. The second was the reappearance of Halley's Comet in May 1910. This was preceded by countless books and articles, scientific as well as popular, which argued that, even if the world were not destroyed in a collision, humanity would be wiped out by the poisonous gases in the comet's tail. The third was the loss of the 'unsinkable' ocean liner, the *Titanic*, in 1912, and with it all faith in the belief that natural forces had finally been subjugated by human ingenuity. These events were accompanied by

recurring political crises – in the Balkans, in Russia and North Africa – which flared up as though in preparation for the final catastrophe. That began in June 1914 when the heir to the Austrian throne was assassinated by a Bosnian revolutionary at Sarajevo. Exactly a month later Austria declared war on Serbia and, one by one, Germany, Russia, Britain, France, Turkey, Japan and the United States entered the conflict. The nightmare, the first mechanized war in history, had begun and the period that Kraus later described in the title of his great satirical play as *Die letzten Tage der Menschheit* (*The Last Days of Mankind*) did not come to an end until 1918. The Habsburg dynasty was deposed, Austria-Hungary dismembered, Vienna reduced to the capital of an insignificant, landlocked Central European republic.

One searches in vain for any sign of these momentous events in Klimt's work. It has been proposed that Klimt intended the battle scene *98* in the background of the portrait of Friederike Maria Beer to be read as an allusion to the war but such a suggestion is not convincing. Klimt seems to have been no more touched by what was happening in the world beyond his studio than he had ever been. In his correspondence the war is mentioned only incidentally. A postcard to Emilie Flöge, dated 27 June 1915, is typical:

TIVOLI SUNDAY Yesterday evening threatening storm three thunder-claps and then gone again, starry sky at night – hot night, hot morning . . . four pictures – one of them has to be finished before I can get away – Down with the enemy! Warmest greetings GUSTAV

One is reminded of the issue of *Die Fackel*, dated 23 February 1915, in which Karl Kraus reprinted side by side, without comment, two articles which had appeared on the same day in the same Viennese newspaper. On the left was a vivid report by a soldier of the dreadful destruction at the front; on the right a description of the opening celebrations for a splendid new café in the city centre. Clearly Klimt was not alone in being oblivious to the carnage. His life, like that of thousands of other Viennese, was unchanged.

Klimt did not live to see the end of the war. On 11 January 1918, he suffered the stroke that he is said to have feared always and which left him paralysed on the right side. He was no longer able to paint. Less than a month later, on 6 February, he died from influenza. His body was too weak to resist it and, deprived of the consolation of painting, his will to live had gone.

157 Schiele drew Klimt in the morgue of Vienna's General Hospital, his beard shaved off, his cheeks pale and sunken, the plump, ruddy face familiar from photographs unrecognizable. Before the end of the year

157 Egon Schiele,
The Dead Klimt, 1918

158 Oskar Kokoschka,
The Tempest, 1914

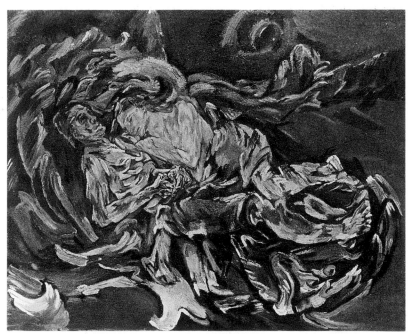

Schiele, too, would be dead, one of the millions of victims of the world-wide influenza epidemic which attacked Vienna with special virulence.

In 1914 Oskar Kokoschka completed one of his greatest paintings, *The Tempest*. It shows the artist himself together with his mistress Alma Mahler lying on a bed which seems to consist of a cloud twisting and turning in the turbulent air above a moonlit mountainous landscape. The figures lie close together, but the man stares into space, his interlocked hands expressing tension and even anguish. Not long after the picture was finished, Kokoschka sold it in order to buy the uniform he needed to join the cavalry and go to war. To compare *The Tempest* with *The Kiss* is to be confronted by the enormous gulf that now existed between Klimt and the younger generation of Viennese painters. In 1914 his work seemed to belong to an almost unimaginable age of luxury and optimism while Kokoschka's embodied a more modern and disturbing sensibility. It continues to do so. Kokoschka still seems like one of our contemporaries while Klimt represents a past with which almost all contact has been broken.

It is not only in comparison with younger artists that Klimt seems out of place. Faistauer's description of Klimt as 'an outsider' rings even truer now than when he wrote it. Given a longer and more coherent view of modern art than Faistauer could take, we see how strange Klimt's work seems in the company of the other great painters of his generation. He was born in 1862, two years later than the Belgian Expressionist James Ensor and one year earlier than Edvard Munch. Toulouse-Lautrec was born in 1864, Wassily Kandinsky, the pioneer of non-figurative art, in 1866. The distance of Klimt's work from what we now recognize as the mainstream of modern painting seems greater still if we remember that the first portrait of Adele Bloch-Bauer dates from the same year as Picasso's *Demoiselles d'Avignon* and the second version of *Judith* from 1909 when Marinetti published his first Futurist Manifesto. By 1918, the year of Klimt's death, abstract painting was well established throughout Europe and Dadaism and Constructivism had undermined the foundations of art itself. If these styles and movements contain the essence of Modernism, Klimt's work cannot be described as modern in any meaningful sense.

Klimt's influence was limited. No school followed him. There was no one quite like him before and no one at all like him afterwards. His effect on the course of painting in the twentieth century was negligible. Yet the transition from the old to the modern can be seen more clearly in his work and the purposes for which it was intended than in that of any other major artist.

BIBLIOGRAPHY

There is a wealth of literature on Klimt, some of it in English but most of it in German. Since the vogue for Klimt's work accompanied that for Art Nouveau during the 1960s, most of the literature dates either from his lifetime or from the last thirty years. Very little indeed was published during the intervening period.

There is a catalogue raisonné of the paintings: Fritz Novotny and Johannes Dobai, *Gustav Klimt* (Salzburg 1967), which also includes a critical essay, a biography and bibliography. It is also available in English (2nd edn Boston 1975). All the paintings are also reproduced, if sometimes almost invisibly, in Johannes Dobai and Sergio Coradeschi, *L'Opera Completa di Klimt* (Milan 1978; French edn Paris 1983). Alice Strobl, *Gustav Klimt – Die Zeichnungen* (3 vols, Salzburg 1980–84) is a complete catalogue of the drawings.

Much essential documentary material is reproduced in Christian M. Nebehay, *Gustav Klimt: Dokumentation* (Vienna 1969), which also includes full biographical information and of which a modified paperback edition exists: *Gustav Klimt: Sein Leben nach zeitgenössischen Berichten und Quellen* (Munich 1976). An invaluable anthology of writing about Klimt, much of it published during the artist's lifetime, is Otto Breicha (ed.), *Gustav Klimt – Die Goldene Pforte* (Salzburg 1978).

Curiously there are few monographs dealing with Klimt's entire career. By far the best of them is Werner Hofmann, *Gustav Klimt* (trans. Inge Goodwin, London 1972). It is a quite brilliant study and the present writer has relied on it heavily from time to time. Alessandra Comini, *Gustav Klimt*, (London and New York 1975) is brief but can be recommended as a general introduction. Another short but useful essay is contained in Jane Kallir, *Gustav Klimt; Egon Schiele* (New York 1980), which contains interesting information about the reception of Klimt's work in the United States.

There are several important books about individual aspects of Klimt's work. Marian Bisanz-Prakken, *Gustav Klimt, Der Beethovenfries* (Salzburg 1977) is an exemplary study of a single work while Thomas Zaunschirm, *Gustav Klimt: Margarethe Stonborough-Wittgenstein* (Frankfurt am Main 1987) is an extended essay about one of Klimt's most impressive portraits. Klimt's relationship with one of his most generous patrons and the fate of the Beethoven frieze are dealt with in Christian M. Nebehay, *Gustav Klimt, Egon Schiele und die Familie Lederer* (Berne 1987). Angelica Bäumer's *Gustav Klimt: Women* (trans. Ewald Osers, London 1986) is an examination of Klimt's most important subject from a feminist point of view. Jean Clair's *La nue et la norme: Klimt et Picasso en 1907* (Paris 1988), is a short but dazzling essay. Full of information and insights not only into Klimt's paintings but also into his relationship with Emilie Flöge and the Viennese fashion industry is Wolfgang Georg Fischer, *Gustav Klimt und Emilie Flöge* (Vienna 1987).

Articles on almost every aspect of Klimt's work abound. Nine of them, most of them important, are collected in a special issue of the *Mitteilungen der Österreichischen Galerie*

(vol. 22/3, nos. 66/7, 1978–79) and they include Peter Vergo on *Philosophy* and the University paintings, Herbert Giese on Klimt's early period and the Company of Artists, and Johannes Dobai on the landscapes. The latter appears in English as the introduction to an illustrated book – *Gustav Klimt: Landscapes* (London 1988). Other articles which the present writer has found useful are: Jaroslav Leshko, 'Klimt, Kokoschka und die mykenischen Funde' in *Mitteilungen der Österreichischen Galerie* (vol. 13, no. 57, 1969) and Peter Vergo, 'Gustav Klimt's Beethoven Frieze', *The Burlington Magazine* (115, no. 839, 1979).

Among general studies of the period which include useful passages about Klimt these are outstanding: Hermann Broch, *Hugo von Hofmannsthal and His Time. The European Imagination, 1860–1920* (trans. and with an introduction by Michael P. Steinberg, Chicago and London 1984); Richard Hamann and Jost Hermand, *Stilkunst um 1900* (vol. 4 of *Deutsche Kunst und Künstler von der Gründerzeit bis zum Expressionismus*, East Berlin 1967); Hans H. Hofstätter, *Geschichte der europäischen Jugendstilmalerei* (Cologne 1963); Nicholas Powell, *The Sacred Spring: The Arts in Vienna, 1898–1918* (London and New York 1974); Peter Vergo, *Art in Vienna, 1898–1918: Klimt, Kokoschka, Schiele and their Contemporaries* (Oxford 1975 and subs. edns); Robert Waissenberger, *Die Wiener Secession* (Vienna 1971; English edn London 1977); William M. Johnston, *The Austrian Mind: An Intellectual and Social History, 1848–1938* (Berkeley, Los Angeles and London 1972); James Shedel, *Art and Society: The New Art Movement in Vienna, 1897–1914* (Palo Alto 1981); Allan Janik and Stephen Toulmin, *Wittgenstein's Vienna* (London 1973) and Celia Bertin, *La femme à Vienne au temps de Freud* (Paris 1989). Finally, there is the book to which the present writer owes a large debt: Carl E. Schorschke, *Fin-De-Siecle Vienna, Politics and Culture* (London 1980).

Also important for anyone interested in Klimt are the catalogues of exhibitions, not only of Klimt's work but also of the Viennese art, architecture and craft of his time. There are too many of them for the space available here, but among the most important are: *Gustav Klimt – Egon Schiele*, New York (Guggenheim Museum) 1965; *Gustav Klimt. Egon Schiele. Zum Gedächtnis ihres Todes vor 50 Jahren. Zeichnungen und Aquarelle*, Vienna (Albertina) 1968; *Gustav Klimt. Henri Matisse*, 3. Internationale der Zeichnung (Mathildenhöhe Darmstadt) 1970; *Gustav Klimt: Zeichnungen*, Vienna (Historisches Museum der Stadt Wien), Hanover (Kestner-Gesellschaft), Munich (Villa Stuck), Linz (Neue Galerie der Stadt-Wolfgang-Gurlitt-Museum) 1984–85; *Experiment Weltuntergang: Wien um 1900*, Hamburg (Kunsthalle) 1981, with an excellent essay by Werner Hofmann; *Traum und Wirklichkeit Wien 1870–1930*, Vienna (Historisches Museum der Stadt Wien); *Vienne 1880–1938, l'Apocalypse Joyeuse*, Paris (Centre Georges Pompidou) 1986; and *Vienna 1900, Art, Architecture and Design*, New York (Museum of Modern Art), 1986.

SOURCES OF QUOTATIONS

The sources of quotations, where they are not given in the text, are listed here by chapter and page number. Unless otherwise stated, all translations are the author's.

INTRODUCTION

9 Eduard Pötzl in the *Neues Wiener Tageblatt*, in Christian M. Nebehay, *Gustav Klimt: Dokumentation*, Vienna 1969, p. 425, n. 13.

16–17 Robert Musil, *The Man Without Qualities*, vol. 1, trans. Eithne Wilkins and Ernst Kaiser, London 1979 (paperback edn), p. 33.

18 Undated typescript preserved in the Vienna City Library, in Nebehay, 1969, p. 32.

19 Emil Pirchan, *Gustav Klimt. Ein Künstler aus Wien*, Vienna and Leipzig 1942, in Otto Breicha (ed.), *Gustav Klimt, Die Goldene Pforte: Werk-Wesen-Wirkung*, Salzburg 1978, p. 34.

CHAPTER ONE

24 In Christian M. Nebehay, *Gustav Klimt: Dokumentation*, Vienna 1969, p. 12.

29 Egon Fridell, *Kulturgeschichte der Neuzeit*, Munich n.d., in Hans H. Hofstätter, *Geschichte der europäischen Jugendstilmalerei: Ein Entwurf*, Cologne 1977 (6th edn), p. 15.

31 Adolf Loos, *Die potemkinsche Stadt* in *Sämtliche Schriften I*, Vienna and Munich 1962, Vienna 1898, p. 153–4.

34 Ludwig Hevesi, *Hans Makart und die Wiener Secession*, in cat. *Experiment Weltuntergang: Wien um 1900*, Hamburg Kunsthalle 1981. p. 10.

35 In cat. *Hans Makart, Entwürfe und Phantasien*, Vienna, Hermesvilla and Salzburg, Residenzgalerie 1975, p. 25.

36–7 Stefan Zweig, *Die Welt von Gestern; Erinnerungen eines Europäers*, Frankfurt 1970 (paperback edn), p. 23.

37 Alfred Lichtwark, *Makartbouquet und Blumenstrauss*, Munich 1894, in cat. *Experiment Weltuntergang* 1981, pp. 19–20.

CHAPTER TWO

40 Christian M. Nebehay, *Gustav Klimt: Dokumentation*, Vienna 1969, p. 81.

CHAPTER THREE

53–7 Ludwig Hevesi in Christian M. Nebehay, *Gustav Klimt: Dokumentation*, Vienna 1969, p. 212.

58 *Neue Freie Presse*, 28 March 1900, in Nebehay 1969, p. 212.

58 Karl Kraus in *Die Fackel*, no. 36, March 1900, in Nebehay 1969, p. 218.

59 Ernst Mach, *The Analysis of Sensations and the relation of the Physical to the Psychical*, trans. C. M. Williams, New York 1959, p. 121.

59 Hermann Broch, *Hugo von Hofmannsthal and his Time. The European Imagination 1860–1920*, trans., ed. and with

intro. by Michael P. Steinberg, Chicago and London 1984, p. 2.

61 Hermann Bahr, *Rede über Klimt*, Vienna 1901, p. 10.

64 Broch 1984, p. 149.

64 In Herbert Giese, *Matsch und die Brüder Klimt, Regesten zum Frühwerk Gustav Klimts*, in *Mitteilungen der Österreichischen Galerie*, vols. 22–23, nos. 66–67, 1978–79, p. 66.

CHAPTER FOUR

67,68 Ludwig Hevesi in Charles Home (ed.), 'The Art Revival in Austria', special number of *The Studio*, 1906, p. Aiv.

68–9 Hermann Bahr, *Secession*, Vienna 1900, p. 2, in Werner J. Schweiger, *Wiener Werkstätte. Design in Vienna, 1903–1932*, trans. Alexander Lieven, London 1984, p. 11.

73 Joseph M. Olbrich in *Der Architekt*, vol. 5, 1899, in cat. *Joseph M. Olbrich, 1867–1908. Das Werk des Architekten*, Darmstadt, Vienna, Berlin, 1967, p. 14.

80 Hans Tietze, *Gustav Klimts Persönlichkeit*, Vienna 1919, in Christian M. Nebehay, *Gustav Klimt: Dokumentation*, Vienna 1969, p. 137.

CHAPTER FIVE

89 Catalogue of the 14th exhibition of the Secession, 1902, 25ff.

90 Anonymous newspaper review, in Hermann Bahr, *Gegen Klimt*, Vienna 1903, p. 67.

90 In Christian M. Nebehay, *Gustav Klimt: Dokumentation*, Vienna 1969, p. 297, n. 4f.

92 Werner Hofmann, *Gesamtkunstwerk Wien* in cat. *Der Hang zum Gesamtkunstwerk*, Aarau and Frankfurt 1983, p. 88.

CHAPTER SIX

99–100 Carl E. Schorschke, *Fin-De-Siècle Vienna; Politics and Culture*, London 1980, p. 8.

101 Carl E. Schorschke, 'Revolt in Vienna' in *The New York Review of Books*, 29 May 1986, p. 25.

103 In Christian M. Nebehay, *Gustav Klimt: Dokumentation*, Vienna 1969, p. 387.

104 Eduard F. Sekler, *Josef Hoffmann – Das architektonische Werk*, Salzburg and Vienna 1982, p. 94.

106–7 Berta Zuckerkandl-Szeps, *Erinnerungen an Gustav Klimt. Zu seinem sechszehnten Todestag*. Wiener Tageszeitung, 6 Feb 1934.

108 Adolf Loos, *Von einem armen reichen Manne* in *Sämtliche Schriften I*, pp. 201–7, in Peter Vergo, *Art in Vienna 1898–1918*, London 1975, pp. 164–5.

CHAPTER SEVEN

113, 114 Josef Engelhart: *Ein Wiener Maler Erzählt; Mein Leben und meine Modelle*, Vienna 1943, p. 124.

116 Published in the catalogue of the 1908 *Kunstschau*, quoted after: Christian M. Nebehay, *Gustav Klimt: Dokumentation*, Vienna 1969, p. 394.

120 Arthur Roessler, *Erinnerung an Egon Schiele* in Fritz Karpfen (ed.), *Das Egon Schiele Buch*, Vienna 1921, quoted after: Christian M. Nebehay, *Gustav Klimt, Sein Leben nach zeitgenössischen Berichten und Quellen*, Munich 1976, p. 278.
125 Adolf Loos, *Ornament und Verbrechen*, Vienna 1908, p. 276.
126 Interview with Berta Zuckerkandl, *Wiener Allgemeine Zeitung*, 12 April 1905, in Johannes Dobai, *Zu Gustav Klimts Gemälde Der Kuss, in Mitteilungen der Österreichischen Galerie*, 1968, vol. 12, no. 56, p. 84.
126 Otto Stoessl, *Kunstschau in Die Fackel*, nos. 259–60, 13 July 1908, p. 29.
127 Stoessl, p. 28.
127 In Werner J. Schweiger, *Der junge Kokoschka*, Vienna and Munich 1983, p. 74.
128 Arthur Roessler, *Der Målkasten. Künstleranekdoten*, Vienna 1924, p. 65, in Nebehay, *Gustav Klimt: Dokumentation*, p. 422, n.5b
129 Berta Zuckerkandl, *Einiges über Klimt, Volkszeitung*, 6 February 1936, in Nebehay, p. 400.

CHAPTER EIGHT
131 Alessandra Comini, *Egon Schiele's Portraits*, Berkeley, Los Angeles and London 1974, p. 130.
132 W.R. Sickert in *A Free House*, O. Sitwell (ed.) London 1947, p. 251.
146 Werner Hofmann, *Gustav Klimt*, trans. Inge Goodwin, London 1972, p. 19.
151 Karl M. Kuzmany, *Kunstschau Wien 1908* in *Die Kunst* vol. 18, 1908, p. 518.

CHAPTER NINE
155 Arthur Schnitzler, *Jugend in Wien, Eine Autobiographie*, ed. Therese Nickl and Heinrich Schnitzler, Munich 1971 (paperback edn), pp 254–5.
158 Stefan Zweig, *Die Welt von Gestern; Erinnerungen eines Europäers*, Frankfurt 1970 (paperback edn), p. 69.
158 Zweig, p. 71.
159 Zweig, p. 74.
159–61 Robert Pincus-Witten, *The Iconography of Symbo-*

list Painting in *Artforum*, January 1970, p. 60.
161 Otto Weininger, *Geschlecht und Charakter*, Vienna 1903, p. 108.
164 In Christian M. Nebehay, *Gustav Klimt, Sein Leben nach zeitgenössischen Berichten und Quellen*, Munich 1976, p. 259.
168 Phillipe Julian, *Dreamers of Decadence – Symbolist Painters of the 1890s*, trans. Robert Baldick, London 1971, p. 44.
168 Felix Salten, *Gustav Klimt, gelegentliche Anmerkungen*, Vienna and Leipzig 1903, in Otto Breicha (ed.), *Gustav Klimt: Die goldene Pforte*, Salzburg 1978, pp. 31–2.
169 In Christian M. Nebehay, *Gustav Klimt: Dokumentation*, Vienna 1969, p. 26.
172 Hans Tietze, *Gustav Klimts Persönlichkeitnach Mitteilungen seiner Freunde* in *Die Bildenden Künste*, 2, 1919, nos. 1–2, p. 10.
173 Wolfgang Georg Fischer, *Gustav Klimt und Emilie Flöge: Genie und Talent, Freundschaft und Besessenheit*, Vienna 1987, p. 111.
173 Weininger, p. 309.
173 Fischer, p. 128.
173 Fischer, p. 112.

CHAPTER TEN
180 In Christian M. Nebehay, *Gustav Klimt schreibt an eine Liebe* in *Klimt Studien*, Salzburg 1978, pp. 109–10.

CHAPTER ELEVEN
193 Arthur Roessler *In memoriam Gustav Klimt*, Vienna 1926, in Christian M. Nebehay, *Gustav Klimt, sein Leben nach zeitgenössischen Berichten und Quellen*, Munich 1976, p. 225.
193 Anton Faistauer, *Neue Malerei in Österreich: Betrachtungen eines Malers*, Zurich, Leipzig and Vienna 1923, p. 11.
196–7 Arthur Roessler, *Der Malerkasten. Künstleranekdoten*, Vienna 1924, p. 1192.
204 In Wolfgang Georg Fischer, *Gustav Klimt und Emilie Flöge: Genie und Talent, Freundschaft und Besessenheit*, Vienna 1987, p. 185 (correspondence no. 336).

LIST OF ILLUSTRATIONS

Measurements are given in centimetres followed by inches, height preceding width.

107 *Margaretha Stonborough-Wittgenstein*, 1905. Oil on canvas, 180×90 ($70\frac{7}{8} \times 35\frac{3}{8}$). Bayerische Staatsgemälde-sammlungen, Munich.

108 *Sonja Knips*, 1898. Oil on canvas, 145×145 ($57\frac{1}{8} \times 57\frac{1}{8}$). Österreichische Galerie, Vienna.

109 Study for *Fritza Riedler*, 1908. Pencil, 41×32 ($16\frac{1}{2} \times 12\frac{5}{8}$). Marlborough Fine Art Ltd, London.

110 Study for *Fritza Riedler*, 1905–06. Pencil on brown paper, 45.2×31.5 ($17\frac{3}{4} \times 12\frac{3}{8}$). Neue Galerie der Stadt Linz.

111 *Hermine Gallia*, 1903–4. Oil on canvas 170×96 ($66\frac{7}{8} \times 37\frac{3}{4}$). National Gallery, London.

112 *Emilie Flöge*, 1902. Oil on canvas, 181×84 ($71\frac{1}{4} \times 33\frac{1}{8}$). Historisches Museum der Stadt, Vienna.

113 Else and Berta Wiesenthal dancing the Faust waltz. Photo Bildarchiv der Österreichische Nationalbibliothek, Vienna.

114 Emilie Floge in a 'Konzert-Kleid'. Historisches Museum der Stadt, Vienna.

115 *Fritza Riedler*, 1906. Oil on canvas, 153×133 ($60\frac{1}{4} \times 52\frac{3}{8}$). Österreichische Galerie, Vienna.

116 *Adele Bloch-Bauer II*, 1912. Oil on canvas, 190×120 ($74\frac{3}{4} \times 47\frac{1}{4}$). Österreichische Galerie, Vienna.

117 *Leda*, 1917. Oil on canvas, 99×99 (39×39). Destroyed in 1945 at Schloss Immendorf.

118 *Water Snakes*, 1904–07. Oil on canvas, 180×180 ($70\frac{7}{8} \times 70\frac{7}{8}$). Galleria Nazionale d'Arte Moderna, Rome.

119 *Danae*, 1907–8. Oil on canvas, 77×83 ($30\frac{1}{4} \times 32\frac{5}{8}$). Private Collection.

120 Viennese prostitute, *c.* 1877. Photo Leo Bachrich. Historisches Museum der Stadt, Vienna.

121 *Death and Life*, 1908–11, revised 1915–16. Oil on canvas, 178×198 ($70\frac{1}{4} \times 78$). Private Collection.

122 Franz von Stuck, *Salome*, 1906. 117×93 ($46 \times 36\frac{1}{2}$). Städtische Galerie im Lenbachhaus, Munich.

123 Max Klinger, *The New Salome*, 1893. Marble, height 88 ($34\frac{5}{8}$). Museum der bildenden Künste, Leipzig.

124 Drawing, 1912. Pencil with red and blue crayon on Japanese paper, 37×55.7 ($14\frac{5}{8} \times 21\frac{7}{8}$). Private Collection.

125 *Nude with Clasped Hands*, 1912–13. Pencil, 55.9×37.3 ($22 \times 14\frac{5}{8}$). Historisches Museum der Stadt, Vienna.

126 Drawing, 1909–10. Pencil with red and blue crayon, heightened with white, on Japanese paper, 37×56 ($14\frac{5}{8} \times 22$). Private Collection.

127 Drawing, 1912–13. Pencil, 37.2×56 ($14\frac{5}{8} \times 22$). Galerie Kornfeld, Bern.

128 Self portrait as genitalia, *c.* 1900. Collection Erich Lederer, Geneva.

129 *The Three Ages of Woman*, 1905. Oil on canvas, 180×180 ($70\frac{7}{8} \times 70\frac{7}{8}$). Galleria Nazionale d'Arte Modena, Rome.

130 *Hope II*, 1907–08. Oil on canvas, 110×110 ($43\frac{1}{4} \times 43\frac{1}{4}$). The Museum of Modern Art, New York; Mr and Mrs Ronald S. Lauder and Helen Acheson Funds, and Serge Sabarsky.

131 *Hope I*, 1903. Oil on canvas, 181×67 ($71\frac{1}{4} \times 26\frac{3}{8}$). National Gallery of Art, Ottawa.

132 ' *The Virgin*, 1912–13. Oil on canvas, 190×200 ($74\frac{3}{4} \times 78\frac{3}{4}$). Národní Galerie, Prague.

133 *The Bride*, 1917–18 (unfinished). Oil on canvas, 166×190 ($65\frac{3}{8} \times 74\frac{3}{4}$). Private Collection.

134 *Unterach on the Attersee*, 1915. Oil on canvas, 110×110

($43\frac{1}{4} \times 43\frac{1}{4}$). Salzburger Landessammlungen-Rupertinum, Salzburg.

135 *Avenue in the Park of the Schloss Kammer*, 1912. Oil on canvas, 110×110 ($43\frac{1}{4} \times 43\frac{1}{4}$). Österreichische Galerie, Vienna.

136 *Island in the Attersee*, *c.* 1901. Oil on canvas, 100×100 ($39\frac{3}{8} \times 39\frac{3}{8}$). Private Collection, New York.

137 Klimt and Emilie Flöge in a boat on the Attersee, 1905. Photo courtesy Fischer Fine Art Ltd, London.

138 Klimt and Emilie Flöge, 1905–6. Photo Bildarchiv der Österreichische Nationalbibliothek, Vienna.

139 *Field of Poppies*, 1907. Oil on canvas, 110×110 ($43\frac{1}{4} \times 43\frac{1}{4}$). Österreichische Galerie, Vienna.

140 *The Sunflower*, 1906. Oil on canvas, 110×110 ($43\frac{1}{4} \times 43\frac{1}{4}$). Private Collection.

141 *Farmhouse with Birches*, 1900. Oil on canvas, 80×80 ($31\frac{1}{2} \times 31\frac{1}{2}$). Österreichische Galerie, Vienna.

142 *Beeches*, 1900. Oil on canvas, 100×100 ($39\frac{3}{8} \times 39\frac{3}{8}$). Staatliche Kunstsammlungen, Gemäldegalerie Neue Meister, Dresden. Photo Deutsche Fotothek, Dresden.

143 Claude Monet, *The Seine at Port-Villez*, 1894. Oil on canvas, 65.4×100.3 ($25\frac{3}{4} \times 39\frac{1}{2}$). Tate Gallery, London.

144 *The Park*, 1909–10. Oil on canvas, 110×110 ($43\frac{1}{4} \times 43\frac{1}{4}$). Collection, The Museum of Modern Art, New York (Gertrude A. Mellon Fund).

145 Piet Mondrian, *Composition 10: Pier and Ocean*, 1915. Oil on canvas, 85×108 ($33\frac{1}{2} \times 42\frac{1}{2}$). Rijksmuseum Kröller-Müller, Otterlo.

146 *Houses at Unterach on the Attersee*, 1916. Oil on canvas, 110×110 ($43\frac{1}{4} \times 43\frac{1}{4}$). Österreichische Galerie, Vienna.

147 *Baby (Cradle)*, 1917–18 (unfinished). Oil on canvas, 110×110 ($43\frac{1}{4} \times 43\frac{1}{4}$). National Gallery of Art, Washington D.C.; Gift of Otto and Franziska Kallir and the Carol and Edwin Gaines Fullinwinder Fund.

148 *Female Nude*, 1914–16. Pencil, 56.9×37.3 ($22\frac{3}{8} \times 14\frac{5}{8}$). Graphische Sammlung der Eidgenössischen Technischen Hochschule, Zurich.

149 Sketch, possibly for *The Bride*, 1914–16. Pencil and red crayon heightened with white on Japanese paper, 56.7×37.2 ($22\frac{3}{8} \times 14\frac{5}{8}$). Private Collection.

150 Drawing, 1912–14. Pencil, heightened with white on Japanese paper, 55.8×37 ($22 \times 14\frac{5}{8}$). Private Collection.

151 *Reclining Nude*, 1914–16. Pencil, 36.9×55.9 ($14\frac{1}{2} \times 22$). Graphische Sammlung der Eidgenössischen Technischen Hochschule, Zurich.

152 *Portrait of a Lady*, 1916. Pencil, 55.4×37.2 ($21\frac{3}{4} \times 14\frac{5}{8}$). Graphische Sammlung der Eidgenössischen Technischen Hochschule, Zurich.

153 *Portrait of a Woman*, 1914. Pencil and red and blue crayon, heightened with white, 50×32.4 ($19\frac{5}{8} \times 12\frac{3}{4}$). Galerie Wolfgang Gurlitt, Munich.

154 *The Friends*, *c.* 1916–17. Oil on canvas, 99×99 (39×39). Destroyed in 1945 at Schloss Immendorf.

155 Interior of Klimt's last studio. Photo Bildarchiv der Österreichische Nationalbibliothek, Vienna.

156 *Mäda Primavesi*, 1912. Oil on canvas, 150×110 ($59 \times 43\frac{1}{4}$). The Metropolitan Museum of Art, New York.

157 Egon Schiele, *The Dead Klimt*, 1918. Black chalk, 47.1×30 ($18\frac{1}{2} \times 11\frac{3}{4}$). Anton Peschka Collection, Vienna.

158 Oskar Kokoschka, *The Tempest*, 1914. Oil on canvas, 181×220 ($71\frac{1}{4} \times 86\frac{5}{8}$). Kunstmuseum, Basle.